MIGRANCY, CULTURE, IDENTITY

In *Migrancy, Culture, Identity*, Iain Chambers unravels how our sense of place and identity is realised as we move through myriad languages, worlds and histories. The author explores the uncharted impact of cultural diversity on today's world, from the 'realistic' eye of social commentary to the 'scientific' approach of the cultural anthropologist or the critical distance of the historian; from the computer screen to the Walkman and 'World Music'.

Migrancy, Culture, Identity takes us on a journey into the disturbance and dislocation of history, culture and identity that faces all of us, to explore how migration, marginality and homelessness have disrupted the West's faith in linear progress and rational thinking, undermining our knowledge and cultural identity.

'Iain Chambers is the fabulist of contemporary cultural studies. These essays tell stories of different worlds that already define our own; moving lightly through border-zones of culture dense with new ideas, they stop to chat with strangers on the way; and they share with us the wise joy in dialogue as a way of working towards a common horizon.'

Meaghan Morris

'This thoughtful, stylish and poetic book extends contemporary concerns with hybridity and alterity. Above all, it offers social and cultural theory a new sense of power and movement.'

Paul Gilroy, *Goldsmiths' College, University of London*

Iain Chambers teaches at the Istituto Universitario Orientale, Naples, and is the author of *Border Dialogues: Journeys in Post-modernity* and *Popular Culture: The Metropolitan Experience*.

COMEDIA
Series Editor: David Morley

MIGRANCY, CULTURE, IDENTITY

Iain Chambers

A Comedia book
published by Routledge

London and New York

First published 1994
by Routledge
11 New Fetter Lane, London EC4P 4EE

Simultaneously published in the USA and Canada
by Routledge
29 West 35th Street, New York, NY 10001

© 1994 Iain Chambers

Typeset in 10/12pt Times by
Ponting–Green Publishing Services,
Chesham, Buckinghamshire
Printed and bound in Great Britain by
T.J. Press (Padstow) Ltd, Cornwall
Printed on acid free paper

British Library Cataloguing in Publication Data
A catalogue record for this book is available from
the British Library

Library of Congress Cataloging in Publication Data
Chambers, Iain.
Migrancy, culture, identity/Iain Chambers.
p. cm.
'Simultaneously published in the USA and Canada' – T.p. verso.
Includes bibliographical references (p.) and index.
1. Emigration and immigration – Social aspects. 2. Cultural
relations. 3. Identity (Psychology) I. Title.
JV6225.C43 1993
304.8–dc20 93–7863
CIP

ISBN 0–415–08801–1 (hbk)
ISBN 0–415–08802–X (pbk)

304. 8 CHA

From the provincial edge of an atlas, from the hem
of a frayed empire, a man stops. Not for another anthem
trembling over the water – he has learned three of them –

but for that faint sidereal drone interrupted by the air
gusting over black water, or so that he can hear
the surf in the pores of wet sand wince and pucker.

<div align="right">Derek Walcott, Omeros</div>

CONTENTS

ACKNOWLEDGEMENTS

Much of this book was written in different parts of the northern hemisphere. In moving across frontiers and living between worlds there are many I wish to thank for their kindness, hospitality, encouragement and conversation.

Firstly, there are Antoine Hennion and Christine Chapuis for their Parisian hospitality, generous friendship and support (and Arthur for his bed). Then there is Homi Bhabha for his careful reading and commentary on chapter 2, and his witticisms while walking beside Venetian canals.

Nelson Moe and Karen Van Dyck introduced me to the evening seminar world of Columbia, and I am grateful for their friendship and reading chapter 4. Larry Shore, very much a migrant himself, and Sarah Regan generously extended food and company to me in New York. I am also indebted to the graduate students of the 'Communications and the City' class at Hunter College, City University of New York, who welcomed me in the spring of 1990 and then stimulated, and sometimes contested, the arguments presented in chapter 6. I also wish to express gratitude to Mick Taussig for offering a transit hospitality in the intellectual dispersal of that city. Andreas Huyssen, Stuart Ewing, Peter Hitchcock and Annabelle Sreberny-Mohammadi all provided me with spaces to speak there.

Even Ruud and Kristin Elster offered exquisite hospitality in Norway.

I have known Dick Hebdige and Jessica Pickard for many a year and I want to thank them for that, for their example, and for a Rioja-tinted summer evening spent somewhere between Stoke Newington and Los Angeles discussing 'home' and 'homelessness'. On that theme I owe a special debt of gratitude to Stuart and Catherine Hall for friendship, inspiration and a supportive household in London.

Also, while in London, I want to thank Angela McRobbie for her writing, conversation and enthusiasm, and Paul Gilroy and Vron Ware for being friends and for the intellectual stimulus of their work.

Many of the arguments in this book were initially developed in lessons and discussion with students at the Istituto Universitario Orientale, Naples. It was, above all, in this place that I was encouraged to take forward a series of questions and transform them into the present book.

Finally, I want to thank Dave Morley for travelling with this material from the beginning, and Lidia Curti for accompanying me on this journey as well as on all the others.

Some of this writing was presented elsewhere before being collected and substantially expanded into the present volume. In Los Angeles I want to thank the editorial collective of *Strategies* and *Emergences*, together with Teshome H. Gabriel and Hamid Naficy, for their encouragement and enthusiasm. I also want to thank the editors of *New Formations* (London) and *Textus* (Genoa) for initially offering me the space to try out various ideas, as well as Jon Bird, Barry Curtis, Tim Putnam, George Robertson and Lisa Tickner for publishing an earlier version of chapter 6 in their *Mapping the Futures* (London & New York, Routledge, 1993). I also wish to thank Professor Augusto Crocco for kindly giving me permission to reproduce two photographs of the Cappella Sansevero in Naples.

These writings are dedicated to the memory of Elizabeth Marion Chambers (née Innes), e alla memoria di Silvio Curti e Iolanda Curti (née Scandurra), and to Robin Rusher.

1

AN IMPOSSIBLE
HOMECOMING

If we rethink culture . . . in terms of travel, then the organic, naturalizing bias of the term culture – seen as a rooted body that grows, lives, dies, etc. – is questioned. Constructed and disputed *historicities*, sites of displacement, interference, and interaction, come more sharply into view.

James Clifford[1]

Homelessness is coming to be the destiny of the world.

Martin Heidegger[2]

One day I recognised that what was more important for me than anything else was how I defined myself to the degree that I was a stranger . . . I then realised that, in his vulnerability, the stranger could only count on the hospitality that others could offer him. Just as words benefit from the hospitality the white page offers them or the bird from the unconditional space of the sky.

Edmond Jabès[3]

On southern Californian highways, around Tijuana close to the Mexican border, are road signs usually associated with the encounter of nature and culture: symbols of leaping deer or prowling bears that warn us to look out for them crossing the road. This time the icon is diverse, it refers to cross-cultural traffic. The graphic indicates people on foot. Desperate to escape the destiny of poverty, they cut or crawl through the border wire and, dodging the speeding automobiles, scamper across the concrete in a dash to flee from the past and in-state themselves in the promise of the North.

This desperate scene of hope, migration and attempted relocation is a fragment, invariably caught in a press photo, on the news, in a television documentary, in immigration statistics, that nevertheless

illuminates much of the landscape we inhabit. When the 'Third World' is no longer maintained at a distance 'out there' but begins to appear 'in here', when the encounter between diverse cultures, histories, religions and languages no longer occurs along the peripheries, in the 'contact zones' as Mary Louise Pratt calls them, but emerges at the centre of our daily lives, in the cities and cultures of the so-called 'advanced', or 'First', world, then we can perhaps begin to talk of a significant interruption in the preceding sense of our own lives, cultures, languages and futures.[4]

This is not to say that London and Lagos are nowadays simply geographically separate urban centres held in the common syntax of the global metropolitan media. They may share certain goods, habits, styles and languages, but for each thing in common there is also a corresponding local twist, inflection, idiolect. They are not merely physically distinct, but also remain sharply differentiated in economic, historical and cultural terms. Nevertheless, such differences are not always and inevitably instances of division and barriers. They can also act as hinges that serve both to close *and* to open doors in an increasing global traffic.

Migration, together with the enunciation of cultural borders and crossings, is also deeply inscribed in the itineraries of much contemporary reasoning. For migrancy and exile, as Edward Said points out, involves a 'discontinuous state of being', a form of picking a quarrel with where you come from. It has thereby been transformed 'into a potent, even enriching, motif of modern culture'.[5] For:

> The exile knows that in a secular and contingent world, homes are always provisional. Borders and barriers which enclose us within the safety of familiar territory can also become prisons, and are often defended beyond reason or necessity. Exiles cross borders, break barriers of thought and experience.[6]

Such a journey acquires the form of a restless interrogation, undoing its very terms of reference as the point of departure is lost along the way. If exile presumes an initial home and the eventual promise of a return, the questions met with *en route* consistently breach the boundaries of such an itinerary. The possibilities of continuing to identify with such premises weaken and fall away. This memory of primary loss, persistently inscribed in the uncertain becoming of the outward journey, has made of exile a suggestive symbol of our times. Indeed, a significant tendency in present-day critical thought, confronted with the shrinkage of the European rationale that once

claimed to speak for all and everything, is to adopt metaphors of movement, migration, maps, travel and sometimes a seemingly facile tourism. However, such metaphors are not restricted to the genealogy of a particular critical paradigm, or confined to the plane of a theoretical turn. Although we might cynically choose to read in recent intellectual peregrinations simply the latest twist in the continuing narrative of patriarchal, occidental intellectual power as it seeks to domesticate the rest and extend its hold over the once excluded and silent, there is clearly also something else occurring here. In the accelerating processes of globalisation we are also increasingly confronted with an extensive cultural and historical diversity that proves impermeable to the explanations we habitually employ. It is this complex and persistent challenge to the world we are accustomed to inhabit that forcibly suggests that we are not merely witness to the latest unwinding in the lax liberal spring of mental eclecticism.

For recent apertures in critical thought instigated by certain internal displacements in the hearth of the West (feminism, deconstructionism, psychoanalysis, post-metaphysical thought) have been increasingly augmented by the persistent question of a presence that no longer lies elsewhere: the return of the repressed, the subordinate and the forgotten in 'Third World' musics, literatures, poverties and populations as they come to occupy the economies, cities, institutions, media and leisure time of the First World.

Such a highly charged punctuation of the cosmopolitan script, destined finally to be recognised as a part of our history and be televised in future riots of the metropolitan dispossessed, compels us to recognise the need for a mode of thinking that is neither fixed nor stable, but is one that is open to the prospect of a continual return to events, to their re-elaboration and revision. This retelling, re-citing and re-siting of what passes for historical and cultural knowledge depend upon the recalling and re-membering of earlier fragments and traces that flare up and flash in our present 'moment of danger' as they come to live on in new constellations.[7] These are fragments that remain as fragments: splinters of light that illuminate our journey while simultaneously casting questioning shadows along the path. The belief in the transparency of truth and the power of origins to define the finality of our passage is dispersed by this perpetual movement of transmutation and transformation. History is harvested and collected, to be assembled, made to speak, re-membered, re-read and rewritten, and language comes alive in transit, in interpretation.

3

To talk of this inheritance, to refer to history, as to refer to translation or memory, is always to speak of the incomplete, the never fully decipherable. It is to betray any hope of transparency. For to translate is always to transform. It always involves a necessary travesty of any metaphysics of authenticity or origins. We find ourselves employing a language that is always shadowed by loss, an elsewhere, a ghost: the unconscious, an 'other' text, an 'other' voice, an 'other' world; a language that is 'powerfully affected by the foreign tongue'.[8]

For the nomadic experience of language, wandering without a fixed home, dwelling at the crossroads of the world, bearing our sense of being and difference, is no longer the expression of a unique tradition or history, even if it pretends to carry a single name. Thought wanders. It migrates, requires translation. Here reason runs the risk of opening out on to the world, of finding itself in a passage without a reassuring foundation or finality: a passage open to the changing skies of existence and terrestrial illumination. No longer protected by the gods or their secular resurrection in the vestments of an imperious rationalism or positivist projection, thought runs the danger of becoming responsible for itself and the safekeeping of being, its only protection lying, as Rilke and Heidegger remind us, in the very absence of protection.[9]

This inevitably implies another sense of 'home', of being in the world. It means to conceive of dwelling as a mobile habitat, as a mode of inhabiting time and space not as though they were fixed and closed structures, but as providing the critical provocation of an opening whose questioning presence reverberates in the movement of the languages that constitute our sense of identity, place and belonging. There is no one place, language or tradition that can claim this role. For although the journey from the centre into the periphery, seeking the unexpected, the bizarre and the wonder of it all, may still dominate this literature – this book, for example – such stories ultimately represent a weak echo in the volume of travel, migration and dislocation that so many people coming from elsewhere have faced and continue to experience. So, *I* finally come to experience the violence of alterity, of other worlds, languages and identities, and there finally discover my dwelling to be sustained across encounters, dialogues and clashes with other histories, other places, other people. For the return of the 'native' not only signals the dramatic necessity 'to abrogate the boundaries between Western and non-Western history', but also returns to the centre the violence that initially

4

marked the encounters out in the periphery that laid the foundations of *my* world.[10]

So this is not necessarily even an account of travel. For to travel implies movement between fixed positions, a site of departure, a point of arrival, the knowledge of an itinerary. It also intimates an eventual return, a potential homecoming. Migrancy, on the contrary, involves a movement in which neither the points of departure nor those of arrival are immutable or certain. It calls for a dwelling in language, in histories, in identities that are constantly subject to mutation. Always in transit, the promise of a homecoming – completing the story, domesticating the detour – becomes an impossibility. History gives way to histories, as the West gives way to the world.

It means to live in another country in which:

> it becomes more than ever urgent to develop a framework of thinking that makes the migrant central, not ancillary, to historical processes. We need to disarm the genealogical rhetoric of blood, property and frontiers and to substitute for it a lateral account of social relations, one that stresses the contingency of all definitions of self and the other, and the necessity always to tread lightly.[11]

Does all this mean I have nothing to say, that every gesture that begins in the West is inherently imperialist, merely the latest move in the extension of my power regarding the others? It is perhaps here that the political and ethical implications of the arguments advanced in this book can be most clearly grasped as an attempt to fracture the vicious circle between speakers and the spoken for. For, in breaking into my own body of speech, opening up the gaps and listening to the silences in my own inheritance, I perhaps learn to tread lightly along the limits of where I am speaking from. I begin to comprehend that where there are limits there also exist other voices, bodies, worlds, on the other side, beyond my particular boundaries. In the pursuit of my desires across such frontiers I am paradoxically forced to face my confines, together with that excess that seeks to sustain the dialogues across them. Transported some way into this border country, I look into a potentially further space: the possibility of another place, another world, another future.

The accumulated diasporas of modernity, set in train by 'modernisation', the growing global economy, and the induced, often brutally

enforced, migrations of individuals and whole populations from 'peripheries' towards Euro-American metropolises and 'Third World' cities, are of a magnitude and intensity that dramatically dwarf any direct comparison with the secondary and largely meta-phorical journeys of intellectual thought. Analogy is risky. There is always the obvious allure of the romantic domestication and intel-lectual homecoming that the poetic figures of travel and exile promise. Still, it is a risk to be run. For the modern migrations of thought and people are phenomena that are deeply implicated in each other's trajectories and futures.

To be forced to cross the Atlantic as a slave in chains, to cross the Mediterranean or the Rio Grande illegally, heading hopefully North, or even to sweat in slow queues before officialdom, clutching passports and work permits, is to acquire the habit of living between worlds, caught on a frontier that runs through your tongue, religion, music, dress, appearance and life. To come from elsewhere, from 'there' and not 'here', and hence to be simultaneously 'inside' and 'outside' the situation at hand, is to live at the intersections of histories and memories, experiencing both their preliminary dis-persal and their subsequent translation into new, more extensive, arrangements along emerging routes. It is simultaneously to en-counter the languages of powerlessness and the potential intimations of heterotopic futures. This drama, rarely freely chosen, is also the drama of the stranger. Cut off from the homelands of tradition, experiencing a constantly challenged identity, the stranger is per-petually required to make herself at home in an interminable discussion between a scattered historical inheritance and a hetero-geneous present.

As such the stranger is an emblem – she or he is a figure that draws our attention to the urgencies of our time: a presence that questions our present. For the stranger threatens the 'binary classification deployed in the construction of order', and introduces us to the uncanny displacement of ambiguity.[12] That stranger, as the ghost that shadows every discourse, is the disturbing interrogation, the estrangement, that potentially exists within us all. It is a presence that persists, that cannot be effaced, that draws me out of myself towards another. It is the insistence of the other face that charges my obligation to that 'strangeness that cannot be suppressed, which means that it is my obligation that cannot be effaced'.[13] As 'the symptom that renders our "selves" problematic, perhaps impos-sible, the stranger commences with the emergence of the awareness

of my difference and concludes when we all recognise ourselves as strangers'.[14] This decentring of the classical 'individual' leads also to the weakening and dispersal of the rationalist *episteme*, of the Western *cogito*, that once anchored and warranted the subject as the privileged fulcrum of knowledge, truth and being.[15]

In such a rendezvous critical thought is forced to abandon any pretence to a fixed site, as though it offered stable foundations upon which the sense of our lives could blithely be erected. It is not solid in its surroundings, immutable in its co-ordinates. It is not a permanent mansion but is rather a provocation: a platform, a raft, from which we scan the horizon for signs while afloat in the agitated currents of the world. Continually constructed from the flotsam and fragments blown in from the storms called 'progress', critical thought rewrites the tables of memory as we attempt to transform our histories, languages and recollections from a point of arrival into a point of departure.[16]

NOTES

1 James Clifford, 'Travelling Cultures', in Lawrence Grossberg, Cary Nelson and Paula Treichler (eds), *Cultural Studies*, London & New York, Routledge, 1992, p. 101.
2 Martin Heidegger, 'Letter on Humanism', in Martin Heidegger, *Basic Writings*, New York, Harper & Row, 1977, p. 219.
3 Edmond Jabès, *Le Livre de l'Hospitalité*, Paris, Gallimard, 1991.
4 Mary Louise Pratt, *Imperial Eyes. Travel Writing and Transculturation*, London & New York, Routledge, 1992.
5 Edward Said, 'Reflections on Exile', in Russell Ferguson, Martha Gever, Trinh T. Minh-ha and Cornel West (eds), *Out There, Marginalization and Contemporary Cultures*, Cambridge, Mass., MIT Press, 1990, pp. 357–63.
6 Ibid., p. 365.
7 To echo Walter Benjamin, 'Theses on the Philosophy of History', in Walter Benjamin, *Illuminations*, London, Collins/Fontana, 1973, and Jacques Derrida, 'Living On, Border Lines', in Harold Bloom *et al.* (eds), *Deconstruction and Criticism*, London, Routledge & Kegan Paul, 1979. On the lightning-flash of being and the danger of its oblivion, also see Martin Heidegger, 'The Turning', in Martin Heidegger, *The Question Concerning Technology and Other Essays*, New York, Harper & Row, 1977. For an acute comparison of Benjamin and Derrida around the question of 'history' and 'translation', see Tejaswini Niranjana, *Siting Translation. History, Post-Structuralism and the Colonial Context*, Berkeley, Los Angeles & London, University of California Press, 1992.
8 Rudolf Pannwitz quoted in Walter Benjamin, 'The Task of the

Translator', in Walter Benjamin, *Illuminations*, London, Collins/ Fontana, 1973, p. 81.

9 Martin Heidegger, 'The Turning', in Martin Heidegger, *The Question Concerning Technology and Other Essays*, New York, Harper & Row, 1977.

10 The quote is from Eric R. Wolf, *Europe and the People without History*, Berkeley, Los Angeles & London, University of California Press, 1982, p. x.

11 Paul Carter, *Living in a New Country. History, Travelling and Language*, London, Faber & Faber, 1992, pp. 7–8.

12 Zygmunt Bauman, 'Modernity and Ambivalence', in Mike Featherstone (ed.), *Global Culture. Nationalism, Globalization and Modernity*, London, Newbury Park & New Delhi, Sage, 1990, pp. 150–1.

13 Emmanuel Lévinas, 'The Paradox of Morality: an Interview with Emmanuel Lévinas', in R. Bernasconi and D. Wood (eds), *The Provocation of Lévinas. Rethinking the Other*, London & New York, Routledge, 1988. Also see the final chapter entitled 'The Elementary Structure of Alterity', in Peter Mason, *Deconstructing America. Representations of the Other*, London & New York, Routledge, 1990.

14 Julia Kristeva, *Stranieri a se stessi*, Milan, Feltrinelli, 1990, p. 9; *Étrangers à nous-même*, Paris, Fayard, 1988.

15 The archaeology of this event – 'Man is an invention of recent date. And one perhaps nearing its end.' – is brilliantly expounded in Michel Foucault's *The Order of Things*, London & New York, Routledge, 1991.

16 The 'table of my memory' (*Hamlet*), the tables, tablets, laws, that are continually put together, inscribed, written up and written upon, 'and also a table, a *tabula*, that enables thought to operate upon the entities of our world': Michel Foucault, *The Order of Things*, London & New York, Routledge, 1991, p. xvii. The rest of the sentence rewrites Benjamin's famous observation on 'progress' and the angel of history from 'Theses on the Philosophy of History', in Walter Benjamin, *Illuminations*, London, Collins/Fontana, 1973.

2

MIGRANT LANDSCAPES

At the tip
of the always dark
of new beginnings.
A.H. Reynolds[1]

Every philosophy also *conceals* a philosophy; every opinion is
also a hiding-place, every word also a mask.
Friedrich Nietzsche[2]

To imagine is to begin the process that transforms reality.
bell hooks[3]

Migration is a one way trip. There is no 'home' to go back to.
Stuart Hall[4]

The imaginary landscape of an inquiry is not without value,
even if it is without rigor. It restores what was earlier called
'popular culture', but it does so in order to transform what was
represented as the matrix-force of history into a mobile infinity
of tactics. It thus keeps before our eyes the structure of a social
imagination in which the problem constantly takes different
forms and begins anew. It also wards off the effects of an
analysis which necessarily grasps these practices only on the
margins of a technical apparatus, at the point where they alter
or defeat its instruments. It is the study itself which is marginal
with respect to the phenomena studied. The landscape that
represents these phenomena in an imaginary mode thus has an
overall corrective and therapeutic value in resisting their
reduction by a lateral examination. It at least assures their
presence as ghosts. This return to another scene thus reminds
us of the relation between the experience of these practices and

9

what remains of them in analysis. It is evidence, evidence which can be fantastic and not scientific, of the disproportion between everyday tactics and a strategic elucidation. Of all the things everyone does, how much gets written down? Between the two, the image, the phantom of the expert but mute body, preserves the difference.

<div align="right">Michel de Certeau[5]</div>

TO DRIFT ACROSS THE PAGE

To begin with these marks on the page, the movement of calligraphy: for to write is, of course, to travel. It is to enter a space, a zone, a territory, sometimes sign-posted by generic indicators (travel writing, autobiography, anthropology, history . . .), but everywhere characterised by movement: the passage of words, the caravan of thought, the flux of the imaginary, the slippage of the metaphor, 'the drift across the page . . . the wandering eyes'.[6] Here, to write (and read) does not necessarily involve a project intent on 'penetrating' the real, to double it and re-cite it, but rather entails an attempt to extend, disrupt and rework it. Although allegorical, always speaking of an other, of an elsewhere, and therefore condemned to be dissonant, writing opens up a space that invites movement, migration, a journey. It involves putting a certain distance between ourselves and the contexts that define our identity. To write, therefore, although seemingly an imperialist gesture, for it is engaged in an attempt to establish a path, a trajectory, a, however limited and transitory, territory and dominion of perception, power and knowledge, can also involve a repudiation of domination and be invoked as a transitory trace, the gesture of an offer: a gift, the enigmatic present of language that attempts to reveal an opening in ourselves and the world we inhabit. This is also the paradox in the belly of writing; like the ambiguity of travel, it starts from known materials – a language, a lexicon, a discourse, a series of archives – and yet seeks to extract from the limits of its movement, from the experience of transit, a surplus, an excess, leading to an unforeseen and unknown possibility.

Writing depends upon the support of the 'I', the presumed prop of the authorial voice, for its authority. Yet in the provisional character of writing this structure oscillates, is put in doubt, disrupted and weakened. So we inhabit a discourse that carries within itself the critique of its own language and identity: for the travel of writing,

<div align="center">10</div>

unless it concludes in babble, or silence, also involves a return. Here something is lost, and something gained. What we lose is the security of the starting point, of the subject of departure; what we gain is an ethical relationship to the language in which we are subjects, and in which we subject each other.

> For writing, like a game that defies its own rules, is an ongoing practice that may be said to be concerned, not with inserting a 'me' into language, but with creating an opening where the 'me' disappears while 'I' endlessly come and go, as the nature of language requires.[7]

The point of the author, the point of arrival, becomes the point of departure, and the boundary of the sentence is breached by the surplus of language.[8] In this manner writing can become a travelogue, a constant journeying across the threshold between event and narration, between authority and dispersal, between repression and representation, between the powerless and power, between the anonymous pre-text and accredited textual inscription. It is a journey that finally comes to circulate and take up temporary residence in that disputed border country in which the official account dissolves into the historical infinite of indigenous narration.[9] Here, not only is the particular authority of the sanctioned description questioned, and the empirical claims of reality subject to scepticism, but the very status of the telling, of language and text, is invested by doubt and dislocation.[10] Like the holed bucket in Conrad's *Heart of Darkness* the narrative leaks. Just as the islands of order and reason – represented by the Central Station and the steam boat pushing up the Congo into the mysterious interior – become fragile and suspect, so writing learns the requirement of 'leaving the ambiguities intact'.[11]

A DIALOGUE BARELY BEGUN

In all the charts of this country – both Spanish and English – a certain sound in Hoste Island bears the name Tekenika. The Indians had no such name for that or any other place, but the word in the Yahgan tongue means 'difficult or awkward to see or understand'. No doubt the bay was pointed out to the native, who, when asked the name of it, answered, 'Teke uneka', implying, 'I don't understand what you mean,' and down went the name 'Tekenika'.

<div align="right">E. Lucas Bridges[12]</div>

L'étranger te permet d'être toi-même, en faisant, de toi, un étranger.

Edmond Jabès[13]

The move into dialogue, into a sense of language that does not merely reflect culture, history and differences but also produces them, involves a break with the romantic idea of the world as a separate entity attendant upon our attention, as though it were the diametrical 'other' of our being and thought: the exotic elsewhere, the untouched difference, the world of the 'natural' and the 'native'. To continue in this vein would be to address the question of difference purely in metaphysical terms and thereby establish another monologue, another mode of ethnocentricity. To adopt that particular stance is but to replay the nostalgia of difference, and to set up a presumed 'authenticity' to be held against the corruption of modernity. It merely reproduces the power of existing positions: I, the nostalgic observer; you, the native, victim of my modernity. It establishes a blind circle that may comfort the observer, but which is powerless to address the conditions she or he nominates. We, in, and with, our differences, are ultimately caught up in the same skein, the same net, the same topology. So it is not simply to the powerful symbolic externalisation of the 'other' as our chosen interlocutor that we should look. We need in particular to pay attention to those conditions of dialogue in which the different powers, histories, limits and languages that permit the process of 'othering' to occur are inscribed. This draws us into an endless journey 'between cultures, languages, and complex configurations of meaning and power'.[14]

It opens up the space of the post-colonial world and 'the possibilities of alter/native ficto-historical texts that can create a world in process while continually freeing themselves from their own biases'.[15] Here there is a relentless transformation of a single time ('modernity', 'progress', the 'West') into multiple spaces and tempos as the gap between worlds is negotiated, and histories are distilled into a specific sense of place and dwelling.[16] In the syncretism of such cultural practices an imposed language – 'English', Western 'civilisation', rock music – can be translated and transformed into what the Palestinian author Anton Shammas calls a 'homeland'.[17]

A—, who brings us coffee, croissants, freshly squeezed orange juice and syrupy dates each morning, is Moroccan. He and his family have lived all their lives in Essaouira: a white-washed town, guarded by

a pink Portuguese fort. With its back to the desert it faces the warm breezes of the Atlantic. There are few guests at the hotel. We strike up a friendship. No, that's too strong a word, too invasive, too romantic. We establish a 'feeling', find each other simpatico. *That's better, more fitting for what we both know, despite the later exchange of addresses, is a transitory experience.*

We don't talk much. I stumble through the remnants of schoolboy French. He nods, occasionally drenching me in a flood of sounds. Naturally, it is L— who frames these encounters: her superior linguistic and social competence somehow giving a sense to the empty spaces between the men.

I sometimes wonder what is the nature of A—'s interest in me, and mine in him. I can't write A—'s story, and yet his presence needs to be acknowledged. I can't re-present him, complete his history, dreams and passions. That would merely close the circle in a distorted mirror of my self. On the edges of that favourite post-modern metaphor – the desert – I meet a real man of the desert. Yet I can't represent him, I don't know how to make him figure in what I want to say. Sure, I could provide him with a background by splicing together bits of the country's history, politics and culture; even something of a foreground: the colour of his djellaba, *his sandalled walk, or his three children that we once glimpsed during an evening stroll. But even if I fragmented him and re-presented him in these splinters that is still not quite the point. He has his own story. It is there in his clothes, his language, his house, in the gestures he makes when indicating the best places to go to eat* tajines, bstilla, couscous, sardines. *A— has a voice, a presence. It is subaltern, still possibly colonised, certainly, by our standards, repressed, invariably hemmed in by the limits of locality, tradition and, why not, the tourism which likes him as he is. Our encounters are circumscribed, the exchange fixed by our respective locations, their sense starkly incomplete and not always comprehensible. Still, in the moments of our brief conversations, and in the connective gloss that L— seeks gently to construct around them, it is possible to recognise the ethics of a space. Here worlds meet. In the silence between the words we can hear the potential murmur of a dialogue barely begun.*

THE OBLIQUE GAZE

Experience had taught him that reason could not be counted on in such situations. There was always an extra element, mysteri-

ous and not quite within reach, that one had not reckoned with.

Paul Bowles[18]

In the oblique gaze of the migrant that cuts across the territory of the Western metropolis there exists the hint of a metaphor. In the extensive and multiple worlds of the modern city we, too, become nomads, migrating across a system that is too vast to be our own, but in which we are fully involved – translating and transforming what we find and absorb into local instances of sense.[19]

It is, above all, here that we are inducted into a hybrid state and composite culture in which the simple dualism of First and Third Worlds collapses and there emerges what Homi Bhabha calls a 'differential communality', and what Felix Guattari refers to as the 'process of *heterogenesis*'.[20] The boundaries of the liberal consensus and its centred sense of language, being, position and politics, are breached and scattered as all our histories come to be rewritten in the contentious languages of what has tended to become the privileged *topos* of the modern world: the contemporary metropolis.

Crowded beneath the white dome of the Sacré Coeur of Montmartre and the distant outline of the Eiffel Tower is Barbès. The blue and cream trains of the Métro pass along Boulevard de la Chapelle, over the Saturday morning market where the predominant language is Arabic. The stalls are piled high with fresh vegetables (yams, mangoes, green bananas, sweet potatoes), fish, sacks of couscous, mountains of mint. The clothing is largely a mixture of the urban male – jeans and open shirts – accompanied by the highly coloured dresses and turbans of West Africa.

The stereotype – the 'black', the 'Indian', the 'native', the 'other' – collapses beneath the weight of such complexity. Stretched between histories it tears, becomes piecemeal. Listening and moving to Soul II Soul, grooving to multiple histories configured in a combinatory sound mix, we recognise that we are all, with our often very different accounts, travelling through the networks of a world bearing the tension between our particular inheritance and potentially common culturescapes. Here, in a post-colonial genealogy of modernity, the tension, the gap, between different symbolic regimes and their shared occupation of the same signs simultaneously draws us into historical specificity and potential communalities.[21]

In the migrant landscapes of contemporary metropolitan cultures,

de-territorialized and de-colonised, re-situating, re-citing and re-presenting common signs in the circuits between speech, image and oblivion, a constant struggling into sense and history is pieced together. It is a history that is continually being decomposed and recomposed in the interlacing between what we have inherited and where we are. In the shifting interstices of this world, whether moving to the acoustic patterns of our bodily beat or the techno-surrealist design of computerised simulations, there exists the opening that redeems and reconstitutes our being.

It is perhaps something that we can hear when Youssou N'Dour, from Dakar, sings in Wolof, a Senegalese dialect, in a tent pitched in the suburbs of Naples. Only six months earlier I had heard his haunting voice in a New York club, this time in the context of the Japanese techno-pop/New Age sound of Ryuichi Sakamoto and No Wave New York guitarist Arto Lindsay.[22] It is surely in these terms, well before intellectual and institutional acknowledgement, that we come most immediately and effectively to recognise the differentiated territories in which the imaginary is being disseminated and the eurocentric voice simultaneously dispersed . . .

This brings us to reconsider the histories we have inherited and inhabit: the histories of language, of politics, of culture and experience. The politics of liberation, of freedom, have invariably appealed to the ultimate possibility of rational transparency: politics providing the communal insistence on the realisation of this rational goal. But what if the world we live in proves to be more intractable? What if such opaqueness, and the real differences it represents, is irreducible to a single explanation? What if in society, and between society and nature, there is no common rule? To accept this opaqueness, this intractability and incommensurability (Jean-François Lyotard's *différend*), means to extend and complicate our sense of 'politics'. It also means to radically rethink not only the limits of the liberal ground of consensus management, but also the Marxist proposal of communal realisation. For both, in the name of reason and freedom, persistently rule out difference and otherness. Referring to Hegel and Marx, William E. Connolly writes:

> The ontology each accepts is a precondition to the credibility of freedom and realisation. But . . . each advances a theory of freedom which supports suppression and subjugation in the name of the realisation for the self and the community. Because each ideal projects the possibility of drawing all otherness into

the whole it endorses, any otherness which persists will be interpreted as irrationality, irresponsibility, incapacity or perversity. It can never be acknowledged as that which is produced by the order it unsettles.[23]

Yet we have slowly come to appreciate that the realisation of resistance is not to be located in a prescribed future. It is already inscribed in the languages of appearances, on the multiple surfaces of the present-day world. There, reworking the relationships of power, resistance hides and dwells in the rites of religion, in the particular inflection of a musical cadence. It inhabits the space of everyday speech, and provides the 'surreptitious creativities' (de Certeau) that lie in the uses and abuses of consumerism. It produces 'a skill ceaselessly recreating opacities and ambiguities – spaces of darkness and trickery – in the universe of technocratic transparency, a skill that disappears into them and reappears again, taking no responsibility for the administration of a totality'.[24] It is where the familiar, the taken for granted, is turned around, acquires an unsuspected twist, and, in becoming temporarily unfamiliar, produces an unexpected, sometimes magical, space. It is where the languages we live in, precisely because we live in them, are spoken and rewritten. In continually drawing upon an already existing lexicon of ready-mades to signify, to trope the trope, as Henry Louis Gates Jr puts it, we can locate in such practices a script of traces, a particular way of picturing, signifying and enframing the world we have inherited.[25] For it is our dwelling in this mutable space, inhabiting its languages, cultivating and building on them and thereby transforming them into particular places, that engenders our very sense of existence and discloses its possibilities.

TERRITORIES OF THE UNFORESEEN

A map can tell me how to find a place I have not seen but have often imagined. When I get there, following the map faithfully, the place is not the place of my imagination. Maps, growing ever more real, are much less true.

Jeanette Winterson[26]

The chronicles of diasporas – those of the black Atlantic, of metropolitan Jewry, of mass rural displacement – constitute the ground swell of modernity. These historical testimonies interrogate and undermine any simple or uncomplicated sense of origins,

traditions and linear movement. Considering the violent dispersal of people, cultures and lives, we are inevitably confronted with mixed histories, cultural mingling, composite languages and creole arts that are also central to *our* history.

In 1492, a year that witnessed the fall of Granada, the last Arab kingdom in Europe, and the 'discovery' of the New World, the Jews were expelled from Spain. They subsequently established themselves in the more tolerant territory of the Ottoman Empire – in Salonica, Cairo, Istanbul, and the island of Rhodes (where the community survived four centuries until the SS dispatched most of its members to Auschwitz in 1944). The subsequent histories of this expelled community, the *sefarditas* (*sefarad* meaning Spain), involved cosmopolitan poly-identities. Organised around the Mediterranean and Muslim World in a shifting combination of Occident and Orient, speaking a fifteenth-century Spanish dialect (Ladino), such identities were shaped by migration and blended histories, full of linguistic and culinary traces: memories of Spain and Greece, later including Italy and France in the case of Edgar Morin's father, Vidal, or Bulgaria, Russia, Turkey, Armenia and Rumania with Elias Canetti. Morin suggests that this represents an identity that is anterior to the subject-citizen of the modern nation state; we might add that, together with the African-American experience of exile in slavery and racism, it also suggests a possible posterior sense of identity with regard to the narrow confines of modern nationalism. One foot is here and the other always elsewhere, straddling both sides of the border.[27]

Hannah Arendt, in her polemic against the Vico–Hegel–Marx thesis that history is 'made' in structures and modelled by violence, chose to underline the unforeseen, the indeterminate and the innovative. In *The Human Condition* she argues that political action rests on the necessary tension with a non-sense that queries the reduction of nature to technology, events to a process, history to a finality. This is to leave open a space, an indeterminacy . . . In that opening, and beyond the abstract ideology of a uniformity stamped with the seals of tradition, nation, race and religion, we are all destined to live in what the Chicano novelist Arturo Islas nominates as a 'border condition'.[28]

I arrived in Naples in 1976. I came with Ethiopian Airlines on a flight bound for Addis Ababa with a stop-over in Rome. There were only four or five of us on the plane. We landed late at night in the fog. It

was, I suppose, a sort of sign for the uncertainty of my journey: a nebulous inauguration for what lay ahead. For I had come not as a tourist or in search of work, but for an appointment in love. From a certain point of view I didn't choose Naples, it was rather as though the city had chosen me. This pink, grey and yellow-coloured town on the sea offered a horizon in front of which a relationship, a life, could acquire form and develop. I, the son of a Scottish mother and English father, citizen of the North, found myself involved in a radically different world. It was one with which I had to struggle to render it comprehensible . . . liveable. So the city also came to represent the scene of an encounter, sometimes a clash, between diverse languages, reasons and histories. My own cultural baggage, my particular story, was continually exposed in this play of difference. My logic and habits could no longer hide in the folds of common sense and a casually assumed cultural habitat now that the sense of reality I inhabited differed so radically from the one in which my logic and habits had been initially formed and recognised. 'Now that he was in a new land, who could tell what normal was?'[29]

A sense of crisis can have many exits; a threat to one's sense of being can also lead to an unexpected opening, a further throw of the dice. I began to read and live the city, without always halting at the borders of its chaos, corruption and decay. I began to experience it as the space of an alternative. It is perhaps in the dialogue that is installed between ourselves and this sense of 'otherness' that our particular selves are most sharply revealed. In such encounters, in an ethics that tries to respect that other voice, language invariably loses its previous anchorage, sense of centre, and direction, as it slips through the openings in dialogue into a wider framework.

To live 'elsewhere' means to continually find yourself involved in a conversation in which different identities are recognised, exchanged and mixed, but do not vanish. Here differences function not necessarily as barriers but rather as signals of complexity. To be a stranger in a strange land, to be lost (in Italian spaesato *– 'without a country'), is perhaps a condition typical of contemporary life. To the forcibly induced migrations of slaves, peasants, the poor, and the ex-colonial world that make up so many of the hidden histories of modernity, we can also add the increasing nomadism of modern thought. Now that the old house of criticism, historiography and intellectual certitude is in ruins, we all find ourselves on the road. Faced with a loss of roots, and the subsequent weakening in the grammar of 'authenticity', we move into a vaster landscape. Our*

sense of belonging, our language and the myths we carry in us remain, but no longer as 'origins' or signs of 'authenticity' capable of guaranteeing the sense of our lives. They now linger on as traces, voices, memories and murmurs that are mixed in with other histories, episodes, encounters.

THE STRANGER'S NOTEBOOK

Le nom autorise le *Je* mais ne le justifie pas.

Edmond Jabès[30]

. . . according to Anglo-American conceptions of masculinity, a man who gives in to language's manifestations, who allows language to happen through him, who valorizes language as energy and movement independent rather than subservient to his rational mastery, is questionable as a man.

Maria Damon[31]

To discuss the decentring of the white male voice, of the European *cogito*, and to bring into view the 'other', a cultural and historical elsewhere, is this merely to draw that 'otherness' back into the range of the voice and the discourse that nominates its own decentring? Perhaps it is: 'The trick or turn is not to assume the representation of de-centring to *be* de-centring . . .'.[32] Yet, for some of us, it forces a confrontation with the effects of instability. It calls upon me to live in fluctuations between a displaced sense of centre, of the 'I', under the gaze of those other eyes/'I's, and to subscribe to a subsequent weakening and uncertainty within the limits of *my* thoughts and actions.

This is not to endorse a retreat into self-reflection, narcissism and solipsism, but rather to propose specifying, locating and limiting a particular self. It is to acknowledge a time that is shared and yet simultaneously limited, by being differentiated, located, placed, inhabited. The insistence on limits, on the propriety of reticence, does not necessarily involve a turning away from engagement, but rather sees in that bounded, historical and differentiated zone the space of questions, potential extensions, further dialogue and subsequent remaking. Such a language, which at times necessarily becomes a language of silence, might permit the development of 'a positive relation to listening to others'.[33] It leads to the modest gaze and curiosity of the stranger – the critic as a collector and wanderer: 'un étranger avec, sous le bras, un livre de petit format' (Edmond Jabès).

19

It is to propose a type of intellectuality that, while trying to understand the 'world from within' (Siegfried Kracauer), is profoundly marked by uncertainty and hesitancy.

This was some time ago. Reading Leslie Marmon Silko recently brought it back to memory.[34] *In the men's room at the Greyhound station in Phoenix, Arizona, the door flies open. I had by now become accustomed to the assertive, bordering on the aggressive, announcement of the male body in American public life. But this was somewhat different. It was a gesture of rage. In walked a dark youth – straight black hair, brown skin, jeans and cowboy boots: an Indian, an Apache. He looked as though he had been roughed up. Glancing at me he then stared into the mirror and, combing back his hair, spat out a stream of invectives against the whites who had harassed and humiliated him on the Saturday night he had chosen to come in from the reservation. I witnessed this scene in awe and astonishment. I was confronted with the heart of America. Not the facile cultural theme of the 'melting pot', although the pressure of its forced recipe clearly lay in the air that night, but rather its mythical heart. For here at the next wash-basin was the other side of the frontier, the 'native', the descendant of Mangus Colorado, Cochise and Geronimo. A privileged figure of the European imaginary and its investment in the West, this most American of the Americans was here despised and ridiculed by those who had usurped his name.*

I met other Indian men on that trip, usually in bus stations. They were looking for work, for money, for small change, for a coffee. They always appeared slightly out of place, drifting across a continent they had lost, seeking a place they were denied.

To question the maps that position myself and others, that spatialise and distance each 'other', is to question that sense of locality in which the European intellectual frequently has more need of the so-called 'Third World' to complete his vision, theory and sense of being, than it has of him. This surely means to think of an alterity that is not conveniently placed elsewhere but is always present. So I am brought back to face my language and my dwelling in it. For every language is figurative and indirect, that is, metaphorical. It is due to this 'weakness' that it is productive.

Here's a story within a story, a metaphor within a metaphor, that reveals a further body. In the historical centre of Naples there is the

20

seventeenth-century *Cappella Sansevero. It was once the private chapel of the Sangro family. The most noted member of this family is undoubtedly Raimondo, the eighteenth-century Prince of Sansevero. Raimondo, like so many of his century, was caught between different worlds. A man of learning, interested in letters and science, a follower of the Enlightenment, he was also drawn to alchemy and the more enigmatic lore of the universe. In the chapel itself, redecorated by Raimondo between 1749 and 1766, there are numerous statues, including a famed veiled Christ by Giuseppe Sammartino. Downstairs in the crypt there are veils of another kind. Behind glass stand two erect bodies revealing their interiors, their arteries, organs and sinews as though through a translucent husk. Myth has it that the Prince of Sansevero had a certain liquid injected into the bodies of these two unfortunate beings. It revealed their insides and preserved their exterior. The chemical and physiological process is not explained; it remains a mystery. (This is one version. Others say that they are not of human origin but are carefully constructed 'anatomical machines'.) Whatever the case, in this shared presence of smooth surface and tangled interior there is a striking allegory of the baroque mixture of reason and excess, a disturbing framing of the eternal dialogue between the surface of rational enquiry and the darker drives of inquisition. Here, however, what is even more disturbing is that all is exposed in a series of surfaces. We never arrive at the depths, at the hidden meaning or constitutive origins. The mask only conceals a further mask.*

The guide book, although it gives a detailed description of the marble figures above, does not refer to the disclosing presence of these human statues downstairs in the crypt.

Another story. About an hour's drive from Naples, to the northeast in the hills surrounding the broad valley of the river Volturno there is the village of Marcianofreddo. Some of us decide to walk to the village. Our arrival is greeted by the tolling of the church bell and the parish priest, Vittorio Morrone, who ushers us into the newly renovated church. He describes the repairs and preparation of the wall behind the altar, which is now covered with a naïve mural of the Madonna in vivid blue. Then his conversation rapidly turns to archaeology, to Egypt, and to the three adjacent rooms full of material he wants us to visit. We don't stay long, and we don't visit the rooms. Leaving the church I pick up some of the publications scattered on a table by the door. They are all written by Morrone and bear such titles as 'Solomon and the Contemporary World: a

Critique of Galileo', 'The Phases of a UFO', 'Einstein's Theory'. They are full of mathematical formulae, references to astrophysics, and geometrical analogies between Solomon's Temple, the Pyramids, the Babylonian temple of Uruk and the lunar cycle. One of them gives the parish address as the 'International UFO Centre, Missionaries of the Divine Saviour', another refers to a further work by the same author that carries the disquieting title, 'From Solomon to the Number of the Beast'. Perhaps God is an astronaut. But what most intrigues me in this science-fiction version of faith is the mixture of secular erudition and religious belief: here rational argument is spurred on by the unlimited desire to comprehend the mysterious logic of universal forces. Was this priest banished to this lost-out parish for his extravagant thoughts as a sort of latter-day Giordano Bruno? And just what sort of catechism was he preaching to his flock?

THE FICTION OF IDENTITY

'There are winners,' said the imprisoned rabbi, the imprisoned saint. 'Winners with their arrogance, their eloquence. And there are losers without words and without signs.'
'The race of the silent is tenacious.'

Edmond Jabès[35]

Representation: that which simultaneously speaks for and stands in for something else.

These meanings are often run together because the notion of mediation underscores them both. As a consequence, the ethical and political motivation behind questions of representation in both its senses will similarly concern the possible conflict of interests between the mediator and the mediated. This expresses an obvious political asymmetry that is considerable because unavoidable.[36]

Language is not primarily a means of communication; it is, above all, a means of cultural construction in which our very selves and sense are constituted. There is no clear or obvious 'message', no language that is not punctuated by its contexts, by our bodies, by our selves, just as there is no neutral means of representation.[37] This understanding of language, as a material that is potentially shared and yet differentiated, is then further compounded when we shift our gaze

22

from the local underworlds of the West, its hidden histories and subaltern cultures, to the further horizons and territories of contemporary metropolitan cultures elsewhere. For here the 'typical' may no longer be London or New York, but Mexico City and Calcutta – contexts and languages that can no longer be assumed to be regulated by a Euro-American norm.

The break-up of universals decisively marks the body. By accepting historical and cultural differentiation, it is no longer possible to think of the body as the passive ground or constant of subsequent social activity. It, too, is a historical and social site that can neither be considered fixed nor taken for granted. For, as Vicki Kirby argues, the assumed referent of the body becomes a flexible zone, interleaved, crossed and composed by multiple discourses, constructed in different languages, tempos and places, received and lived with disparate meanings that are diversely em-bodied.[38] To treat the world, its possibilities and its individuals, in a contingent manner brings us to the threshold of enabling differences to be, and 'calls into question the project of perfecting mastery of the world on the grounds that, given resistances built into the order of things, the project would reduce everything to a straitjacket while pursuing an illusory goal'.[39]

There is the emergence at the centre of the previously peripheral and marginal. For the modern metropolitan figure is the migrant : she and he are the active formulators of metropolitan æsthetics and life styles, reinventing the languages and appropriating the streets of the master. This presence disturbs a previous order. Such an interruption enlarges the potential as the urban script is rewritten and an earlier social order and cultural authority is now turned inside out and dispersed. All is revealed in the dexterity of moulding the languages of modernity and cultivating the city according to different rhythms, making it move to a diverse beat. It is to speak the languages – linguistic, literary, cultural, religious, musical – of the dominator, of the master, but always with a difference. Language is appropriated, taken apart, and then put back together with a new inflection, an unexpected accent, a further twist in the tale. As Gayatri Spivak puts it: 'In post-coloniality, every metropolitan definition is dislodged. The general mode for the post-colonial is citation, re-inscription, re-routing the historical.'[40]

It is the dispersal attendant on migrancy that disrupts and interrogates the overarching themes of modernity: the nation and its literature, language and sense of identity; the metropolis; the sense of

centre; the sense of psychic and cultural homogeneity. In the recognition of the other, of radical alterity, lies the acknowledgement that we are no longer at the centre of the world. Our sense of centre and being is displaced. As historical, cultural and psychic subjects we, too, are uprooted, forced to reply to our existence in terms of movement and metamorphosis.

The single, homogeneous point of view, that sense of perspective and critical distance, born in the Renaissance and triumphant in colonialism, imperialism and the rational version of modernity, is what we are now called upon to question and undo. A presumed mastery of the world – from the 'realistic' eye of the painter to the 'scientific' perspective of the cultural anthropologist and the critical distance of the historian: the sight/site of God – to which the rest of the world and its peoples are subjected (the 'Orient', the 'native', the 'other') is being challenged. To set language against itself, noting the diverse inhabitation of the very same medium, for example, 'English', is to wrest from language itself the truth that it is always partial and partisan: it speaks for someone and from a specific place, it constructs a particular space, a habitat, a sense of belonging and being at home.

None of us can simply choose another language, as though we could completely abandon our previous history and freely opt for another one. Our previous sense of knowledge, language and identity, our peculiar inheritance, cannot be simply rubbed out of the story, cancelled. What we have inherited – as culture, as history, as language, as tradition, as a sense of identity – is not destroyed but taken apart, opened up to questioning, rewriting and re-routing. The elements and relations of our language and identities can neither be put back together again in a new, more critically attuned whole, nor be abandoned and denied. The zone we now inhabit is open, full of gaps: an excess that is irreducible to a single centre, origin or point of view. In these intervals, and the punctuation of our lives, other stories, languages and identities can also be heard, encountered and experienced. Our sense of being, of identity and language, is experienced and extrapolated from movement: the 'I' does not pre-exist this movement and then go out into the world, the 'I' is constantly being formed and reformed in such movement in the world.

Despite our desperate, eternal attempts to separate, contain, and mend, categories always leak. Of all the layers that form the open (never finite) totality of 'I', which is to be filtered out

24

as superfluous, fake, corrupt, and which is to be called pure, true, real, genuine, original, authentic?[41]

... that famous old 'I' is, to put it mildly, only an assumption, an assertion, above all not an 'immediate certainty'.[42]

In this movement our sense of identity can never be resolved. I might self-consciously try to halt the journey and seek shelter in the comforting categories of being, let us say, white, British and male, and thereby cut off further conversation. But the movement in which we all are caught, the languages and histories into which we are thrown, and in which we appear, lies beyond such individual volition. The awareness of the complex and constructed nature of our identities offers a key that opens us up to other possibilities: to recognise in our story other stories, to discover in the apparent completeness of the modern individual the incoherence, the estrangement, the gap opened up by the stranger, that subverts it and forces us to acknowledge the question: the stranger in ourselves.[43] So identity is formed on the move. 'Identity is formed at the unstable point where the "unspeakable" stories of subjectivity meet the narratives of history, of a culture.'[44] In that passage, and the sense of place and belonging that we construct there, our individual stories, our unconscious drives and desires, acquire a form that is always contingent, in transit, without a goal, without an end.

Such a journey is open and incomplete, it involves a continual fabulation, an invention, a construction, in which there is no fixed identity or final destination. There is no final referent that exists outside our languages. As Nietzsche insisted, there are no facts, only interpretations. Just as the narrative of the nation involves the construction of an 'imaginary community', a sense of belonging sustained as much by fantasy and the imagination as by any geographical or physical reality, so our sense of our selves is also a labour of the imagination, a fiction, a particular story that makes sense. We imagine ourselves to be whole, to be complete, to have a full identity and certainly not to be open or fragmented; we imagine ourselves to be the author, rather than the object, of the narratives that constitute our lives. It is this imaginary closure that permits us to act. Still, I would suggest, we are now beginning to learn to act in the subjunctive mode, 'as if we had' a full identity, while recognising that such a fullness is a fiction, an inevitable failure.[45] It is this recognition that permits us to acknowledge the limits of our selves, and with it the possibility of dialoguing across the subsequent

differences – the boundary, or horizon, from which, as Heidegger points out, things unfold: both towards us and away from us. This fictive whole, this 'I', is, as Nietzsche would have it, a life-preserving fiction, one that conserves us, and saves us from the discontinuities of the unconscious, from schizophrenia, self-destruction and the entropy of madness. It is this knot, the interminable tying together of the stories across the 'resistance to identity at the very heart of psychic life', that holds us together.[46]

Such a construction, however imaginary and fictive the apparent resolution it offers – the whole, the full and complete 'I' – is also a his-story, a her-story, a cultural narrative, a fabricated reality like any other. And it is in this fictive coherence that it paradoxically becomes possible to think beyond the minimal pragmatics of the closure necessary to perpetuate any act. If, while setting down the full stop, thereby permitting the account to acquire shape, significance and force, we here recall Nietzsche's insistence on the fictive character of the world, we are invariably reminded of the mutability of our construction and, with it, of the precariousness of our narrative and identity.[47] It is to perceive in this interval not a rigid limit but the shadow line of a potential transit.

In this intermingling between the usually separated worlds of fact and fiction, history and narrative, rational closure and unconscious opening, the metaphor slips through sequential linearity and rational explanation to interrupt it, subvert it, complicate it. The analytical and the poetic are contaminated, realism and the fantastic are confused. Linearity, the rational explanation and apparent closure of the 'I', is deviated, disrupted and displaced by the interruption and interval of another story. Here language does not necessarily involve a neat unfolding towards eventual resolution and finality, but rather a navigation through a potential vortex of voices, a dissemination of sense in which we sometimes choose to halt, and at other times choose to travel.

This suggests that movement and migration – from Africa to the Americas, from rural space to urban life, from ex-colonies to metropolitan centres – involves a complex transformation. For, beyond the generalities of 'modernity' or 'capitalism', there is no single frame or cognitive map that unites these experiences and histories. This implies that there is no privileged representation of reality, no single tongue or language in which 'truth' can be confidently asserted. Across language, myth and metaphor there lie the interconnections, but they do not automatically lead to a shared

recognition or identity. Language, myth and metaphor may be common, but they are also inhabited in different ways. Indeed, it is paradoxically the increasing access to a collective syntax – television, rock music, 'English' – that has simultaneously also provided the means for registering the extension and complexity of a differentiated world.

In this mutable sharing there is no complete or closed explanation. Movement and multiplicity frustrate any logic that seeks to reduce everything to the same, to the apparently transparent discourse of 'history' or 'knowledge'. These partial forms, these incomplete encounters, like language itself, provide the thresholds for new encounters, new openings, unrehearsed possibilities, that 'alienate the holism of history'.[48] This involves entering a state of hybridity in which no single narrative or authority – nation, race, the West – can claim to represent the truth or exhaust meaning.

> Even when we describe the totally unknown, we can do so only in terms of the partially known or the known. Instead of admitting the failure of our categories, we love to clobber our empirical experiences until they fit these categories.
>
> The problems of such translation are not unique to the West. There is an Indian folk tale about some people who saw a pig for the first time. At first they were bewildered, then one of them confidently claimed that it was a rat that had eaten too much. Another disagreed, and as confidently said that it was an elephant, shrunken due to starvation. Neither was willing to give up his or her categories and admit that this was a new experience.[49]

The Guyanese writer and critic Wilson Harris has recently pointed out that the experiences of movement and marginality do not merely refer us to geographical locations – just as the word 'Europe' implies more than a physical place – but, rather, provide a critical angle or perspective on cultural formations and emerging cultural capacities.[50]

This transformation in our understanding of movement, marginality and modern life is inextricably tied to the metropolisation of the globe, where the model of the city becomes, in Raymond Williams' words, the model of the contemporary world.[51] The migrant's sense of being rootless, of living between worlds, between a lost past and a non-integrated present, is perhaps the most fitting metaphor of this (post)modern condition. This underlines the theme of diaspora, not

only black, also Jewish, Indian, Islamic, Palestinian, and draws us into the processes whereby the previous margins now fold in on the centre. As a further supplement, think of migration, movement and the historical harvest of hybridity that characterise such diverse post-colonial novels as Salman Rushdie's *Midnight's Children*, V.S. Naipaul's *The Enigma of Arrival*, Michelle Cliff's *No Telephone To Heaven*, and the poetic sequence of Edward Kamau Brathwaite's *X/Self,* and set them alongside the altogether more modest peregrinations through the world that many of us in the West experience through the media, tourism and travel, and its effects on our sense of reality, time and space. In the evocation of audio, alimentary and visual pleasures through the naming of places – Trinidad, Kingston, London, Paris, New Delhi, New York – we come across cities that are both real and invisible, to echo Italo Calvino: places whose symbolic and *real* alterity provide another chance, a further question, another opening.

However, this seemingly common grid, offering simultaneous connection and distinction, cannot obliterate the real differences between the forced movement and exiles of individuals and peoples induced by war, economic deprivation, political repression, poverty, racist slavery, and that diffuse sense of mobility that characterises metropolitan life, charted in the privileged channels of movement represented by the media, information technology, advertising, tourism and a generalised consumerism.[52] In the gap between such connections and differences we can begin to unwind the self-reflexive national idiom and its xenophobic refusal of external referents in its formation, in its making. It permits us to contest the denial, inscribed in the authorised versions of English history, language, literature and identity, for example, that Africa and New York also form part of a black cosmopolitanism that lives in south London, or that certain Birmingham identities can draw upon an imaginary that was committed to celluloid in Bombay. This is to bring home that the birth of modernity does not lie unilaterally in the history of European expansion and the modalities of remaking the world in its own image – the Industrial Revolution, capitalism, representative democracy – but equally lies in the savage repression of ethnic, religious and cultural alterity, in the brutality of the black African diaspora, the Atlantic racist slave system, ethnic pogroms and the imperial sacking of the globe that made its history, my history, the history of modernity and 'progress', possible. As Paul Gilroy has so brilliantly argued, there is a prophetic sense in which a black woman, man or

child living in Charleston, or Bristol, or Kingston, in the mid-nineteenth century was not simply the victim of modernity, progress and the modern nation state that was built on their enslavement and racist subjugation, but was also its producer, its maker, part of the constitutive cultural and historical fabric of modern Euro-American societies.[53]

THE GAP

Truth is the death of intention.

<div align="right">Walter Benjamin[54]</div>

Through the language of nomination the Western intellectual sanctifies his ignorance (the 'Subject of Europe'), renders the rest of the world transparent ('Asia', 'Africa', 'Latin America'), and 'erases' the real distance of location and difference, and the subsequent 'measure of silence'.[55] Still, there is a striking note in this story of unequal exchange. Jacques Derrida, himself a voice from the periphery (Algiers), from a diaspora (Jewish), was almost unanimously condemned in the 1970s and 1980s by metropolitan left-wing critics for his supposedly de-politicised language of deconstruction. Yet, in the aperture induced by displacement of the body of Derrida's words elsewhere, he has provoked an extensive revaluation of political and cultural discourses, particularly in the area of subaltern studies and post-colonial criticism. Opening up the gaps in language, contesting its presumed unity and metaphysical authority, Derrida's work has suggested the spaces in which other worlds could appear and begin to collate the blankness surrounding the hegemonic European text.[56] Through suspending, interrogating, deferring and differentiating sense, Derrida has offered the chance to break a historical silence and query the ethnocentric conclusion intent on a truth that invariably leads to 'some domestic benefit'.[57]

It has brought us to render account, however partial and limited, of the tear in culture and language revealed by the previous territories of silence, following the emergence within language of the previously shunned, excluded, travestied and ignored. In the heart of English – where the nomenclature invariably stands in not merely for the linguistic practice, but also for a literature, a culture, a history, a nation and an identity – and in the historical passage to the edges of Empire, and then back to the centre, a once seamless sensibility is rewritten, sundered, split open, occupied, transformed. When the

'imaginary of the West' (Edward Said) no longer physically lies elsewhere, at the edges of the map, in the margins of history, culture, knowledge and æsthetics, but migrates from the periphery to take up its home in the contemporary metropolis, then our story, the languages we inhabit, implodes under the pressure of these new and urgent co-ordinates.

The earlier European intertwining of national language, literature and identity is unpicked, and the epic of modern nationalism is forced open to meet the exigencies that emerge from more complex patterns. In this belated encounter we come finally to recognise that the construction of the 'other' has been fundamental to the historical, cultural and moral reproduction of our 'selves' and *our* particular sense of the world, of the centre, of knowledge, of power. To name is to possess, to domesticate is to extend a patronage. We are usually only willing to recognise differences so long as they remain within the domain of our language, our knowledge, our control.

But if, as Benjamin, Wittgenstein and Heidegger insisted, we dwell in language, and its limits are the limits of our world, then to meet others within its fabric is to stretch it, double it, interrogate and remake it. It leads to a highly charged practice when we encounter diverse worlds, histories, cultures and experiences within an apparent communality. It is a meeting, a putting yourself on the line, that is invariably accompanied by uncertainty and fear. For it involves an encounter with a previous sense of the self, of one's reason and certitude. A self 'that cannot abide its own non-mastery of the world fears and hates the other for concretising its own specificity and limits, and seeks to reduce otherness at every opportunity to a form of sameness and identity modelled on itself'.[58]

In this process of interrogation, the train of time, from which we apparently gaze back on other worlds left along the tracks of progress and civilisation, is in danger of being derailed. In the oscillations of language and identities grow the seeds of doubt. Perhaps the sense of our journey does not lie only in one direction, perhaps there is no terminus at the end of the tracks to justify our insistent movement forward? Perhaps we are riding blinded by a future whose redemption ultimately lies at our backs, in the rubble, misery and confusion that we think we have already overcome? To travel with that earlier sense of purpose, forearmed with the truth, is to move with the presumption of a mission, as though to carry the gospel into heathen parts. It is to claim to come from a centre, represented by those tracks that cut straight as a die across the tangled territories of history and being. It

is to collude, now further down the line and in an altogether more benevolent tone, in the project of the presumed destiny of the West that was once pursued in the fiercely aggrandising terms of religion, colonialism, racism and imperialism.

Clearly, a refusal of the destiny of the West need not simply imply a slide into historical oblivion and cultural suicide. Rather than seeking to speak on every occasion and in every location (in the name of science, rationalism, technology and knowledge), it is perhaps also necessary to acquire the habits of listening: to open up our language, our domesticating principles, to the unforeseen consequences of conversation, dialogue, even incomprehension. This may merely serve to register the unequal distribution of economic, cultural and symbolic powers. Yet in signifying limits we already expose ourselves to the possibility of an opening. For we are thrown into that ambiguous space in which differences are permitted a hearing, in which both speakers and the syntax of conversation run the risk of modification.

This necessarily weakens the absolutism, once offered by the frame of language, in which the rise of a national tongue and literature provided the intersecting narratives, consensus traditions and mythical context for so much of our cultural and national identity. It signals the boundaries of that particular sense of belonging in language and encourages us to venture abroad with a weakened and more restricted sense of one's own idiom. To entertain this other sense of community, one not necessarily inscribed in the confines of a national language, literature and identity, is to grasp that side of modernism in which the historical tropes of migrancy and movement become central.

Discoveries and conquests, and the subsequent Eurocentric domestication of space, reach their furthest point in modern-day tourism and the 'neutral' gaze of knowledge. But to conclude the account at this point is to refuse the ambiguity and enigma that lie on the other side of the tale. It is not simply to refuse to take that leap into Conradian dissolution. It is, above all, to see in the journey only a verification of the self and the same, a confirmation that refuses to register encounters with the obscure, the inscrutable, the unknown, the unspoken. It is to assume that all is light and there is no mystery, that language is certain, and there is no 'heart of darkness' in the irresolvable soul of meaning where, as Conrad expresses it in *Lord Jim*, the 'last word is not said – probably shall never be said'.[59]

Such a failure to 'chart the journey', involves a refusal to turn to

31

the 'other' side of reason, and therefore involves a failure to comprehend that light can only be appreciated in terms of its shadows, just as the Occident cannot exist without its 'Orient'. It means to ignore that *my* linguistic, cultural and historical space is tied to what lies 'out there'; it is to deliberately ignore that it is positioned and located by this difference. In this incompleteness there lies the historical and ethical significance of my own partial and partisan readings. For the meaning of *it all* can only be conceived as an excess, as something that flees closure, that outruns my language. To inscribe this awareness into our activities is to assume in the openness of our language other inscriptions, further sense.

If what passes for knowledge emerges within language, then critical knowledge involves an exploration of language itself. This is to undo the ruling idea of Western thought, the timeless, metaphysical, idea that reason operates independently of language and the historical and cultural conditions in which it is deployed. It is to disassemble the presumed link between truth and logic, established as the basis of Western philosophy in Greek thought. This inaugurates the 'end of philosophy and the task of thinking'; for it is to be sceptical of the possibility of a pure reason somehow existing beyond the contamination and collusion of language, history, culture and being.[60]

For reason itself is a metaphor. It involves the transport, transformation and translation of some 'thing' in language. The figuring of this thing in metaphorical processes once again suggests that the distinction between critical and poetic nomination becomes hazy, and that the assumption that one is somehow closer to the truth than the other becomes questionable. In translation – the 'metaphor for the historical necessity of bearing witness' – we are opened up to the possibility of silence and the incommensurable.[61] The task (of the translator, to conclude the title of Walter Benjamin's essay) is, as the original German for task – *Aufgabe* – suggests, and as Paul de Man emphasised, also an impossibility, a defeat: 'The translator has to give up the task of rediscovering what was there in the original.'[62] *Tradurre è tradire*: to translate is to betray a primary intent or metaphysical truth. Benjamin's essay confirms 'that it is impossible to translate'. As Shoshana Felman suggestively argues, Paul de Man recognised that it was impossible to dispose of the body – of Walter Benjamin – of the text, by simply restoring it to a self-explanatory whole. That story, that history, is neither settled nor closed; it has to be read without disposing of the body.[63]

It is this language that holds us, as both hostage and support. The idea that knowledge is constructed, produced through the activity of language, that it is constantly re-written, re-cited and re-sited, subverts all appeals to the idea of a 'natural' truth and its obvious factuality. It is this resistance to the 'naturalness' of the tongue that releases the possibilities of language and the interminable activities of meaning.

ROOTED IN THE UPROOTED

In *History: The Last Things Before the Last*, Siegfried Kracauer argued that the motor of history lay in the non-identity between reason and reality. He compared the emergence of modern histori-ography, one of the central genres of modernity, to the rise of photography and their shared proposal, in Leopold von Ranke's words, to show 'how things actually were'. The analogy that Kracauer draws between these two modern forms of representation – photography and historiography – confirms a sense of time and memory framed by images. Yet it simultaneously confronts us with a disquieting gap. And it is this gap, represented by the space of an impossibility – the impossibility of showing 'how things actually were' – that permits us to consider the fracturing of time and the break-up of the homogeneous continuum of a single and unique History. The falling away of self-identity between reason and reality, between knowledge and the subject, after Nietzsche, after Freud, after feminism, after the ingression of other worlds, forces us to consider a rapid succession of horizons that challenge the pretence to rational transparency in our languages and communication. For, if reason is more complex, always fractured, open, partial, partisan and incomplete, then we are encouraged to include the zones that its illumination obscures. We are encouraged to consider knowledges that inhabit the shadows, that lie in the shades of ambiguity. It is to propose the difficult moment of letting go as old certainties are abandoned for the uncertain outcome of continual encounters in which all worlds and chronologies become unstable, subject to question and reformulating. To rethink your time and place within a culture, a language, an institution, a tradition, a set of histories, is to rethink the purpose, direction and limits of these very categories.

Along with his Proustian search for 'lost time', and an idea of historical knowledge that comes to be most fully embodied in the figure of Ahasuerus, the Wandering Jew, Kracauer insisted on the

epistemological value of the image. This runs throughout his writings, from the early newspaper articles on mass entertainment, travel, dance, the detective story and the hotel lobby, written during the Weimar Republic, to his posthumously published book on the philosophy of history. For, as he puts it, images, however humble and marginal their origins, 'help us to think *through* things, not above them'.[64]

This draws me into thinking further about the secular knowledge generated by the image and the thesis advanced by Kracauer's contemporary, Walter Benjamin. In his famous essay on art in the epoch of technical reproduction, Benjamin argued that the secular reproduction of the work of art led to its politicisation. Today, we might extend that judgement to include the realm of knowledge. Inhabiting and extending the languages of technical reproduction, we find that it is not simply the image, but knowledge itself, that has been secularised and has now lost its aura. In the mental architecture supplied by the prosaic poetics of technology we construct knowledges that are constantly having to breach the boundaries of such a precarious concept. For we discover ourselves to be simultaneously uprooted by representations while rooted in them. Perhaps, as Heidegger argued, the co-existence of that closure and opening reveals the saving power of the situation.[65]

Barcelona, December. I have just observed a skeleton propped up on a first-floor balcony overlooking the street: a carnival prop, a festive provocation? Near by, there is a further echo of baroque allegory, this time in the form of an exhibition to record one of its most perspicuous commentators. Between Carrer del Carme and Carrer de Hospital there is the ancient Hospital de la Santa Creu. Here there is an installation by Francesc Abad: 'La línia de Portbou. Homenatge a Walter Benjamin.' It is shut. Over the next few days I return several times in the hope of entering, but without luck. Closed for the holidays it provides a space for speculation. Walter Benjamin, the collector, the reader of the city street, the thinker at the crossroads, the pearl diver (Hannah Arendt), might have appreciated this unexpected appointment. Perpetually on the margins of European culture (German, French, Jewish), Benjamin was a migrant, in transit, a frontier spirit who, in constantly travelling to the border, speaks to our times.

Many months later Benjamin's name causes me to stumble over another trace, and fall through a gap into another story, there to

bear witness to the discontinuous narrative of the fragment. In a newspaper article I discover that Benjamin was in regular corres- pondence with a person subsequently immortalised in François Truffaut's film Jules et Jim *(1961). Jules, interpreted in the film by Oskar Werner, was in real life the German writer Franz Hessel. Author of several semi-autobiographical novels that comment on the streets, boulevards and squares of Paris and Berlin in the period 1910–30, this 'flâneur philosopher', as he referred to himself, published in 1929 a book on flâneurship entitled* Spazieren in Berlin *(now republished as* Ein Flâneur in Berlin*).[66] This book attracted Benjamin's attention and he wrote a short essay on it called 'The Return of the Flâneur'.*

Hessel, like Benjamin, was dogged by ill-fortune. Like Benjamin he, too, was Jewish. Like Benjamin he had fled from Nazism to France in 1938. With the outbreak of war, although his son had done his military service in the French army, he was interned. Hessel managed to escape, but with the establishment of the Vichy regime was interned again. Subsequently released, he died a few months later, in 1941.

In 1913 Hessel had married Helen (Catherine/Jeanne Moreau in Truffaut's film). At this date the ménage à trois with the Frenchman Henri-Pierre Roché had already begun. Forty years later at the age of 73 Roché published his only novel recounting the story: Jules et Jim*.[67] Eight years later Truffaut picked it up off a book stall.*

Recently the diaries of both Henri-Pierre Roché and Helen Hessel have been published in France.[68] The protagonist of these affairs, the centre of the trio, is clearly Helen. Rilke dedicated several poems to her, she danced in clubs in Munich, wrote poetry, illustrated journals, was Parisian correspondent for the Frankfurter Allgemeine *after her transfer to the French capital in 1925, and helped her lovers to publish in bilingual literary journals. At the time the three of them had mooted writing a book together. But the idea was soon abandoned because, as Helen wrote: 'The truth is that art doesn't interest me. What really moves me is life, how it develops in continual fluctuation.'*

Helen Hessel died in 1982 at the age of 96. She was the only one of the three to have seen Truffaut's film. In a letter to a friend she wrote: 'Voilà. For me this experience has been a double reassurance. I have lived, and in a rather monstrous manner. I am dead and I live again.'[69]

In intellectual terms the history of modernity has invariably been represented as a tragedy. We are encouraged to consider it as an epoch of decadence and decay, the moment when the promise of history is sullied and finally frustrated by the loss of authenticity. Yet, despite the immense horror revealed by modernity, there existed scenes in its daily drama that although frequently ignored or dismissed were pregnant with promise. Among these were the concealed histories that accompanied the rhythms of modernity that were being written in the department stores and on the dance floors, as later in supermarkets and soap operas and a domestic, frequently female, space.[70] Elsewhere such rhythms were also being scored and signified in the officially shunned 'mumbo jumbo' (Ishmael Reed) of the poetry, literature and music of ex-slaves and the subsequent formation of an urban black æsthetic, an æsthetic that has proved central to the modern metropolitan experience. While usually denied a voice in the official account, these metropolitan stories have secretly undermined the presumptions of a monolithic or homogeneous culture and from their marginal and migrant formations helped forge the modern art of always 'being in between' (Michel de Certeau).

On Forty-Second Street in New York, on the corner of Seventh Avenue, if I remember rightly, there is an electronic scoreboard perched on the roof of one of the few low buildings in the area. It relays in real time the accumulation of the US national debt, divided into cost per family. I stand there fascinated, watching the zeros tick by. Outside the Centre Pompidou in Paris another score is being kept. Here an electronic clock ticks off the seconds remaining until the arrival of the twenty-first century and the end of the twentieth (choose the version you prefer). What are we to make of these two clocks: one obsessed with a debt to the past, the other betting on the future?

Back in New York, under the high-vaulted roof of Grand Central Station I hear the harp-like cascading sounds of a kora, the stringed instrument of the West African griots, subsequently popularised with the international success of Mory Kante and 'Akwaba Beach' (1987). Only this is not a kora, an acoustic folk harp built of bamboo, but a stainless steel electric instrument. Now called the Gravikord, and available for $1199, its polyrhythmic sound accompanies my walk through the cavernous foyer. Much later, around midnight, still at Forty-Second Street, but this time underground in the subway,

*waiting for the uptown train, I observe the self-proclaimed 'can man'
at work. He is thin, black and hyper-active. By his side is a plastic
bag full of empty beer cans. Before those waiting for the train, he
picks one out of the bag and, rapping on the uniqueness of his
activity, cuts out the top of a 'Budweiser' and proceeds to shred its
sides with a sharp knife. Then, after a push and a twist, he holds out
the completed object: a narrow-based, bulbous-bodied ashtray, a
flower vase, an 'objet trouvé'. I decide to buy one. They cost $2. I
only have a $5 note and only really want one. We compromise. I
leave him with $5, and he signs the can on the bottom. He gains an
extra $3 and I acquire an art work.*

*In both instances there is a fascinating oscillation between the
industrial and the archaic: the artisan instrument that goes electric,
industrial waste being transformed into an æsthetic object 'before
your very eyes'. Or, better still, we are witness to the simultaneity of
the archaic and the industrial.*

EXPOSURE

What you chart is already where you've been. But where we are
going, there is no chart yet.

Audre Lorde[71]

Today the logic in which opposition and resistance simply mirror and
invert the language of the oppressor, as though in a world turned
upside down, is breaking up, coming undone, being challenged.
Among the consequences is the fragmentation of a homogeneous and
transcendental sense of the 'other'.[72] It, for we are talking of a
concept, not a specific, historical, body, is now plunged into time and
circumstances; it comes alive. A fixed scheme of location and
reassuring identity shatters. A rationalising totality in which every-
thing was referred back to a centre, presumably secured by the
neutral voice of 'knowledge', 'science', 'culture' and its associated
Eurocentric accent, passes into vernacular confusion and slides
towards a fragmentary complexity and 'the bitter stubbornness of a
wandering question'.[73] Becoming concrete, everything is forced into
movement. The process of enframing travels, finds itself involved in
dialogue, in exchange and interrogation. The abstract idea of differ-
ence dissolves to subsequently reappear in diverse, sometimes
radically distinct, histories.

There occur an undoing and dispersal of the binary logic that

established the perpetual dialectic of subordinate reply and reaction to power and hegemony. Subordinate subjects have invariably been ordained to the stereotyped immobilism of an essential 'authenticity', in which they are expected to play out roles, designated for them by others . . . for ever. To reread the accounts of black music presented by white criticism frequently forces us to recognise the imposition of this Hegelian arrangement. For many, the blues and R&B, or Rastafarian 'locks', are considered more 'authentic', somehow closer to a 'black' essence – while the glitzy styles of Tamla Motown, the artifice of disco, the electronic plagiarism of house music, straightened or permed hair, represent obvious forms of betrayal, a denial of roots. The corollary that seals this logic and finally condemns the subordinate to the eternal role of 'authenticity' is that success is suspect: it automatically suggests a sell-out. In the restrictive arrangements of authenticity and betrayal, wider cultural, historical and economic relationships, in which further senses of the self might be realised, are prematurely foreclosed. Expression and representation are compelled to support the collective burden and unity of a presumed representation: does this painting, photograph, music, style, fully represent and correspond to the black essence?[74]

In the passage from nameless property ('slave') to person there explodes the struggle to establish a sense of identity, to find a voice, and to claim a political and cultural place. This murderous transit has formed and reinforced an autonomous sense of black identity. Black literature, music and culture are a testament to that story. Yet, in this tale of resistance and the formation of identity, there also lies an unbearable confinement; as though black culture, whether by force or choice, is somehow completely separated, cut off from the further conditions that simultaneously invest and disinvest us of our lives. For there also exists a sense of being and belonging that includes not only ethnicity and race, but also sexuality, gender, language, nation and travel. A confinement to an ethnic essence can only involve a story that cannot contemplate the excess of meaning that challenges unicity and permits differences to be. For most white people this is translated into the mirrored comfort of reflecting the universal; for those designated 'black', it is taken up and translated into the troublesome specificity of a 'minority' question: 'an object in the midst of other objects'.[75] In the attention devoted to the margins the power being exercised at the centre is invariably obscured. For the very idea of ethnicity is used only to refer to 'minority groups' and never to white power and hegemony. So the 'minority' spokesperson

is expected to speak in the terms of the ethnic group, restricted to the black 'community', while the white writer, artist or film maker is left free to speak about everything.[76]

The Sankofa film *Territories* (1984) problematises this question by refusing to bear the burden of simply celebrating a black authenticity. In emphasising the struggle into being, into narrative, of the diverse stories of the black diaspora, the film propels us all into an unguaranteed space that enables other positions and possibilities to emerge. It forcefully underlines the idea that ethnicity does not simply belong to the 'other', but is also part of being white. The unquestioned understandings of nation, race and ethnicity, both black and white, are displaced and opened up for questioning: just what does it mean to be 'black', 'white', 'British', or even 'European', today? It is where language is disrupted, where a silence, a space, an interrogation, opens up in its midst, that the further dimension of our dwelling in language begins to emerge. This punctuation of the unity of a tongue, a subject, an identity and a historical sense – in this case collectively nominated in the terms 'black', 'English' and 'British' – intensifies the importance of the art of the fragment, of the dream and the collage.[77] Here the dispersal of language holds out the promise of the dissemination of further sense, of other voices, other histories.

'I burst apart. Now the fragments have been put together again by another self.'[78]

The contemporary re-inscription of ethnicity by black British photographers, film makers, musicians and artists reveals a language increasingly disinvested of a stable essence that guarantees its 'authenticity'. A fixed *unicum* is transformed, transposed and translated into a collection of traces, memories, myths, stories, sounds and language that are both in and yet not completely of the West (C.L.R. James). Born out of the history of modern racial slavery and its chilling nexus of 'reason and racial terror' (Paul Gilroy), it is such an inheritance – historically specific but ultimately bound to a shared global and ethical destiny – that combines in shifting configurations of transitive coherence that we choose to call identity.

THE LIMIT

The problem of the value of truth stepped before us – or was it we who stepped before this problem? Which of us is Œdipus

39

here? Which of us sphinx? It is, it seems, a rendezvous of questions and question-marks.

Friedrich Nietzsche[79]

There is in all this movement a moment in which we meet the extreme extension of cognitive possibilities – war, death, our heart of darkness, the unspeakable, the terror of the void: 'The horror, the horror'. It is Franz Rosenzweig who opens his monumental work *Der Stern der Erlösung* (The Star of Redemption), published in 1921, by insisting on the anguish in the face of death that precedes all forms of comprehension: that anguish which dissuades us from claiming that everything is intelligible. There is a city, such as Beirut, Baghdad or Sarajevo, that can become the tangible zone of horror, the dark core of the unspeakable and the indecipherable. When thought is organised by the disruption of differences, rather than the levelling logic of rationalism, we are drawn out of the shelter of its presumed resolutions to travel under the wider skies of a troubling complexity. It is a mode of thinking:

> that contemplates the present as a myriad of conflicts, none of which can be suppressed, in which frontiers are not barriers but thresholds, sites of transit, of movement. If one had to define the modern subject it would be as a frontier subject. The classical language of politics and philosophy is not able to describe this zone of shadows and horrors, nor dissolve them.[80]

It is a wet, grey afternoon in March, the drizzle slanting in the yellow headlights of the cars. I enter the Angelica cinema on Houston, near the corner of Broadway. Just a few minutes' walk away there is the remarkable Mary Kelly exhibition Interim *at the New Museum . . . aah, the joys of New York. At the bar in the elegant foyer I order a cappuccino and a piece of cheesecake. I've decided to see* Black Rain, *not the Ridley Scott movie set in contemporary Osaka, but Shōhei Imamura's film based on the homonymous novel by Masuji Ibuse. The book is on sale by the ticket booth.*

Downstairs, in the almost empty cinema that periodically rumbles with the passing subway trains, I follow the story of Yasuko. Yasuko is a young woman who experienced the black rain that fell on Hiroshima after the explosion of the atom bomb. Fleeing the destroyed city, she, along with her uncle and aunt, go to live in the countryside. Despite her uncle's efforts to find her a partner she is unable to marry. All know that she was caught in the radioactive

shower. She is for ever marked, contaminated. Eventually, Yasuko succumbs to radiation sickness and death. The subtitled, black-and-white, visuals underline the delicate bitterness of the story. In black and white it is not the aura of realism, retrospective or documentary, that is recalled, so much as the poetic starkness of a harrowing morality play. I, too, felt as though I had been marked.

Many months later my mother phoned me in Italy. She had just seen Black Rain *on British television. 'It's terrible what people do to each other. They shouldn't do things like that.' Taken off-balance, I could only mumble my assent.*

In *Le Monde* of 23 August 1990 there is an article on Poland, tourism and post-war reconstruction. Warsaw was almost completely razed to the ground during the Second World War. Eighty-five per cent of the buildings were destroyed; 800,000 died under the effects of Nazi bombs, mines and flame-throwers; 450,000 of the dead were Jews. Old Warsaw, the historical centre, was subsequently rebuilt. Working from photographs, drawings and memory, architects and engineers, employing the latest techniques, and using the opportunity to install modern plumbing, have reconstructed the ancient centre and returned it to its pre-bellic appearance. In this simulacrum of a previous Warsaw all traces of the ghetto have been removed. There remains only the giant Jewish cemetery and its 'tombs without descendants'.[81]

In 1979 the concentration camps of Auschwitz and Birkenau became part of the UNESCO patrimony of protected historical monuments. In the guide books describing this 'architecture of atrocity and its urbanisation of genocide', the barracks reserved for homosexuals and gypsies are still passed over in silence.[82] The almost total annihilation of a people, the calculated eradication of what historically had been the most potent symbol of the West's internal 'other' (the 'Jewish question'), clings to memory. More marginal, less rooted, figures are expelled from remembrance, even from a collective participation in the shared oblivion of death. But then the full impact of the Holocaust – not as an accidental aberration but as something intrinsic to the sense of modernity and the West: 'the terrible revelation of its essence' – has yet to be fully inscribed in the body of contemporary history, culture and critical thought.[83]

In all this evidence there exists an ethos. Like an open wound that calls for attention, we are exposed to difference, interrogation and ambiguity. It is this, as Hans-Georg Gadamer puts it, that constitutes

the opening of experience. It is in this gap that we recognise our limits, learn to control our narcissism (personal, cultural, national), and come to recognise ourselves in the ethics of solidarity.[84]

A PERPETUAL DEPARTURE

> . . . you can't go home again. Why? Because you are home . . .
>
> Marjorie Garber[85]

> An authentically migrant perspective would, perhaps, be based on an intuition that the opposition between here and there is itself a cultural construction, a consequence of thinking in terms of fixed entities and defining them oppositionally. It might begin by regarding movement, not as an awkward interval between fixed points of departure and arrival, but as a mode of being in the world. The question would be, then, not how to arrive, but how to move, how to identify convergent and divergent movements; and the challenge would be how to notate such events, how to give them a historical and social value.
>
> Paul Carter[86]

Theory is a practice frequented by self-awareness. We are caught in a condition in which we practise the 'ethics of the suspension of theory'. This is our 'eternal return': seeking to understand this suspension as we are exposed to the difference between sign and event. *Ethos* means to locate oneself in another place. In the endless interplay between *ethos* and *topos* we are forced to move beyond rigid positions and locations, beyond forms of judgement dependent upon the abstract identification of values that have already been decided and legislated for in advance. Criticism involves a perpetual departure. It transports us beyond the comfort offered by a model of rationality and morality that provides a conclusion, an ending. In movement we recognise the impossibility of completing the journey. Between a here and a there (fort . . . da), however, we experience the possibility of the promise . . . of the impossible. This is the destiny of the address to the other – disturbing, uncanny: it emerges with the dispatch of the letter, and it travels without an ultimate destination. To travel is to recognise a distance, a difference, that renders the experience possible. Our experience, the experience that we all have, is that we are on this journey.[87]

Tahar Ben Jelloun writes:

Friends of the Good, know that we have met through the secrecy of the Word in a circular street, perhaps upon a ship plying a course unknown to me. This story has something of the night; it is obscure and yet rich in images; it should end with a feeble, gentle light. When we reach dawn, we shall be delivered. We shall have aged by a night, a long, heavy night, a half-century, and a few white pages scattered in the white marble courtyard of our house of memories. Some of you will be tempted to dwell in that residence, or at least occupy a small part of it suited to the dimensions of your bodies. I know that the temptation to forget will be great: oblivion is a spring of pure water that must on no account be approached, however thirsty you may feel. For this story is also a desert. You will have to walk barefoot on the hot sand, walk and keep silent, believing in the oasis that shimmers on the horizon and never ceases to move toward the sky, walk and not turn around, lest you be taken with vertigo. Our steps invent the path as we proceed; behind us they leave no trace, only the void. So we shall always look ahead and trust our feet. They will take us as far as our minds will believe this story.[88]

New York–London–Paris–Barcelona–Berlin–Naples: 1990–2

NOTES

1 Poetry reading at the Bronx County Hall, New York, Spring 1990.

2 Friedrich Nietzsche, *Beyond Good and Evil*, Harmondsworth, Penguin, 1973, p. 197.

3 bell hooks speaking at the DIA Center for the Arts conference, 'Critical Fictions', 11–12 May 1990, New York; now collected in Philomena Mariani (ed.), *Critical Fictions. The Politics of Imaginative Writing*, Seattle, Bay Press, 1991.

4 Stuart Hall, 'Minimal Selves', in L. Appignanesi (ed.), *Identity. The Real Me. Post-Modernism and the Question of Identity,* ICA Documents 6, London, ICA, 1987, p. 44.

5 Michel de Certeau, *The Practice of Everyday Life*, Berkeley, Los Angeles & London, University of California Press, 1988, pp. 41–2.

6 Ibid., p. xxi.

7 Trinh T. Minh-ha, *Woman, Native, Other*, Bloomington & Indianapolis, Indiana University Press, 1989, p. 35.

8 Trinh T. Minh-ha is rewriting Roland Barthes, displacing and going beyond the point set by the author, 'the voice loses its origins . . . writing begins': Roland Barthes, 'The Death of the Author', in Roland Barthes, *Image–Music–Text*, London, Collins/Fontana, 1977.

9 This theme, which today can be theoretically summarised in the

encounter between new historicism and deconstructionism, is clearly central to many narratives written in English in the 1980s: Jeanette Winterson, Graham Swift, Peter Ackroyd, Salman Rushdie, not to speak of Latin American 'magic realism', or such North American writers as Vonnegut, Hawkes, Pynchon and DeLillo. I was reminded of this by a paper given by Susana Onega Jaén – 'British Fiction in the 1980s, Historiographic Metafiction, the Way Ahead' – at the XIV Congreso de asociación española de estudios anglonorteamericanos at Vitoria-Gasteiz, Spain, in December 1990.

10 For a further discussion on the limits of writing, particularly in the field of ethnography, and the recent 'textualism' of cultural anthropology, widely associated with the work of James Clifford, see David Tomas, 'From Gesture to Activity, dislocating the Anthropological Scriptorium', *Cultural Studies* 6 (1), January 1992.

11 Michael Taussig, *Shamanism, Colonialism and the Wild Man. A Study in Terror and Healing,* Chicago & London, University of Chicago Press, 1991, p. 10.

12 E. Lucas Bridges, *Uttermost Part of the Earth*, London, Hodder & Stoughton, 1951, p. 36.

13 'The stranger permits you to be yourself, while transforming you into a stranger': Edmond Jabès, *Un étranger avec, sous le bras, un livre de petit format*, Paris, Gallimard, 1989, p. 9.

14 Chandra Mohanty, quoted in Lata Mani, 'Multiple Mediations. Feminist Scholarship in the Age of Multinational Reception', *Inscriptions* 5, 1989, p. 5.

15 Bill Ashcroft, Gareth Griffiths and Helen Tiffin, *The Empire Writes Back*, London & New York, Routledge, 1989, p. 154.

16 Ibid., p. 36.

17 DIA Center for the Arts conference, 'Critical Fictions', 11–12 May 1990, New York; now collected in Philomena Mariani (ed.), *Critical Fictions. The Politics of Imaginative Writing*, Seattle, Bay Press, 1991.

18 Paul Bowles, *The Sheltering Sky,* New York, Vintage, 1990, p. 134.

19 Michel de Certeau, *The Practice of Everyday Life*, Berkeley, Los Angeles & London, University of California Press, 1988; see chapter 6 in this volume.

20 Felix Guattari, 'The Three Ecologies', *New Formations* 8, Summer 1989, p. 139.

21 Homi K. Bhabha, 'DissemiNation', in Homi K. Bhabha (ed.), *Nation and Narration*, London & New York, Routledge, 1990.

22 For this shifting mix of different cultures, diverse contexts, in which identities are crossed and contaminated, but not for that reason necessarily debilitated or lost, listen to Youssou N'Dour's *The Lion*, 1989, and *Set,* 1990, and Ruichi Sakamoto's *Beauty*, 1989.

23 William E. Connolly, *Political Theory and Modernity,* Oxford & New York, Basil Blackwell, 1989, p. 132.

24 Michel de Certeau, *The Practice of Everyday Life*, Berkeley, Los Angeles & London, University of California Press, 1988, p. 18.

25 On overturning the trope and re-signification in black literary culture, see Henry Louis Gates Jr, *Figures in Black*, New York & Oxford, Oxford

University Press, 1989.

26 Jeanette Winterson, *Sexing the Cherry*, London, Vintage, 1989, p. 81.

27 Edgar Morin, *Vidal et les siens*, Paris, Seuil, 1989.

28 DIA Center for the Arts conference, 'Critical Fictions', 11–12 May 1990, New York; now collected in Philomena Mariani (ed.), *Critical Fictions. The Politics of Imaginative Writing*, Seattle, Bay Press, 1991.

29 Maxine Hong Kingston, *China Men*, New York, Vintage, 1990, p. 110.

30 'The name authorises the *I* but does not justify it': Edmond Jabès, *Un étranger avec, sous le bras, un livre de petit format*, Paris, Gallimard, 1989, p. 11.

31 Maria Damon, 'Talking Yiddish at the Boundaries', *Cultural Studies* 5 (1), January 1991, p. 25.

32 Gayatri Chakravorty Spivak, 'Reading *The Satanic Verses*', *Third Text* 11, Summer 1990, p. 48.

33 Rosi Braidotti, *Patterns of Dissonance*, Cambridge, Polity Press, 1991, p. 145.

34 Leslie Marmon Silko, *Storyteller*, New York, Little, Brown and Company, 1981.

35 Edmond Jabès, *The Book of Questions*, vol. 1, Middletown, Wesleyan University Press, 1976, p. 50.

36 Vicki Kirby, 'Corporeographies', *Inscriptions* 5, 1989, p. 112.

37 Ibid., pp. 112–13.

38 Ibid.

39 William E. Connolly, *Political Theory and Modernity*, Oxford & New York, Basil Blackwell, 1989, p. 161.

40 The rest of the quote runs on in this revealing manner, '*The Satanic Verses* cannot be placed within the European avant-garde, but the successes and failures of the European avant-garde are available to it.' Gayatri C. Spivak, 'Reading *The Satanic Verses*', *Third Text* 11, Summer 1990, p. 41.

41 Trinh T. Minh-ha, *Woman, Native, Other*, Bloomington & Indianapolis, Indiana University Press, 1989, p. 94.

42 Friedrich Nietzsche, *Beyond Good and Evil*, Harmondsworth, Penguin, 1973, pp. 28–9.

43 Julia Kristeva, *Stranieri a se stessi*, Milan, Feltrinelli, 1990, p. 10; *Étrangers à nous-même*, Paris, Fayard, 1988.

44 Stuart Hall, 'Minimal Selves', in L. Appignanesi (ed.), *Identity. The Real Me. Post-Modernism and the Question of Identity*, ICA Documents 6, London, ICA, 1987, p. 44.

45 '. . . one ought to employ "cause" and "effect" only as pure *concepts, that is to say as conventional fictions for the purpose of designating mutual understanding, not explanation.*' Friedrich Nietzsche, *Beyond Good and Evil*, Harmondsworth, Penguin, 1973, p. 33.

46 I have borrowed the metaphor of the knot from A. S. Byatt, 'Identity and the Writer', in L. Appignanesi (ed.), *Identity. The Real Me. Post-Modernism and the Question of Identity*, ICA Documents 6, London, ICA, 1987, p. 26; the quote is from Jacqueline Rose, *Sexuality in the Field of Vision*, London, Verso, 1986, p. 91.

47 This is to push, or twist, a little further Stuart Hall's comments on the

necessity of arbitrary closure to permit the articulation of any politics or identity; see 'Minimal Selves', in L. Appignanesi (ed.), *Identity. The Real Me. Post-Modernism and the Question of Identity*, ICA Documents 6, London, ICA, 1987, p. 45. For a full exposition of the Nietzschean argument on the 'purely invented world of the unconditional and self-identical', see 'Part One, On the Prejudices of Philosophers', in *Beyond Good and Evil*, Harmondsworth, Penguin, 1973.

48 Homi K. Bhabha, 'DissemiNation', in Homi K. Bhabha (ed.), *Nation and Narration*, London & New York, Routledge, 1990, p. 318.

49 Ashis Nandy, 'Dialogue and the Diaspora', *Third Text* 11, Summer 1990, p. 102.

50 Wilson Harris, 'In the Name of Liberty', *Third Text* 11, Summer 1990.

51 See the chapter 'The New Metropolis' in Raymond Williams, *The Country and the City,* London, Chatto & Windus, 1973.

52 On some further, and fascinating, connections established in this globalised migrancy and the subsequent creolisation of cultures, see Peter Wollen's 'Tourism, Language and Art', *New Formations* 12, Winter 1990.

53 Paul Gilroy, *Promised Lands*, London, Verso, 1993.

54 Walter Benjamin, *The Origin of German Tragic Drama*, London, Verso, 1990, p. 36.

55 Gayatri Chakravorty Spivak, 'Can the Subaltern Speak?', in C. Nelson and L. Grossberg (eds), *Marxism and the Interpretation of Culture*, Urbana, University of Illinois Press, 1988, pp. 272–80.

56 Ibid., pp. 292–4.

57 Jacques Derrida, quoted in ibid., p. 293.

58 Elizabeth Grosz, 'Judaism and Exile. The Ethics of Otherness', *New Formations* 12, Winter 1990, p. 81.

59 See the chapter on Conrad in Allon White's *The Uses of Obscurity. The Fiction of Early Modernism*, London, Routledge & Kegan Paul, 1981.

60 The phrase comes from one of Heidegger's last essays, 'The End of Philosophy and the Task of Thinking', in Martin Heidegger, *Basic Writings*, New York, Harper & Row, 1977.

61 This is from Shoshana Felman's brilliant essay on Paul de Man, 'Paul de Man's Silence', *Critical Inquiry* 15 (4), Summer 1989, p. 734.

62 Paul de Man, *The Resistance to Theory*, quoted in ibid., pp. 736–9.

63 Ibid., p. 738.

64 Siegfried Kracauer, *History: The Last Things Before the Last* , New York, Oxford University Press, 1969, p. 192.

65 Martin Heidegger, 'The Question Concerning Technology', in Martin Heidegger, *The Question Concerning Technology and Other Essays,* New York, Harper & Row, 1977.

66 The novels form an urban trilogy, *Kramladen des Glücks*, 1913, *Pariser Romanze,* 1920, *Heimliches Berlin*, 1927.

67 Now available in English: Henri-Pierre Roché, *Jules et Jim,* London, Marion Boyars, 1993.

68 Henri-Pierre Roché, *Carnets. Les Années Jules et Jim*, Marseilles, André Dimanche; Helen Hessel, *Journal d'Helen*, Marseilles, André Dimanche.

69 All the details and quotes are drawn from a fascinating article by

Elisabetta D'Erme, 'Diario di un mitico triangolo', *il Manifesto*, 17 July 1992.

70 See, for example, Janice Radway, *Reading the Romance*, Chapel Hill & London, University of North Carolina Press, 1984; Mary Ann Doane, *The Desire to Desire,* Bloomington & Indianapolis, Indiana University Press, 1987; Christine Geraghty, *Women and Soap Opera*, Cambridge, Polity Press, 1991; Lidia Curti, 'What is Real and What is Not: Female Fabulations in Cultural Analysis', in Lawrence Grossberg, Cary Nelson and Paula Treichler (eds), *Cultural Studies*, London & New York, Routledge, 1992.

71 Audre Lorde in an interview with Pratibha Parmar and Jackie Kay in Shabnam Grewal, Jackie Kay, Liliane Landor, Gail Lewis and Pratibha Parmar (eds), *Charting the Journey. Writings by Black and Third World Women*, London, Sheba Feminist Publishers, 1988, p. 130.

72 See Angie C. Chabram and Rosa Linda Fregoso, 'Chicana/o cultural representations, reframing alternative critical discourses', *Cultural Studies* 4 (3), October 1990.

73 Edmond Jabès, *The Book of Questions*, vol. 1, Middletown, Wesleyan University Press, 1976, p. 26.

74 The debate on essentialism and anti-essentialism has been extensively explored recently by certain black British male intellectuals and white American feminists; see Kobena Mercer, 'Black hair/style politics', *New Formations*, 3, Winter 1987, and 'Black Art and the Burden of Representation', *Third Text* 10, Spring 1990; Paul Gilroy, 'It Ain't Where You're From, It's Where You're At ... The Dialectics of Diasporic Identification', *Third Text* 13, Winter 1991; Judith Butler, *Gender Trouble. Feminism and the Subversion of Identity*, London & New York, Routledge, 1989; and Jane Flax, *Thinking Fragments,* Berkeley, Los Angeles & London, University of California Press, 1990.

75 Frantz Fanon, *Black Skins, White Masks,* London, Pluto, 1991, p. 109.

76 Kobena Mercer, 'Black Art and the Burden of Representation', *Third Text* 10, Spring 1990.

77 As, for example, in Isaac Julien's beautiful film *Looking for Langston,* British Film Institute, 1989.

78 Frantz Fanon, *Black Skins, White Masks,* London, Pluto, 1991, p. 109.

79 Friedrich Nietzsche, *Beyond Good and Evil,* Harmondsworth, Penguin, 1973 , p. 15.

80 Franco Rella, 'Nella zona dell'orrore', *il Manifesto*, 9 September 1990, p. 34.

81 Frédéric Edelman, 'Les simulacres de la nuit', *Le Monde*, 23 August 1990.

82 Ibid.

83 See Philippe Lacoue-Labarthe, *Heidegger, Art and Politics. The Fiction of the Political,* Oxford, Basil Blackwell, 1990, p. 37. Also Zygmunt Bauman, *Modernity and the Holocaust*, Cambridge, Polity Press, 1989, and Jean-François Lyotard, *The Postmodern Explained to Children*, London, Turnaround, 1992.

84 Hans-Georg Gadamer, Istituto Italiano per gli Studi Filosofici, Naples, 12 November 1990.

85 Marjorie Garber, *Shakespeare's Ghost Writers. Literature as Uncanny Causality,* London & New York, Methuen, 1987, p. 159.
86 Paul Carter, *Living in a New Country. History, Travelling and Language,* London, Faber & Faber, 1992, p. 101.
87 After Jacques Derrida and Carlo Sini, Istituto Italiano per gli Studi Filosofici, Naples, 1 March 1991.
88 Tahar Ben Jelloun, *The Sand Child*, New York, Ballantine Books, 1989, pp. 7–8.

3

THE AURAL WALK

'One hundred solitudes form the whole of the city of Venice –
this is its spell. An image for the man of the future'. Nietzsche's
observation refers not to 'lonely crowd', that spectre of col-
lective angst, nor to Poe's Man of the Crowd, who found a
vicarious vitality among the throng, but to the artifice of
luxurious solitude: solitude as the most exquisite refinement of
all urbane design. Could it be that we come to the city in order
to achieve solitude? Such has been the unspoken premise of the
modern city of utopian individualism. By solitude I do not
mean isolation. Isolation is a state of nature; solitude is the
work of culture. Isolation is an imposition, solitude a choice.

Brian Hatton[1]

The Sony Walkman. Launched on the world in the spring of 1980,
this urban, hi-fi, gadget was based on an idea that came to Akio
Morita, President of Sony, while, rather appropriately, walking in
New York. Over the decade and now into the nineties the Walkman
has offered access to a portable soundtrack that, unlike the transistor
radio, car stereo and the explicitly opposed intention of the bass-
boosted 'ghetto blaster' or 'boogie box', is, above all, an intensely
private experience. However, such a refusal of public exchange and
apparent regression to individual solitude also involves an un-
suspected series of extensions. With the Walkman there is simul-
taneously a concentration of the auditory environment and an
extension of our individual bodies.

For the meaning of the Walkman does not necessarily lie in itself
– it sits there, neat, usually black, often wrapped in leather, and quite
oblivious – but in the extension of perceptive potential. People who
walk around with a Walkman might simply seem to signify a void,

the emptiness of metropolitan life, but that little black object can also be understood as a pregnant zero, as the link in an urban strategy, a semiotic shifter, the crucial digit in a particular organisation of sense. For the idea of the void, of nothing, always introduces us to the paradox that nothing can only be known by knowing nothing, that is, something.[2] So we might suggest that the apparent vacuity of the Walkman opens up the prospect of a passage in which we discover, as Gilles Deleuze reminds us in *Logique du sens* (1969), those other cities that exist inside the city. There we move along invisible grids where emotional energies and the imaginary flow, and where the continual slippage of sense maintains the promise of meaning.

In the manifest refusal of sociability the Walkman nevertheless reaffirms participation in a shared environment. It directly partakes in the changes in the horizon of perception that characterise the late twentieth century, and which offers a world fragmenting under the mounting media accumulation of intersecting signs, sounds and images. With the Walkman strapped to our bodies we confront what Murray Schafer in his book *The Tuning of the World* calls a 'soundscape', a soundscape that increasingly represents a mutable collage: sounds are selected, sampled, folded in and cut up by both the producers (DJs, rap crews, dub masters, recording engineers) and the consumers (we put together our personal play lists, skip some tracks, repeat others, turn up the volume to block out the external soundtrack or flip between the two).[3] Each listener/player selects and rearranges the surrounding soundscape, and, in constructing a dialogue with it, leaves a trace in the network.

The Walkman, like the transistor radio, the portable computer, the mobile phone and, above all, the credit card, is a privileged object of contemporary nomadism. Yet, as Chantal de Gournay has pointed out, while the computer and global credit status transmit you through a-topic space in a 'virtual', rather than a corporeal, reality, where time is 'fatal' and space incidental, the Walkman, on the contrary, draws the world into you, reaffirms your body, and laconically signals a 'diasporic identity' put together in transit.[4] Like Walter Benjamin's description of the Parisian arcades that let light into their interiors, the Walkman brings the external world into the interior design of identities.

In this mobile, wrap-around world, the Walkman, like dark glasses and iconoclastic fashion, serves to set one apart while simultaneously reaffirming individual contact to certain common, if shifting, measures (music, fashion, æsthetics, metropolitan life . . .

and their particular cycles of mortality). So the Walkman is both a mask and a masque: a quiet putting into act of localised theatrics. It reveals itself as a significant symbolic gadget for the nomads of modernity, in which music on the move is continually being decontextualised and recontextualised in the inclusive acoustic and symbolic flux of everyday life.[5] Still, if the Walkman so far represents the ultimate form of the art of transit, it also represents the ultimate musical means in mediating the ambient. For it permits the possibility, however fragile and however transitory, of imposing your soundscape on the surrounding aural environment and thereby domesticating the external world: for a moment it can all be brought under the STOP/START, FAST FORWARD, PAUSE and REWIND buttons.

The fascination of the image of the Walkman, apart from the inner secret it brazenly displays in public (what is s/he listening to?), is the ambiguous position that it occupies between autism and autonomy: that ambiguous mixture of danger and saving power, to paraphrase Heidegger's quotation from Hölderlin, that characterises modern technology. Therefore, to understand the Walkman involves multiplying on it diverse points of view, and appreciating that it does not subtract from sense but adds to and complicates it. Pursuing this we might say that our relationship to the Walkman 'will be free if it opens our human existence to the essence of technology'.[6] By 'essence' (*Wesen*) Heidegger intends something that endures through time, that dwells in the present, that offers a 'sense' of technology that is not merely reducible to the 'technological'. Despite the nostalgia for authenticity that permeates Heidegger's discourse we can nevertheless bend his words in a suggestive direction. To the question what is technology and, in this particular case, the Walkman, we can answer that it is simultaneously a technical instrument and a cultural activity. To continue with the German philosopher's concerns, the Walkman is an instrument and activity that contributes to the casting into sense, to the re-presenting, or en-framing (*Gestell*), of the contemporary world. In retracing the etymology of 'technology' back to the Greek *technē* and its ancient connection to the arts, to *poiēsis* and knowledge, Heidegger suggests a wider frame for thinking its sense, its particular truth.

However, as both instrument and activity, the Walkman is not simply an instrument that reveals the enduring truth of technology and being; it is also an immediate historical reality and practice. As part of the equipment of modern nomadism it contributes to the

prosthetic extension of mobile bodies caught up in a decentred diffusion of languages, experiences, identities, idiolects and histories that are distributed in a tendentially global syntax. The Walkman encourages us to think inside this new organisation of time and space. Here, for example, the older, geometrical model of the city as the organiser of space has increasingly been replaced by chronometry and the organisation of time. The technology of space has been supplemented and increasingly eroded by the technology of time: the 'real time', the 'nanoseconds' of computer chips and monitor blips, of transitory information on a screen, of sounds snatched in the headphones. It leads to the emergence of a further dimension. 'Speed suddenly returns to become a *primitive force* beyond the measure of both time and space.'[7]

To travel, and to perform our *travail*, in this environment we plug in, choosing a circuit. Here, as opposed to the discarded 'grand narratives' (Lyotard) of the City, the Walkman offers the possibility of a micro-narrative, a customised story and soundtrack, not merely a space but a place, a site of dwelling. The ingression of such a privatised habitat in public spaces is a disturbing act. Its uncanny quality lies in its deliberate confusion of earlier boundaries, in its provocative appearance 'out of place'. Now, the confusion of 'place', of voices, histories and experiences speaking 'out of place' forms part of the altogether more extensive sense of contemporary semantic and political crisis. A previous spatial hierarchy has had increasingly to confront an excess of languages emerging out of the histories and languages of feminism, sexual rights, ethnicity, race and the environment that overflow and undercut its authority. The Walkman is therefore a political act? It is certainly an act that unconsciously entwines with many other micro-activities in conferring a different sense on the *polis*. In producing a different sense of space and time, it participates in rewriting the conditions of representation: where 'representation' clearly indicates both the semiotic dimensions of the everyday *and* potential participation in a political community.

In Bruce Chatwin's marvellous book *The Songlines* we are presented with the idea that the world was initially sung into being.

> I have a vision of the Songlines stretching across the continents
> and ages; that wherever men have trodden they have left a trail
> of song (of which we may, now and then, catch an echo); and
> that these trails must reach back, in time and space, to an

isolated pocket in the African savannah, where the First Man opening his mouth in defiance of the terrors that surrounded him, shouted the opening stanza of the World Song, 'I AM!'.[8]

The Nietzschean vision of the world, that is, a world of our making, dependent on our activity and language for its existence, is here laid out as the human adventure in which the movements of peoples, and the rigours and rhythms of bodies, limbs and voice, set the patterns, the design, the nomination, of the land, the country, our home. The religious aura of this nomadism has clearly waned in the more secular networks of Western society. Perhaps it still continues to echo inside the miniaturised headphones of modern nomads as the barely remembered traces of a once sacred journey intent on celebrating its presence in a mark, voice, sign, symbol, signature, to be left along the track.

NOTES

1 Brian Hatton, 'From Neurosis to Narrative', in Linda Brown and Deyan Sudjic (eds), *Metropolis. New British Architecture and the City*, London, ICA, 1988.

2 See Brian Rotman's interesting study of the question, *Signifying Nothing. The Semiotics of Zero*, London, Macmillan, 1987.

3 Murray Schafer, *The Tuning of the World*, New York, Alfred Knopf, 1977.

4 Chantal de Gournay, 'Citadins et nomads. L'espace public à l'épreuve des technologies de communication mobile', paper given at the Centre de Sociologie de l'Innovation of the École Nationale Supérieure des Mines, Paris, 9 January 1992.

5 Shuhei Hosokawa, 'The Walkman Effect', *Popular Music* 4, 1984, pp. 171–3. This is a brilliant, pioneering essay on the question of the Walkman. It is extracted from a full-length study in Japanese: Shuhei Hosokawa, *Walkman no Shûjigaku*, Tokyo, Asahi Shuppan, 1981.

6 Martin Heidegger, 'The Question Concerning Technology', in Martin Heidegger, *The Question Concerning Technology and Other Essays*, New York, Harper & Row, 1977, p. 3.

7 Paul Virilio, *Lo spazio critico*, Bari, Dedalo, 1988, p. 15; *L'Espace critique*, Paris, Christian Bourgois, 1984.

8 Bruce Chatwin, *The Songlines*, London, Picador, 1988, p. 314.

4

DESIRING MACHINES

Matter, that thing the most solid and well-known, which you are holding in your hand and which makes up your body, is now known to be mostly empty space. Empty space and points of light. What does this say about the reality of the world?

Jeanette Winterson[1]

These days electronic keyboards come with 'feel' buttons destined to inscribe programmed 'mistakes' into what would otherwise be the too perfect reproduction of sound.[2] Micro-circuits and computer chips permit a reproduction that is more 'real' than the real. We are introduced to a world in which the purely indexical factor is compounded by an intertextual assembly of sounds and lights that confound the metaphysics of realism. Cinema, science fiction writing, pop music, photography and, above all, computer animation increasingly orbit around the investigation of such a composite reproduction of 'reality'.

It is particularly the computerised ambient of 'digital dialogues' and digital memories that suggests the supernatural aura of an immaterial world.[3] Here we are encouraged to 'act out the fantasy of "realising the reverie"', and thereby evade capture in received referents, older authorities and languages.[4] Such electronic alchemy apparently beckons us to live in a simulated world where everything is constructed, fabricated and fabulated according to our needs, pleasures and whims. But, of course, we have always constructed simulated worlds: myths and narratives that string together the miscellaneous, the disparate and the incomplete into a continuum of personalised and collective meaning. Our very lives, explanations, interpretations and memory lie in an imaginary web sustained by language. The world itself is being continually assembled, woven

together and projected in this fabrication. It, too, has become a fable (Nietzsche), a phantasmagoria (Benjamin); sometimes a nightmare.

Something has clearly occurred: a shift in the constellation of sense has to be registered. For, although our bodies remain the stuff of future stars it is as though a critical link in the continuum has snapped. Transformed into bodiless, electronic metaphors – sliding signifiers, blips on a screen, digits in a programme, a set of self-referring combinations organised around the figure of zero – solid referents have increasingly been replaced by abstract forms 'as though they were still in the brain' (Rainer Maria Rilke).

Central to the unease, and the sense of homelessness induced by this situation, is the immediate connotation of this fabulated world with falsity. In its artifice, the simulation is considered 'artificial', and loses all the material (and ontological) weight associated with 'reality'. And yet there is an important rendezvous here to be recorded between the disintegration of the referential paradigm of reality, once so dear to a positivist view of science and the æsthetics of realism, and the continual envelopment of our environment by the seemingly autogenetic images and languages of the mass media. The resulting epistemological interrogation, together with the everyday experience of living in an increasingly mediated world, leaves us with a sense of reality that has become a little more complicated, more contingent, certainly more dependent upon the languages of representation. Here the appeal to 'authenticity' sounds somewhat hollow, nostalgic and seemingly out of place. Our means of measurement and value are no longer obviously guaranteed by a metaphysics of the 'real'. That discourse has also been revealed to be a narrative: its pretence to be an immutable, solid, fact turns out to be a question of interpretation.

Of course, in the testimony of both the visual arts and critical thought we continue to witness the endeavours to transform the fluidity of life into less transitory forms. Yet the attempts themselves betray, even announce and celebrate, their precariousness, while at the same time seeking a moment's redemption in transcendence. Such a *poiēsis* is organised around the dream, the project, of representing the unrepresentable, of speaking the unspeakable, of naming the unnameable. Any comment, any formal language of apprehension, whether it follows the codes of critical thought or, for example, photography, remains for ever on the margins of what it seeks to represent or picture. Between the lines of prose, or as a shadow in the photographic negative, the energies of the everyday

world appear as ghosts, as phantom traces that, although casting a penumbra over the page or photograph, always remain beyond the eye.[5]

For the attempt to picture, describe and capture this elsewhere, the crazed itinerary of a positivist 'science' that once believed itself capable of draining the world through its sieve, is also the stuff dreams are made of. If the rationalist illusions and once monstrous pretensions of both the natural and human sciences are these days beginning to be abandoned, there still remains the dream material, the dreaming, the imaginative and poetic constructions with which we continue to confer sense on the world. It is in this seemingly immaterial process of metaphor and association (already, for example, rehearsed in the Surrealist refusal of modernist functionalism, in the 'edible' architecture of Antonio Gaudi and Dalí's 'hypermaterialism') that the quotidian and the exceptional are most strikingly combined. Functionalism – objects surgically stripped bare by the rationalist scalpel – is 'the complete negation of the image of dwelling'.[6] And it is surely in the idea of dwelling – 'poetically dwells man' insists Heidegger quoting Hölderlin – where, caught between earth and sky, our mythical past (the deities) and our desired future (mankind), the wider sense of our existence resides. For by dwelling Heidegger does not merely imply the inhabitation of a building. He wants to locate in the term the responsibility for the cultivation and culture of a place: '*spaces receive their essential being not from "space" but from places*'.[7] I will return to this point in a moment.

The refusal of a formal distinction between reality and the simulacrum is inextricably tied to the increasing blurring, confusion and permeability of boundaries, the continual crossing of frontiers. Where the distinction between the real and the artificial, the organic and the inorganic, the authentic and the simulacrum, was once confidently proclaimed, this is clearly no longer possible. Our bodies are invaded by technology, whether in the institutions of health or leisure, and, at the same time, they are continually re-membered and re-appear within the electronic world of modern communications: cinema, television, compact discs, computer graphics . . . the multimedia world of simulations. Each is contaminated and pollinated by the other. In that most artificial yet tactile of human bodies – Arnold Schwarzenegger's – the prosthetic contract, whereby the haphazard logic of the 'natural' has been replaced by the constructed dictates of the 'biological', is continually revealed: the machine beneath the

skin in *Terminator*, the other memory – that of a dream, of reality? – in *Total Recall*. Out of such bodies emerge other realities, other bodies: *Eraserhead, Alien, Videodrome, Robocop, Tetsuo*. This is a world populated by what Donna Haraway calls 'cyborg culture'.[8]

For Walter Benjamin all this would merely confirm his views on the genesis of fetishism. It is fetishism that 'suppresses the barriers that separate the organic from the inorganic world' and is 'at home in the world of the inert as in the world of flesh.'[9] But, in this adept confusion of Marxist and Freudian discourses, what is being referred to here: an obscured use-value, or a displaced object of desire, an unnecessary addition or an essential excess? Just as Benjamin once noted of photography, the ubiquitous computer informs us on the 'unconscious of vision'.[10]

For those of us who grew up in the sixties the instability and mutability of reality was once most vividly suggested through hashish, certain species of mushroom and LSD. Today, the 'doors of perception' have also been opened, in a more public manner, by the metropolitan practice of consulting a screen for self-realisation in both leisure and work. In the flat, two-dimensional, logic of the media screen we now reach towards the possibility of contemplating the invisible. In the electronic simulation of computer hyper-space it is as though the archaic link between knowledge and sight, revealed in the ocular etymology of 'theory', is starkly accentuated by the clarity of the computer image.

There is here both an extension and a mutation.

With the World Library potentially *on line*, waiting to be individually customised and annotated, we electronically browse, comment and cut-and-paste our way through its contents – words, but also images, films, sounds – assembling our own hyper-texts.[11] In this endless library, just like in the infinite spirals of the Mandelbrot Set, we travel through finer and finer scales towards an increasing complexity, where the moment of closure is indefinitely postponed.

In the computer, in its tactile language, its digital manipulations, where forms appear as though directly transferred from the mind to the screen, and the screen itself presents us with a simulation of the brain, we come also to participate in the spectacularisation of the invisible. Is this simply one step beyond the earlier attempt to visualise Einstein's brain: 'his head bristling with electric wires: the waves of his brain are being recorded, while he is requested to "think of relativity"'?[12] Perhaps the answer lies in Barthes's own rhetorical

question: 'What does to "think of" mean exactly?'[13] It is not
Einstein's brain, but this very idea of a thing – 'relativity' – existing
elsewhere, waiting to be discovered by an independent rationalist
gesture, as though lying outside the discourse that names it, that is
now interrogated. The falling away of earlier dualities – the real and
the represented, reality and the simulacrum, the authentic and the
artificial, the original and the false – leads to casting previous
epistemological certainties into an instructive confusion. One thing,
however, does begin to emerge. Along this ambiguous and uncanny
threshold between 'real' and 'artificial' bodies, the Cartesian in-
dependence of mind, the *cogito* of the rational individual as the
presumed foundation of modern identity, is increasingly dispersed.[14]

It is above all the computer that suggests a dialogue with the
infinite: for here everything can be digitalised and reproduced *ad
infinitum*. As Jean Baudrillard points out, this machine proposes a
'virtual eternity – not as in death, which is durable, but as in the
ramifications of artificial memories, which are ephemeral.'[15] The
dream of rendering the infinite finite, that is, visible, is apparently
realised by computers. They offer the endless fascination of 'the
spectacle of thought'.[16] Yet, despite Baudrillard's perpetual attempt
to situate himself 'beyond' – 'beyond thought, desire, history, the
end of history, and even himself' – the moral resistance (that critical
distance he ironically denies) in the grain of his description of
computing still reveals a belief in an original, in a state of things that
existed prior to their representation, reproduction, simulation.[17]

Is this still not an argument about fetishism, about the distinction
between 'truth' and 'appearances'? What, to echo Nietzsche, does it
mean to talk of thought, or anything else for that matter, if it does not
appear, if it is not displayed, as if it could exist in a 'pure' or 'natural'
state without being represented, as though it was before or beyond
language? There is no a priori, no thought without a medium, a
mediation, a scene, a spectacle. Yet the dream of being redeemed by
authenticity can still be plainly heard in Baudrillard's particular
description of the Men of Artificial Intelligence crossing mental
space strapped to their computers:

> Just as we can suggest that glasses or contact lenses might one
> day become the integrated prosthesis of a species whose gaze
> will have gone, so we can fear that artificial intelligence and its
> technical aids will become the prosthesis of a species whose
> thought will have disappeared.

Artificial intelligence is without intelligence, because it is without artifice. The genuine artifice is the artifice of the body in a state of passion, is the sign of seduction, of ambivalence in gesture, of ellipse in language, is the mask of the face, the shaft which alters meaning, and which for this reason we call the shaft of wit.[18]

These de-sexed machines are celibate. They can never know the pleasure of seduction; they can generate and combine but can never live the ecstasy of an illusion, the irony of language. This explains 'the deep melancholy of computers'.[19] We are drawn into a coma induced by the vacuum of the screen.

Surely this tale, organised around a fear for the state of the 'genuine', is too neat, its evocation of the 'real world', with its passions and seductions subject to the 'objective reality of knowledge', too beguiling. There emerges the suspicion that so much of the reading of Baudrillard has perhaps involved a terrible misunderstanding. His demented descriptions have been mistaken for prescriptions. For beneath all the demonic swirl of his language there is his clear insistence on the fact that we have lost contact with the real world. He is not the dazed seer of the brave new world of postmodernity, but rather the urgent prophet of its apocalypse. His viral language, like that of Paul Virilio's, is, above all, the declared symptom of a perceived predicament: we have all been contaminated and are about to disappear. In his voice we can hear the hysterical timbre of the Situationists, mixed in with the cooler accents of Frankfurt and Marxism, and, behind them all, the echo of the older and deeper romantic creed intent on protecting 'human values' (and the 'humanities') from the menace of the new barbarism of the machine (and its 'sciences'). The accumulation of all this negation somehow seems to suggest that we are excluded from the latter *by nature*.

We could return to the question of reality, to the paradox of being threatened by our own products, and, carrying them both with us, address again the wider question of dwelling. What does it mean to dwell in this reality, where boundaries are continually crossed and semantic indicators increasingly confused by this traffic? How do we transform this space into a place, a habitat?

The computer and its users are the modern objects–subjects *par excellence*. The programmer in particular has taken the place once occupied by the engineer, the nuclear scientist or the astronaut. The

programmer has acquired the cloak of Merlin. For what he, some-times she, offers is magic: solutions for undreamed-of problems, travel in unimagined places. Both computer and programmer are a hyper-embodiment of the state (and frustration) of being desperately modern. As contemporary myth, the computer, with its access to the secret codes of order (from the banal assurance of statistics through the open world of mathematics to the infinity of fractals, entropy and the 'science of chaos'), offers comforting referents in the dissolution of late modernity. While 'the grand systems of classical ideology – Marxism, socialism, liberalism – begin to crack and lose their credibility a new model of social organisation, based on pro-grammers and communicating machines, is proposed to the public'.[20] The symbology of all this takes us well beyond the existing organ-isation of society and deep into the older spiritual economy of the very desire for knowledge.

The computer can be said to represent both an ending and a beginning. As a metaphor of the ambiguity of modern knowledge it holds opposites together. Knowledge is visualised and totalised. Western metaphysics is paraded as though in a universal calculus on screen. Here every *body*, as a figure of rational assembly and appearance, can be ordered, simulated and seemingly explained. But, at the same time, a distinct aura of mystery and magic pervades the situation.

For in the zone of 'bodiless exultation', in cyberspace, we also confront the alchemy of anthropological mutation.[21] This world, with its promise of full intelligibility, the world of 'total man', is inhabited by an omnipotent intelligence without a body, an ensemble of information without limbs or organs, a radically alternative form of creation.[22] The physical structure of the body is abandoned in this up-dated scene from *Frankenstein*, and even the matter of Einstein's brain is no longer necessary. Here, in the infinity of the memory chips, the body of *homo telematicus* is finally superseded, de-materialised. Projected into the fourth and eternal dimension of cyberspace, anatomy is replaced by the electric impulses of 'pure' intelligence.

In this universe, without bodies or apparent material support, we 'surf the datawaves' and travel across the interface into the empire of the 'Network Nation', only occasionally heeding the guide book manuals on the dangers of bugs, crashes and viruses.[23] We journey between the myths of auto-replication (the Golem, the 'anatomical machines' of the Prince of Sansevero, Dr Frankenstein's monster,

the artificial intelligence of future cyborgs) and the utopia of 'liberating' the information universe.[24] Dismembered and re-assembled on the other side of the screen as points of light, as an electronic traveller, as ghostly cosmonaut, we seek to *re-member* ourselves as the memory of desire and the erotics of knowledge relentlessly combine.[25] The lifeless matter of silicon and circuits, animated by electricity, resurrects our double and with it the promise of eternity in some memory bank or other. This passage beyond death, beyond the corpse, is, of course, the drama of Dr Frankenstein and his creation.

Here, staring deep into the computer screen, the dream of humanis-ing technology – the monster finally becomes 'user-friendly' – of translating its hard logic into a soft environment, of moulding it to fit our habitat, is apparently realised. The encounter between presumed opposites – the organic body and the machine – has become osmotic, and the passage between the two seemingly immaterial. The gap has been closed, reduced to a *frisson* of anticipated pleasure, a domes-ticated thrill. Here, living on the frontiers of *technē*, in the zone of *poiēsis*, technology, technique and metaphor fuse into a language of being, and the ancient rift between science and music is apparently healed.[26] The distinction between man and machine is replaced by a continuum in which the rational and the imaginary amalgamate. In a sort of state of Zen, where meaning floats, we live the fascination of traversing and transgressing that old frontier and entering, as it were, a fourth dimension.

But perhaps all this is merely the latest version of a boy's adventure story. The earlier exploration of exterior space has now been replaced by the full recognition of male narcissism in an interior journey, mirrored not merely in the face gazing into the monitor but, above all, in the interior, œdipal language dialoguing in the circuitry of the mother board. In the private conversation of the interface there apparently lies the final triumph of male logic over female emotions, of cold calculation over hot impulses, of planning over passion.[27] Yet, where many women are apparently expected, and inducted, to use the computer on an instrumental and functional level, that is, 'rationally', as typists and secretaries servicing the electronic wor(l)d, it is more likely to be men who become emotional in their enthusiasm, and are transformed into little boys self-absorbed in their own electronic navels and the infantile pleasures of a new toy. In this Wonderland Alice has changed sex. The initial projection has come full circle in the blatant exposure of a male fantasy.

That is probably the case. But the story will surely not end here. For in this floating world, what the Japanese call *ukiyo*, we can also discover the co-ordinates of a wider existence.[28] In the fluctuating reproduction of reality where images mutate, and sense migrates and dematerialises under the law of simulation, speed and simultaneity, we are confronted with the rules of the game upon which language and communication are constructed: the scene of signs (Jacques Derrida).[29] In the passage from rigidity to fluidity, from binaries to bifurcation, inherited identities and roles enter the malleable space of the sign. Images, including the images we have of ourselves, can come to be electronically fused with the libidinal forces of our imaginary.

Our bodies become other bodies, that is, objects on the screen, further signs. The moments of writing, viewing, inscription, physical and imaginary travel all represent attempts to link these two shores, to navigate between the corporeal and the incorporeal, to break the rigid dualism of subject and object, of male and female, of reality and imaginary, in a recognition of desire.[30] It is that desire, inscribed with all its cultural and historical signatures, that situates us, and not the apparent technical effacement of our selves as our bodies are dematerialised in the simulated and self-referring order of media metamorphosis. In this migrancy it is the *dialogue* of desire, of motion, of shifting sense and senses, of openings, rather than technology and the techniques distilled in the alienated body confronting the machine, that becomes the fulcrum of sense and provides the narrative ground upon which we base our movement.

So, and to take up our journey again, what if what we call 'reason' is historically gendered? The construction of Artificial Intelligence is clearly not a neutral process, nor is the potential flexibility of open-ended programming and interfacing necessarily acknowledged in the patriarchal rationalisations and vocabulary of computerese: 'slave', 'abort', 'boot-up' . . .[31] There is also the paradox of computers removing much of the physical muscle from military affairs, of apparently de-masculinising the war machine when it is software, as much as hardware, determining the outcome of conflict.[32] In turn, we find men using their gender to protect their ideological and economic status through simulating a reality – that of the skilled print compositor – that no longer exists: these days they are merely glorified typists, keying in text for computerised composition.[33]

Moving beyond the pre-existing social relations that have taken up their home in the computer world, we are drawn into questions that

lie at the heart of the very logic of programming. In the bluntest of terms there lies the choice between the hierarchical organisations of programs that move abstractly from axiom to theorem to corollary and the opposed *ad hoc* style of the *bricoleurs* who construct theorems by rearranging, borrowing and re-negotiating already available materials. In the latter case there is a 'preference for treating symbols on screen as physical objects rather than as abstractions, for anthropomorphizing the program, or for seeing things in terms of relationships rather than in terms of properties – preferences that are discouraged in the usual course of computer training'.[34] From here the interface clearly shifts from confrontation to co-operation, from one-dimensional abstraction to icons, touch-sensitive screens, voice recognition and eventually 'virtual reality', where, with head-mounted monitors and data gloves, the interface becomes kinæsthetic and relies on the apparently tactile manipulation of seemingly three-dimensional material as the user directly handles the objects on screen, moves behind the filing cabinets on the 'desk top', even going through screen doors into other 'rooms'.[35]

Here the institutional and ideological processes that install computers – their projection, programming and utilisation – within the presumed 'neutral' co-ordinates of logic, linearity and objectivity, and the invariable consecration of these terms by masculinity and progress, are challenged and playfully dispersed. Knowledge, as the presumed beneficiary of the limpid and linear accumulation of time, of progress, now reveals that darker underside of shadows where again we meet 'reason lined with desire'.[36] We find ourselves in the space of Christine Buci-Glucksmann's 'baroque reason', a reason that incorporates desire, and whose strangeness and uncanny excess provide us with the allegory of an alternative modernity that transgresses the 'mercantile reason' of rationalism.[37] To the limitless freedom of the rational individual of classical thought the baroque allegory opposes the symbolic net of our being captured in language, in history, in mortality.[38]

We can perhaps ask ourselves at this point whether the computer is the triumphant culmination of a process of total rationalism, or is rather, and more interestingly, the simulacrum of our being caught in that dream. In the second case it re-proposes our limits, and our historical re-entry into a more circumscribed and contingent world. No longer blinded by the patriarchal light of 'progress' we can now find our place and return to our computers without the company of Enlightened Man, abandoned like a 'ghost with an erection'.[39]

In the uncanny property of the computer to present a 'world picture' we confront the boundary set by the screen, the tinted glass that lies between the apparently concrete world and the simulated one of ethereal lights. Still:

A boundary is not that at which something stops but, as the Greeks recognised, the boundary is that from which something *begins its essential unfolding*. That is why the concept is that of *Horismos*, that is, the horizon, the boundary.[40]

It is this opening, this awareness, this reflection, that permits us the 'courage to make the truth of our presuppositions and the realm of our own goals into the things that most deserved to be called into question'.[41]

NOTES

1 Jeanette Winterson, *Sexing the Cherry*, London, Vintage, 1990, p. 8.
2 Andrew Goodwin, 'Pushing the Feel Button', *New Statesman & Society*, 5 January 1990, p. 49.
3 See Andy Cameron, 'Digital Dialogues: an Introduction', in the issue of *Ten.8* entitled *Digital Dialogues. Photography in the Age of Cyberspace*, vol. 2, no. 2, Autumn 1991.
4 Victor Burgin, 'Realising the Reverie', ibid., p. 9.
5 Michel de Certeau, *The Practice of Everyday Life*, Berkeley, Los Angeles & London, University of California Press, 1988.
6 Tristan Tzara, quoted in Anthony Vilder, 'Homes for Cyborgs', in *Ottagno* 96, September 1990, p. 43.
7 Martin Heidegger, 'Building, Dwelling, Thinking', in Martin Heidegger, *Basic Writings*, New York, Harper & Row, 1977, p. 332; Heidegger's emphasis.
8 Donna Haraway, 'A Manifesto for Cyborgs. Science, Technology, and Socialist Feminism in the 1980s', *Socialist Review* 80, 1985.
9 Walter Benjamin, *Parigi. Capitale del XIX secolo*, Turin, Einaudi, 1986.
10 Ibid., p. 19.
11 This is the philosophy behind the aptly named *Project Xanadu* due to go public sometime in the early 1990s. The principles of hyper-texting can be experienced with a program supplied with every Macintosh computer, *HyperCard*. There is also the electronic journal *Postmodern Culture* from Raleigh, North Carolina, available 'free via electronic mail': pmc@ncsuvm.cc.ncsu.edu.
12 Roland Barthes, 'The Brain of Einstein', in Roland Barthes, *Mythologies*, London, Paladin 1973, p. 68.
13 Ibid., p. 68.
14 Francis Barker, 'The Artificial Body and the Disappearance of Space', at the conference 'La Piazza nella Storia', Salerno, 9 December 1992.

15 Jean Baudrillard, 'Le Xérox et l'infini', *Traverses* 44–45, Paris, 1987, p. 21.
16 Ibid., p. 18.
17 The quote on Baudrillard's 'beyond' comes from the anonymous reviewer of *Cool Memories II* (Paris, Galilée, 1990) in *Informazione Filosofica* 1, December 1990, p. 71.
18 Jean Baudrillard, 'Le Xérox et l'infini', *Traverses* 44–45, Paris, 1987, p. 18.
19 Ibid., p. 19.
20 Philippe Breton, *La Tribu informatique*, Paris, Métailié, 1990, p. 25.
21 The classic statement on cyberspace is William Gibson's *Neuromancer*, London, Grafton Books, 1986.
22 Norbert Wiener, *The Human Use of Human Beings*, London, Sphere Books, 1968.
23 The quotes are from Steven Levy, 'High-Tech Lynchings', *Macworld*, March 1992, p. 65.
24 Philippe Breton, *La Tribu informatique*, Paris, Métailié, 1990.
25 Robert D. Romanyshyn, *Technology as Symptom and Dream*, London & New York, Routledge, 1989.
26 For a quick flight through this universe, see Stewart Brand's *The Media Lab*, Harmondsworth, Penguin, 1988.
27 On the deployment of the rational/irrational dualism in defining the 'feminine', see chapter 2 of Susan J. Hekman's *Gender and Knowledge. Elements of a Postmodern Feminism*, Cambridge, Polity Press, 1990.
28 Cynthia Kadohata, *The Floating World*, London, Minerva, 1989.
29 Jacques Derrida in J.-F. Lyotard and T. Chaput (eds), *Épreuves d'Écriture*, Paris, Centre Georges Pompidou, 1985, pp. 11–12.
30 Jacques Derrida, ibid., p. 38.
31 Ruth Perry and Lisa Greber, 'Woman and Computers', *Signs* 16 (1), Autumn 1990. This is a special number of *Signs* entitled 'From Hard Drive to Software: Gender, Computers and Difference'.
32 Paul Edwards, 'The Army and the Microworld, Computers and the Politics of Gender Identity', *Signs* 16 (1), Autumn 1990.
33 See Cynthia Cockburn's account of the changes brought about in the male world of the British printers in the newspaper industry under the impact of information technology: *Brothers. Male Dominance and Technological Change*, London, Pluto, 1983.
34 Sherry Turkle and Seymour Papert, 'Epistemological Pluralism. Styles and Voices within the Computer Culture', *Signs* 16 (1), Autumn 1990, p. 93.
35 James D. Foley, 'Interfaces for Advanced Computing', *Signs* 16 (1), Autumn 1990, p. 95. For example, Xerox offers Rooms software for Microsoft Windows. This permits the user to move between diverse screens or 'desktops' by going through 'doors' into different 'rooms'.
36 Robert D. Romanyshyn, *Technology as Symptom and Dream*, London & New York, Routledge, 1989, p. 10.
37 Christine Buci-Glucksmann, *La Raison baroque*, Paris, Galilée, 1983. For Buci-Glucksmann this is the space of the other, of the feminine, but also the 'complementary world' of heresies that speak – Baudelaire and

Benjamin, the Kabala and the avant-garde – in the languages of excess and transgression of an elsewhere, of an alternative scansion of historical time.

38 Ibid., pp. 27–8.
39 Walker Percy, quoted in Robert D. Romanyshyn, *Technology as Symptom and Dream*, London & New York, Routledge, 1989, p. 200.
40 Martin Heidegger, 'Building, Dwelling, Thinking', in Martin Heidegger, *Basic Writings*, New York, Harper & Row, 1977, p. 332.
41 Martin Heidegger, 'The Age of the World Picture', in Martin Heidegger, *The Question Concerning Technology and Other Essays*, New York, Harper & Row, 1977, p. 116.

5

THE BROKEN WORLD: WHOSE CENTRE, WHOSE PERIPHERY?

> Three crows flap for the trees,
> And settle, creaking the eucalyptus boughs.
> A smell of dead limes quickens in the nose
> The leprosy of Empire
>
> Derek Walcott[1]

> ... if, as I was saying, the act of cultural translation (both as representation and as reproduction) denies the essentialism of a prior given originary culture, then we see that all forms of culture are continually in a process of hybridity. But for me the importance of hybridity is not to be able to trace two original moments from which the third emerges, rather hybridity to me is the 'third space' which enables other positions to emerge.
>
> Homi K. Bhabha[2]

> ... the very idea of English Literature as a study which occludes its own specific national, cultural and political grounding and offers itself as a new system for the development of 'universal' values is exploded by the existence of post-colonial literature.
>
> Bill Ashcroft, Gareth Griffiths and Helen Tiffin[3]

> What would happen to logocentrism, to the great philosophical systems, to the order of the world in general if the rock upon which they founded this church should crumble?
>
> Hélène Cixous[4]

Sounds, voices, languages are always inscribed in places. Under the signs of language, power and 'English', the above quotations – citations from the once ignored peripheries of the Caribbean, India, Australia and Algeria – throw up fundamental questions in an epoch

67

of post-colonialism. These are encountered in the implosion of British (and Western) culture under the impact of its inhabitation by other voices, histories and experiences. In the real and imaginary journeys that constitute the modern maps of metropolitan cultures there emerge linguistic and musical islands that form chains of identity based on very different rhythms of time and being. The accents of Empire that return in the voices of post-colonial subjects – both travelling from the 'periphery' and erupting at the centre – find expression in a cross-cultural cosmopolitanism that reworks and rewrites the once hidden histories of black Atlanticism and imperial diaspora in the grammar of modern nomadic identities. As testimony there exist the noted literary voyages of Derek Walcott and Salman Rushdie, the deliberately dislocating dub poetry of Big Youth, Michael Smith and Linton Kwesi Johnson, the trope of journey and transformation so central to the recent emergence of black women's writings in the United States and the Caribbean, the more local signature of post-realist black British cinema and photography, and the ubiquitous mobility of black electronic riddims world-wide.[5]

As fruits of a 'forced poetics' that emerge from the prison house experience of slavery, racism and colonialism, this previously subordinated syntax reveals 'the submerged, surrealist experience and sensibility' that lie within the standard stereotypes of English language and literature and Eurocentric cultures.[6] This particular moment proposes what the French critic Christine Buci-Glucksmann, commenting on Benjamin's famous meditations on Paul Klee's 'Angelus Novus' – the angel of history – calls a moment of temporal intensity. In such an instance there occurs a rupturing of time: an arrest that permits the political and epistemological reversal of the histories of the previously vanquished.[7]

In more immediate terms, among the signs that encourage me to posit this rupturing of time and the emergence of an 'other' cultural semantics and syntax is the growth of a particular black British metropolitan æsthetic that gives distinctive shape and direction to questions of post-colonial culture and identity.[8] In the pictorial arts there has been the controversial but indicative exhibition *The Other Story* at the Hayward Gallery in 1990; in cinema, the Black Audio Film Collective with *Handsworth Songs* (1986), Sankofa with *Territories* (1984), *The Passion of Remembrance* (1986) and *Looking for Langston* (1989), Isaac Julien's *Young Soul Rebels* (1991); in popular music the extensive creolisation of diverse black music traditions with Soul II Soul and the Young Disciples; in criticism the

journal *Third Text*; and in the literary mode, apart from the most obvious case of Salman Rushdie, there are the hilarity of cultural hybridity in Hanif Kureishi's *The Buddha of Suburbia*, the memorable testimonies of the women of colour in *Charting the Journey*, and V.S. Naipaul's harrowing biography of the Empire narrative in reverse – *The Enigma of Arrival* – which takes us to the mystery that lies at the heart of darkness of modernity and finds us not in the Congo but at Stonehenge, on windswept Salisbury Plain, at the ancient heart of empire: the site of William Blake's Jerusalem ('Albion's druidy shore') and 'other unspeakable rites'.[9] These words, these images, these sounds, these voices, all 'bring into play certain disregarded yet exciting pathways into the reality of traditions that bear upon cross-cultural capacities for genuine change in communities beset by complex dangers and whose antecedents are diverse.'[10]

Encouraged by this material I want to consider a set of overlapping perspectives that draw upon some of the wider currents and questions set in movement by post-colonialism, feminists and black intellectuals, and which today are decisively breaking in on established views to inform an emerging critical horizon.

VOICES

But one level has certainly to be challenged: the metropolitan interpretation of its own processes as universals.

Raymond Williams[11]

While the imperial metropolis tends to understand itself as determining the periphery . . ., it habitually blinds itself to the ways in which the periphery determines the metropolis – beginning, perhaps, with the latter's obsessive need to present and re-present its peripheries and its others continually to itself.

Mary Louise Pratt[12]

Perhaps the first significant element to register in the discussion of a sense of history, language and identity that emerges in this period is that there is a growing hesitancy in pretending to offer a rationalist synthesis of the voices and forces released in the post-colonial world, as if these can simply be plotted on to the existing map of knowledge. Sometimes the voices met with may converge, but they may also separate out to the point of incomprehension and dissonance. For

here, as Lévinas says, to travel critically means to journey not like Ulysses, on the way home, but like Abraham, cast out of the previous house of knowledge and destined never to return.

This suggests the need to connect – without reducing to the same – those currents that sweep through the contemporary critical world in the Occident, which, in condensed, displaced and partial fashion, seek to speak of an elsewhere, of other worlds, and whose co-presence and mixing disturb and decentre our previous sense of knowledge and being. It involves embracing a mode of thought that is destined to be incomplete. Western thought, with its promise of a mastery of the complete picture is confronted by the incompleteness of 'the spilled, the broken world', to use Thomas Pynchon's memorable phrase: a world broken down into complexities, diverse bodies, memories, languages, histories, differences.[13] The post-colonial presence, where the abstract metaphor of the 'Other' is now metamorphosed into concrete, historical bodies, challenges the screen of universal thought – reason, theory, the West – that has historically masked the presence of a particular voice, sex, sexuality, ethnicity and history, and has only granted the 'Other' a presence in order to confirm its own premises (and prejudices).[14] Edward Said's *Orientalism* is the classic study of this discursive power at work, and the present crisis of cultural anthropology its most eloquent witness. For although the latter frequently narrates the death of the 'native' this is often only a thinly disguised metaphor for the death of the claims of the discipline itself. Now decidedly marked by the historical and ethical impossibility of speaking for the 'other', these ambiguous funeral rites invariably return us to reconsidering the asymmetrical powers of representations, and our place within them, in the present day world.[15]

Here, in this crisis of enunciation, we can also recognise a potential convergence between radical feminist theory – Luce Irigaray, Carla Lonzi, Hélène Cixous, Alice Jardine, Rosi Braidotti, Jane Flax, Susan Hekman, Judith Butler – with its sustained critique of the phallogocentric Cartesian subject, and the post-colonial critique of the presumptions of occidental discourse: a convergence that is directly inscribed in the work of Gayatri Spivak, Trinh T. Minh-ha, bell hooks, Paul Gilroy and Homi Bhabha, for example, and which is destined for greater dialogue. For the dissonance that emerges over the disagreement 'as to the theoretical significance . . .' (Rosi Braidotti) of gender and ethnicity, sex and race, rightly threatens to develop into a radical critique of knowledge and the

intellectual discourses, institutions and disciplinary regimes that sustain it.[16]

DISRUPTING AUTHENTICITY

Is one really black enough? And who is black enough anyway?

Isaac Julien[17]

It is this longing for a center, an authorizing pressure, that spawns hierarchized oppositions.

Gayatri Chakravorty Spivak[18]

To these preliminary observations is to be added the further question of not merely what today is a language, literature and history such as 'English', but, above all, who are the 'English' now that identities can no longer be grounded in the notorious referents of 'earth and blood'. That phrase comes from Heidegger's infamous Rector's address of 1933, but such an ethnic grounding of identity was not foreign to the Leavises or even E.P. Thompson and the late Raymond Williams.[19] The framework of present-day 'English' is clearly sustained and, what is more important, renewed across the interstices of increasingly diverse histories, cultures and memories. Confronted with the previously eclipsed presence of a 'cross-cultural medium' we are carried by 'a deeper and stranger unity of sensibility *through* and beyond polarised structures'.[20] At this point the finite and closed consolation once associated with the presumed uniqueness of a community can either withdraw into the dead husk of blind cultural conceits or else fruitfully fragment and remake itself under the weight of a multiple inheritance.

In the West, however, we have inherited an authoritative testimony that has always regarded cultural fragmentation and mobility with horror. Intent on conserving the timeless sanctuary of the unique and singular expression of the work of art against the dispersive movements of industry, urbanisation and capitalism, it has fought an endless rearguard action against modernity. In disavowing the discontinuous tempos and cultures of the city, commerce and modernity, this critical tradition has persistently sought radical alternatives in the assumed continuities of folk cultures, 'authentic' habits and 'genuine' communities.

To go elsewhere to find such 'authenticity', now that local roots, histories and traditions in the West have apparently been dispersed and destroyed, only perpetuates the mirror phase of that infantile

71

drive. We seek to return to the beginnings, no longer our own, but that of an 'Other' who is now requested to carry the burden of representing our desire. The Western demand for the mythical uncontaminated space' of an authentic 'native' culture perpetuates the imperial gesture through a seemingly opposed modality.[21] It involves a defence of 'the archaic as a pure anti-Western value precisely because it aspires in *Occidental* fashion to an irredeemable absolute'.[22] Through these paradoxes the Occident continues to secure itself as subject, the origin and destination of critical discourse, while simultaneously ignoring the processes and mediations – imperialism, neo-colonialism, capitalism, the Western media – that violently brought those differences, those 'natives', those other cultures, into our world, simultaneously shaping and distributing them.[23]

To question this particular critical drive is to contest the presumed destining of the West. It is to query a projection – 'when the spiritual strength of the West fails . . . the joints of the world no longer hold' – that ultimately links a blinkered faith in 'progress' to the eventual consummation of occidental reason in the Holocaust.[24] And it links all of us in the West to the assumed destiny of the world that modern imperialism iterates not only in territorial conquest and economic mastery, but in the very articulation and dissemination of knowledge. It invariably still strikes us as a paradox to consider an idea of 'knowledge' that is not in the end of occidental origin. It is this imperial setting and inheritance, as Edward Said points out, that 'is the true defining horizon, and to some extent, the enabling condition of such otherwise abstract and groundless concepts like "otherness" and "difference"'.[25] Notice that Edward Said refers here to both a horizon and an 'enabling condition'. The presence of the West does not simply lead to a state of subjection involving the unilateral cancellation of subaltern identities and cultures, it also produces a milieu that provides the syntax in which differences represent an interruption, an interrogative punctuation and opening.[26] This suggests, as Said goes on to say, the 'idea of a collective as well as a plural destiny' in the epoch of post-colonialism.[27]

Such a prospect, with its recognition of the ontological impact of mobility and contingency, leads inevitably to undoing our confidence in declarations of 'authenticity'. Yet 'authenticity' is an idea that has proved to be central both to the initial establishment of the cultural, literary and moral canons of the 'English' tradition and to many of the post-colonial forces, writers, artists and individuals who

are now contesting and transforming it. In the idea of roots and cultural authenticity there lies a fundamental, even fundamentalist, form of identity that invariably entwines with nationalist myths in the creation of an 'imagined community'.[28] In rewriting the discourse of roots and tradition, the terms of a metropolitan myth are inverted but the same oppressive disposition of power, positioning, subjectivity, agency and attendant modes of hegemony are inadvertently reproduced.

However, whenever tradition appears in the form of a temporal and cultural continuum that unfolds according to the logic of its origins, that is as a teleology, its version of the past (and the future) is inescapably accompanied by the appendix of a historical interrogation. As a 'determination in advance', tradition masks the powers and complexities of its heterogeneous configuration in the repetition of the identity of the same.[29] By disentangling the knots of that monothetic discourse and loosening ourselves from its rigid ordinances, a further, more open, discontinuous and historical, framework emerges.

While in the metropolitan verse of Aimé Césaire the case is altogether more subtle, the distinct qualities of *négritude* in the writings of Léopold Sédar Senghor, for example, however powerful and poignant their appeal, curiously mirror the prejudiced stereotypes of Europe. This deliberately adopted black 'other' reconfirms the position already prescribed for him and her and reinforces the binary opposition between a completely separate black reality and that of the white world, as though the history of the last four hundred years had not had a profound impact on all cultures and their composite sense of identities. The binary logic of imperialism (and Western thought) is here continued and extended through the reproduction of dominant structures in subordinate languages, thereby recreating the hierarchical mechanisms that first put the native in her and his place:

> Nativism, alas, reinforces the distinction by revaluating the weaker or subservient partner. And it has often led to compelling but often demagogic assertions about a native past, history or actuality that seems to stand free not only of the colonizer but of worldly time itself . . . to accept nativism is to accept the consequences of imperialism too willingly, to accept the very radical, religious and political divisions imposed on places like Ireland, India, Lebanon, and Palestine by imperialism itself.[30]

73

To relinquish such a perspective leads us to recognise a post-colonial and post-European context in which historical and cultural differences, while moving to different rhythms, are coeval, are bound to a common time. 'Communication is, ultimately, about creating shared Time.'[31] To acknowledge this shared, if unequally occupied, space means to deny the temporal (and teleological) distance between 'primitivism' and 'progress' that has consistently justified so much of the intellectual, political and cultural capital invested in the centre–periphery model of culture and history. It is to contest the moral geography of Western taxonomies that, whether following religious or secular compasses, has permitted evil to be externalised by relegating it to the 'savage' and 'heathen' peripheries of the world. Then, in a reverse image, that imperious gesture has more recently been extended to a mourning for the pristine culture of the primitive, that is, the past, the elsewhere, from within the perceived decay of the metropolitan present.[32]

What, then, does the de-colonisation of culture actually mean: the recuperation of an essential culture that existed before the historical moment of colonisation, or the idea of admitting different histories to a complex and syncretic present composed of cross-cultural transfigurations? Does there even exist the possibility of returning to an 'authentic' state, or are we not all somehow caught up in an interactive and never-to-be-completed networking where both subaltern formations and institutional powers are subjected to interruption, transgression, fragmentation and transformation?

So, if the notion of authenticity has clearly been seminal to this whole discussion, we can perhaps at this point also begin to register its waning. To return, rather than simply to re-visit or re-view, that is, to apparently turn back and return 'fully', to African, Caribbean or Indian roots in pursuit of a displaced and dispersed authenticity today hardly seems feasible. The impossible mission that seeks to preserve the singularity of a culture must paradoxically negate its fundamental element: its historical dynamic.[33] Post-colonialism is perhaps the sign of an increasing awareness that it is not feasible to subtract a culture, a history, a language, an identity, from the wider, transforming currents of the increasingly metropolitan world. It is impossible to 'go home' again. This means to find oneself subject to ever wider and more complex webs of cultural negotiation and interaction, where, for example, 'immigrant women are subject-ed by the double articulation of discourses of cultural difference and patriarchy. This makes their attempts to negotiate their selfhood in

74

daily life both more interesting and perhaps more exemplary of the contradictions within which subaltern experience is represented and lived.'[34] Such a trajectory has been beautifully represented in Mira Nair's film *Mississippi Masala* (1991).

Here, in the post-colonial world, the arrow of time, of linearity, of nation and identity, and the 'progress' of occidental history, is deflected into diverse spaces that disrupt the single, unfolding narrative by introducing multiple sites of language, narrative, his-stories and her-stories, and a heteronomy of different pulses. The abstract individuation of time in logical and instrumental categories is challenged by those who refuse to adopt it and choose rather to adapt it in researching their own axes of orientation.[35] The interruption of *that* understanding of time, and its translation into a particular place, brings us to recognise the historical and cultural specificity of such an apparently universal discourse on value as that embodied in the æsthetic (and moral) authority of the 'Great Tradition' of English literature. Sealed between the emergence of a secular, national print language, a national literature and the modern nation state, such a universal lodestone of national letters and identity is brusquely exposed to contingency. It, too, is susceptible to eventual decentring and dispersal. This reveals a further sense of 'English' articulated on the 'other' side of modernity. Here there exists a making that reaches beyond the local tension between bucolic roots and faith in the further inevitability of 'progress', to engage with the violent interruptions of forced diasporas, induced migrations and racism. Beyond the parochial frame of the metropolitan centre and nation state, there have emerged the 'scores of particularities that had been frozen by foreign rule', and with them such potent tropes of modernity as migration, displacement, dislocation and composite, cosmopolitan identities.[36] At this point, 'English' becomes a continuum of intersections, encounters and dialogue: a palimpsest that emphasises the powers of impurity. Language becomes the scene of traces, of those immediate places, or local authenticities if you like, for which there is no final word, no metaphysical state.[37] Such a refusal of a mono- and ethno-centric view of literature, culture, history, reli-gion, music, identity and language leads inevitably to the dis-mantling of an obvious centre that legislates for these variations. But it simultaneously does not permit the possibility of the 'native' (whether white English or black Jamaican) returning 'home' to a 'pure' or 'authentic' state.

CULTURAL PASSAGES AND THE POETICS OF PLACE

> It has to be forged, quite paradoxically, from the 'inside', out of elements of the very system of representation it seeks to go beyond.
>
> Sarat Maharaj[38]

> So, if you really want to hurt me, talk badly about my language. Ethnic identity is twin skin to linguistic identity – I am my language. Until I can take pride in my language, I cannot take pride in myself. Until I can accept as legitimate Chicano Texas, Spanish, Tex-Mex and all the other languages I speak, I cannot accept the legitimacy of myself. Until I am free to write bilingually and to switch codes without always having to translate, while I still have to speak English or Spanish when I would rather speak Spanglish, and as long as I have to accommodate the English speakers rather than having them accommodate me, my tongue will be illegitimate.
>
> Gloria Anzaldúa[39]

This brings us to the further prospect of rethinking the binary logic that lies behind so much of the discussion of cultural imperialism and the centre–periphery figure it tends to employ. What we are witnessing in 'English' – as language, literature, history, identity – is part of a wider process of dislocation and decentring in which cities like London, Paris, New York and Los Angeles remain centres to the degree that they become multi-centres of different histories, cultures, memories, experiences. At the same time they have increasingly to confront what are today probably more 'typical' world cities such as Cairo, Bombay, Mexico City, Lagos, Shanghai, São Paulo, where occidental culture is translated, adapted and reworked for local contexts and circumstances, and then sometimes transmitted back to its apparent 'origins' in the West. This proposes, in the anthropologist James Clifford's deeply suggestive phrase, 'a new marking of "the West" as a site of ongoing power and contestation, of centrality and dispersal'.[40]

Now such cultural travelling clearly not only affects theory. It is initially experienced, absorbed and worked through in everyday secular culture. So it would seem fitting to consider this situation by exploring the metropolitan vernacular. I have chosen to look at an aspect of popular music.

Before beginning I would like to set out a proviso borrowed from
Roland Robertson:

> I do not agree with the implication that the problematic of the
> interplay between the particular and the universal is unique to
> capitalism. Indeed I would claim that the differential spread of
> capitalism can partly be explained *in terms of its accom-
> modation to* the historical 'working out' of that problematic.
> Nor do I agree with the argument that we can, in an explanatory
> sense, trace the contemporary connection between the two
> dispositions, directly to late twentieth-century capitalism (in
> whatever way that may be defined). Rather, I would argue that
> the consumerist global capitalism of our time is wrapped into
> the increasingly thematized particular–universal relationship
> in terms of the connection between globewide, universalistic
> supply and local, particularistic demand. The contemporary
> *market* thus involves the increasing *interpenetration* of culture
> and economy: which is not the same as arguing, as Fredric
> Jameson tends to do, that the production of culture is *directed
> by* the 'logic' of 'late' capitalism.[41]

Rock music in the 1980s and the 1990s is clearly the sound of an
established, largely Anglo-American, hegemony. It not only occu-
pies radio, television, clubs, restaurants, pubs and discothèques, but
also accompanies our work, shopping and travel. It is the sound
score of our time. But it is a hegemony that has simultaneously
created the conditions for an international sound network that
subsequently encouraged a proliferation of margins and an emer-
gence of other voices. In the wake of these developments, sur-
prising trajectories can emerge on the musical map, resulting in
stories of unexpected influences and strange combinations. In the
early 1980s, for example, certain Italian dance records such as
Trilogy's 'Not Love', Capricorn's 'I Need Love' and Telex's
'Brainwashed' were being taken up in Chicago by a black DJ such
as Farley Jackmaster Funk to be electronically mixed down into the
local 'house' sound. Since then, via the telegraphic station of
metropolitan fashion and the perennial request for dance floor
novelty, house music has returned to Italy and, after further
Mediterranean re-mixing, been subsequently dispatched to achieve
success in British house 'raves' and parties. A similar story of this
type could also be written around the international impact of rap
music and its telling translation into urban scenarios that initially

seem quite separate from the cultural and ethnic climate of New York or Los Angeles.[42]

A further connection here springs from the recent history of the sounds of the so-called periphery, of the 'Third World': the 'world music' phenomenon. These musics, coming from diverse places around the world, can be considered not merely as a commercial ploy directed from the centre, the most recent 'discovery' of the record industry, but also as representative of a cultural, economic and historical shift that disputes the very nature of the centre–periphery distinction. This is to suggest a break with the unilateral causality, economism and political positivism that has tended to dominate the debate on cultural imperialism and neo-colonialism, and which invariably assumes 'that economics determines cultural hier-archies'.[43]We might ask ourselves not only what truth the spatial metaphor of centre–periphery reveals, but also what particular disposition of knowledge and powers it hides. This means to re-open that space, to re-think old indications and formulate new questions.

One way to do this is to take the opportunity provided by the breach in the soundtrack, the opening in the beat, proposed by the recent promotion and distribution of 'World Music' in Western cultures and cities. Initially signalled within the metropolitan rock empire by the musics of such groups as Talking Heads (New York) and Dissidenten (Berlin), the door was more firmly opened by the transplanted popularity of reggae and Latin rhythms in the 1970s and 1980s.[44] Subsequently, what might once have been merely con-sidered as the enlargement of the North Atlantic musical axis to include some Caribbean and Latin American musics is now being stretched to frame potentially global sonorities. It ranges from the modern tango of Buenos Aires to the fusions achieved on the traditional Arab lute, the oud, by Rabih Abou-Khalid.[45]

To write the story of 'World Music' is to face the same dilemma as that facing:

the Third World intellectual: such a person cannot afford politically to accept the 'truths' provided by colonial history, for this is a history written by oppressors from the First World; nor is there any longer an indigenous, native discourse and intellectual position, given the history and impact of colonial-ism on the colonized, and given that the Third World is now a resistant and resisting effect or projection of the First World. The problem is how to speak a language of the colonizer which

78

nevertheless represents the interests and positions of the colonized? If the subaltern can speak, what language is able to articulate, to speak or adequately represent the subaltern's position?[46]

That history, which is simultaneously part of my history and yet not reducible to it, is not something that I shall be attempting to write here. What, from my participation in the question, I will more simply try to do is to suggest a cultural economy of music able to begin to address an ethics of difference. Hopefully it might intimate how we could fruitfully move beyond the abstract polarities and positioning organised around the centre–periphery distinction and divide.

Youssou N'Dour and Ruichi Sakamoto playing together in New York; Cheb Khaled at the Place de la Bastille in Paris; Les Têtes Brûlés in Naples: are these simply examples of the centre pillaging the periphery, bringing home exotic sounds from the edges of the empire? Are we merely passive witnesses to the structures of capital imposing their institutions and organisation on new territories: the final triumph of the commodity as it takes over our ear? Or is there also something more subtle, more complex involved? The second perspective would suggest the need to overcome the limits of a simple dualism, and to think in terms of the extensive consequences of historical and cultural differences that are increasingly drawn into the coeval frame of a common time.

This would be to propose that the sounds of 'world music' function not simply as a stereotypical 'other' that confirms and closes the circle of ethnocentric identification: exotic embellishments requested for refurbishing the rock soundtrack. It would be to suggest that such sounds also offer a space for musical and cultural differences to emerge in such a manner that any obvious identification with the hegemonic order, or assumed monolithic market logic, is weakened and disrupted by the shifting, contingent contacts of musical and cultural encounters. This represents the instance of a musical and cultural conversation in which the margins are able to reassess the centre while simultaneously exceeding its logic. It is this complex, asymmetrical, structuring of the field of power that is masked in the simple hierarchies imposed by the centre–periphery distinction.

Further, the very conditions of such encounters, sustained by the simultaneous electronic reproduction of the same sound in multiple locations and contexts, disrupt the existing hierarchies running

outwards from the centre towards the periphery. They scramble the narrow historicism of pre-existing chronologies. I can take, for example, 'North Africa' as a musical motif and, working backwards in time, play in successive order the African inspired ethno-beat sounds of Dissidenten (Berlin) and Kunsertu (Sicily), an example of contemporary raï music from Algiers sung by Chaba Fadela, a traditional piece for the Arab lute from the Maghreb, and conclude in a folk club in London's Soho in the mid-1960s, where I first heard this possibility played on Davey Graham's guitar. However, this is not necessarily a historical reconstruction intent on recovering older patterns of musical migration and cultural formations, whether that is the iconoclasm of the Sixties' counter-culture or the more ancient musical passage between Africa and Europe once sustained by Arab culture. Nor is it merely autobiographical in its reach. It involves something more than travelling back in time. Reconstructing historical moments in the space of an apparently shared language we see how raï music, for example, is transformed and translated into diverse cultural and historical places, into different ways of inhabiting and identifying with it. Sounds traverse different places. So raï, an urban music initially associated with feminine culture in Algiers, particularly in the port of Oran, is now under threat from local Islamic fundamentalism while on the other side of the Mediterranean it is promoted as a predominantly male genre amongst immigrant diasporas and metropolitan audiences. These particular histories are both connected and disconnected, picked up and permitted, by such sounds becoming contemporary and co-terminous possibilities, moving to diverse tempos, overlapping in the contexts and contamination permitted by the electronic media. We are talking here of a sort of transversal movement in which once separated regions and reasons are put in contact. It further underlines the instability and contingency of the idea of 'authenticity' in the modern world of musical and cultural nomadism.

The international medium of musical reproduction underlines 'a new epoch of global culture contact'.[47] Modern movement and mobility, whether through migration, the media or tourism, have dramatically transformed both musical production and publics and intensified cultural contact. It is often argued that this inevitably leads to a flattening out of the globe, now reduced to a single economic and cultural order. Apart from the artless determinism of that argument, details on the ground betray the verdict. In West Africa, in Senegal, Youssou N'Dour continues to release cassettes

destined to circulate in bootleg form in the local markets of Senegal and Gambia, while (at least until recently) simultaneously being distributed on Virgin CDs elsewhere in the world. Different publics, different markets, different distribution, sometimes different mixes and sounds, these are the cultural signatures of difference. And, to echo Jacques Derrida, such differences represent both real distinctions and the impossibility of arresting the sense of such differences in any one of those sites. N'Dour's music both marks, and is marked by, difference and defers the possibility of an unequivocal sense.

Such a decentring, the subsequent break-up and undoing of the dualism of centre and periphery, and with that of the associated poles of 'falsity' and 'authenticity', invariably takes us elsewhere. As a minimum, to 'see Others not as ontologically given but as historically constituted would be to erode the exclusive biases we so often ascribe to cultures, our own not least'.[48] Speaking of the postcolonial condition, Kwame Anthony Appiah writes: ' . . . its post-, like that of postmodernism, is also a post- that challenges earlier legitimating narratives'.[49] Beyond the schema of economic imposition and cultural monopoly we might begin to think in terms of contamination and hybridity in the circulation of cultures, mutations that lead to unexpected extensions and configurations; a multi-lateral, however unequal and asymmetrical, series of exchanges, in which, for example, there is no 'authentic', untouched, non-contaminated 'Africa':

> . . . there is a clear sense in some post-colonial writing that the postulation of a unitary Africa over and against a monolithic West – the binarism of Self and Other – is the last of the shibboleths of the modernizers that we must learn to live without.[50]

Once again, this involves an inevitable weakening in any abstract understanding of the idea of authenticity. The notion of the pure, uncontaminated 'other', as individual and as culture, has been crucial to the anti-capitalist critique and condemnation of the cultural economy of the West in the modern world. Such a perspective invoked its own surreptitious form of racism in the identification by the privileged occidental observer of what should (a further ethnocentric desire and imperative) constitute the native's genuine culture and authenticity. But who is defining authenticity here? The observed, the other, is once again spoken for and positioned, and thereby reproduced as a domesticated difference within the occi-

dental ordering of the world. The other has no voice, is not allowed to speak and define her or his own sense of being (or authenticity) in the contemporary conditions of existence. This relationship, with its centrality to the reproduction of a Western sense of knowledge and selfhood, has been most dramatically spelt out by Gayatri Chakravorty Spivak:

> The person who *knows* has all the problems of selfhood. The person who is known, somehow seems not to have a problematic self. These days it is the same kind of agenda that is at work. Only the dominant self can be problematic; the self of the Other is authentic without a problem, naturally available to all kinds of complications. This is very frightening.[51]

To refuse the mechanisms of this binarisms and its techniques and technologies for separating out and subsequently positioning cultures, arts and . . . individuals, and to choose to move in the traffic between such worlds, caught in the sights, sounds and languages of hybridity, where there is neither the stability of the 'authentic' nor the 'false', does not mean that there are not real differences of experience, of culture, of history, of power. But to talk of differences, even radical and incommensurable ones, in economic, political and cultural terms, and of their embodiment in ethnicity, gender and sexuality, is to talk of an understanding of the making of identities in movement, under and in, processes. To talk of authenticity has invariably involved referring to tradition as an element of closure and conservation, as though peoples and cultures existed outside the languages of time. It is to capture them in the anthropological gaze, where they are kept in isolation and at a 'critical distance', as though they do not experience movement, transformation, and the disruption that the anthropologist represents: the West. It has been to refuse an understanding of a contingent formation in which a tradition, a history, a language, can become 'an element of freedom', a moment of active *redefinition*, that opens up the world to other claims on its destiny.[52]

We discover that there is no recovery of the unequivocal, 'no place for such absolutism of the pure and authentic'.[53] Perhaps we can draw inspiration from so-called Third World musicians and artists, forced to constantly construct their identities on the move between different worlds, and begin to entertain the idea of 'homelessness' and migrancy as the 'irrevocable condition of . . . world culture'.[54] It serves to underline a central distinction between music as the

assumed site of 'authenticity', with its associated closure of community and a ready to wear 'identity', and music as a source of difference, where unicity and ethnocentricity are constantly contested and denied.[55]

All this suggests that it is perhaps no longer useful to speak solely in terms of the clash between blocs of cultural power, between imperialist hegemony and subaltern movements, or to reduce critical judgement to the morality of threatened 'authenticities', co-option and sell-outs. It means, rather, to talk of a 'politics of transfigurations', of 'atonal ensembles', and an ethics of difference, in which common sounds, languages, syntax, materials and institutions are occupied and articulated in diverse directions.[56] If rock music is a global language and institution, a communicative practice, it stands in an analogous relationship to other worldly languages, offering both a shared grammar and network, and a shifting historical–cultural syntax in which meanings are contingent and identities contextualised. It is both held in common and differentiated. It is a material that is inhabited and marked in different ways; it is rewritten, becomes somebody else's place, somebody else's inscription. This is not to deny the real differences in power that we come across in the processes of globalisation in which the so-called advanced world continues to produce the 'Third World' as a necessary consequence of requiring areas of underdevelopment for its own development. Neither is it to ignore the brutal defeats and dead-ends, or the fact that not everyone finds a voice or a place here. But it is still to insist on this opening, where the universal rationalism that globalisation pretends to achieve is interrupted and stutters in local inflections and dispersal.

The 'Third World' is changing rapidly in many different ways. It was always a portmanteau concept into which many radically different types of society and culture were crammed and, as the relations between the core and the periphery change and a new world system begins to merge, it will open up yet new fields of difference. Cultures within the peripheries will change at different rates and in different directions. However, we can be sure that these changes will take place along the triple axes of migration, urbanization and cultural contact. The choice between an authentic nationalism and a homogenizing modernity will become more and more outmoded. Questions of cultural identity, both in the core and the peripheries, become

more complex as we begin to understand that there is no single model of a hybrid or composite culture, but many different possibilities. One advantage of the linguistic paradigm – creole, vernacular, esperanto, etc. – is that it can provide us with a precise sense of the range of options available.[57]

This brings me back to the hegemony of rock music, and to the presumed desert of homogeneity. After all, Simon Frith informs us that rock is dead, and I tend to agree.[58] Still, if white, Anglo-American, rock has apparently stumbled into Death Valley, and can only rehearse the æsthetics of its disappearance, for others its exhaustion may mark new beginnings. If, as Jean Baudrillard is fond of reminding us, the desert is the place of the empty repetition of dead meanings and abandoned signs, it is also the site of infinity: a surplus, as Emmanuel Lévinas argues, that permits others to exist, that permits others to exist apart and irreducible to our selves.[59] So the occidental metaphor of emptiness and exhaustion – the desert – perhaps also holds the key to the irruption of other possibilities: that continual deferring and ambiguity of sense involved in the travelling of sounds and people who come from elsewhere, but who are now moving across a landscape that we also recognise and inhabit: modernity or post-, advanced capitalism, the industries and networks of trans-national communications, the city, the end of the millennium.

To return to our initial question, is all this simply yet one more example of the centre expropriating the periphery, or does it involve something more? To put it another way, are we still caught up in peripheral histories that are in one moment recovered by metropolitan audiences and in the next forgotten, or is there now in play a movement of historical decentring in which the very axis of centre and periphery, together with its economic, political and cultural traffic, has, as a minimum, begun to be interrogated from elsewhere, from other places and positions?[60] For is it not possible to glimpse in recent musical contaminations, hybrid languages and cultural mix-tures an opening on to other worlds, experiences, histories, in which not only does the 'Empire write back to the centre', as Salman Rushdie puts it, but also 'sounds off' against it? Is there not here, apart from the obvious economic power of the Western world to distribute and market these sounds, that novel, these words, those stories, a poetic twisting and turning of language against itself that constantly undercuts hegemonic pretensions on reality and 'wreaks havoc upon the Signified'[61] – in other words, yet further evidence of

what Gloria Anzaldúa calls a 'border tongue', where language is employed to break the law and results in a 'critique of empire coded ongoingly on the spot'?[62] The master's language is transformed into creole, into the immediate alliteration of group idiolect, and all varieties of local cultural refashioning, as it moves to a different tempo in 'a reversal of colonial history'.[63] The result is a hybrid art that confounds and confuses earlier categorisations through a vernacular mixing of languages that were previously separated by æsthetic, social and geographical distinctions – aptly summed up in the pseudonym of the Nigerian visual artist Middle Art.[64] In this deconstruction of both language and its technologies, in these gaps, in the holes in prose, the breaks in sound, there emerge further means and meanings: those differences that permit the process of deferring, and the dispersal and redistribution of powers, of authority, of centre and periphery. In the cultural replay, the historical repetition, there exists an opening into another place.

For here we are moving in the sphere of the enunciation and its performative history, the site of cultural speech. It is the history and shifting contexts of the use of cultural languages, rather than abstract considerations of their grammar and syntax, that open up the space of other memories, other rhythms, other lexicons. In these messy and unresolved discourses, in which speech is the site of individuation, the relationship between language and signification is no longer metaphysical, as though controlled and ordered by the abstract categories of 'History', 'English', the 'culture industry', 'capital', or the 'West'. We are no longer dealing with closure – the unique and authorised version of events – but with the perpetual opening up and interrogation of such categories, and their constant relocation beyond presumed borders and limits. Seemingly shared grammars and syntax are differentiated, undone, dispersed, simultaneously weakened and spread. There is no longer an 'original' presence to ground them in a presumed 'authenticity', stable source or fixed 'originary, holistic, organic identity'.[65] In the space of this 'third culture, neither native nor white' (Gregory Bateson), the canon, the voice of authority, of the patriarch, of the Occident, is deferred and decentred.[66]

To recognise this 'doubling of modernity' (Homi Bhabha) is not to say that everything is now the same. We may share the languages of representation, but your history, your experience, cannot be simply exchanged for mine. Each is marked in different ways; they contain elements (linguistic, religious, cultural, historical) that are impossible to translate into the transparency of a common sense. In the

ensuing dialogue of difference our sense of each other is displaced, both of us emerge modified. This is to open up a movement beyond ethnocentricity; to open up the possibility of a 'representational practice that is premised on the mutual imbrication of "us" and "them"'.[67] Previous margins – ethnic, gendered, sexual – now reappear at the centre. No longer restricted to the category of a 'special issue' (e.g. 'race relations'), or 'problem' (e.g. 'ethnic minorities', 'sexual deviancy'), such differences become central to our very sense of time, place and identity.

In this context, to think of power, the struggle to find a voice, to be represented (both politically and historically), involves not so much a struggle between separate blocs or distinct realities, where these alternatives and margins, each with a clear and full sense of identity, press in on the centre. Here we are not necessarily confronted with a counter-discourse that sets argument against argument, position against position, but rather with a continuous disbanding and dispersal of the terms that claim to represent us, them, and reality. Declared identifications are explored for their ambivalence, thereby permitting the unsuspected irruption of historical and cultural disturbances to figure. This is to trace out something that emerges, and continues to emerge, in the perpetual process of identity and identifying with the possibilities of the world. Opposed to the metaphors of war – strategies, tactics, manoeuvres, positions – it is the metaphor itself, that is, the open-ended, transforming, powers of language and its rights to signify, to name, that takes over. We move from the politics of margins to the politics of difference: a movement that overthrows the previous power/knowledge axis that once positioned and presumed to fully explain the margins, the periphery, the 'others'.

Here to be 'black' can be a political and cultural term of identification among diverse groups of Caribbean, African and Asian inheritance held in a shared field of representations, rather than employed as a self-referring biological category or racial bloc. As Paul Gilroy points out, we are not dealing with an 'ethnic absolutism', but with something that 'needs to be viewed much more contingently, as a precarious discursive construction'.[68] For it indicates a cultural and historical passage that provides the flexible 'location for the transformation of ethnic self-identity'.[69] Here being 'black' doubles the initial sign to propose a de-centred, supplementary space that simultaneously continues to signal difference while all the time postponing, deferring, any ultimate meaning.

But, for the moment, I will choose to end on a slightly different note. In Gurinder Chadha's film *I'm British But ...* (1988) there is a suggestive reworking of the centre–periphery question in the context of metropolitan pop music and youth cultures.[70] On a roof top in Southall in London, a group of Asian-British musicians are performing a song in the Bhangra style: a world beat composite of Punjab folk, Bombay film and Western disco (subsequently cross-fertilised with the black metropolises of New York and Los Angeles in Bhangra rap). They are lamenting their exile from their Punjab homeland, while down in the street other Britons of Asian descent are observing and in some cases dancing to the sound. In this doubling of a scene from twenty years previously – the Beatles playing 'Get Back' on the roof of the Apple offices – the Western stereotype is strikingly mimicked and displaced into a very different sense of history, of identity, of centre.

NOTES

1 Derek Walcott, 'Ruins of a Great House', in Derek Walcott, *Selected Poetry*, London, Heinemann, 1981.

2 Homi K. Bhabha, 'The Third Space. Interview with Homi Bhabha', in Jonathan Rutherford (ed.), *Identity. Community, Culture, Difference*, London, Lawrence & Wishart, 1990, p. 211.

3 Bill Ashcroft, Gareth Griffiths and Helen Tiffin, *The Empire Writes Back*, London & New York, Routledge, 1990, p. 196.

4 Hélène Cixous and Catherine Clément, *The Newly Born Woman*, Manchester, Manchester University Press, 1987, p. 65.

5 For significant critical guides to contemporary black British cinema and photography, see the ICA document *Black Film/British Cinema*, London, 1988, and D.A. Bailey and S. Hall, 'Critical Decade. Black British Photography in the 80s', *Ten. 8* (3), 1992.

6 The term 'forced poetics' comes from Edmond Glissant, while the subsequent quote is from Edward Kamau Brathwaite; both in Edward Kamau Brathwaite, *History of the Voice*, London & Port of Spain, New Beacon Books, 1984, p. 13.

7 Christine Buci-Glucksmann, *La Raison baroque*, Paris, Galilée, 1983, pp.21–2.

8 An excellent opening into this area is provided by the London published journal *Third Text*. There, for example, can be found a significant contribution on the question of contemporary black æsthetics in the debate between Kobena Mercer, 'Black Art and the Burden of Representation', *Third Text* 10, Spring 1990; and Paul Gilroy's 'It Ain't Where You're From, It's Where You're At ... The Dialectics of Diasporic Identification', *Third Text* 13, Winter 1991.

9 Hanif Kureishi, *The Buddha of Suburbia*, London, Faber & Faber, 1990;

Shabnam Grewal, Jackie Kay, Liliane Landor, Gail Lewis and Pratibha Parmar (eds), *Charting the Journey. Writings by Black and Third World Women*, London, Sheba Feminist Publishers, 1988; V.S. Naipaul, *The Enigma of Arrival*, New York, Vintage, 1988. But see also Edward Kamau Brathwaite, *X/Self*, London & New York, Oxford University Press, 1987, and Merle Collins, *Rotten Pomerack*, London, Virago, 1992.

10 Wilson Harris, *The Womb of Space. The Cross-Cultural Imagination*, Westport, Greenwood Press, 1983, p. xv.

11 Raymond Williams, 'Metropolitan Perceptions and the Emergence of Modernism', in Raymond Williams, *The Politics of Modernism*, London, Verso, 1989, p. 47.

12 Mary Louise Pratt, *Imperial Eyes. Travel Writing and Transculturation*, London & New York, Routledge, 1992, p. 6.

13 Thomas Pynchon, *Vineland*, London, Minerva, 1990, p. 267.

14 See Rosi Braidotti, *Patterns of Dissonance*, Cambridge, Polity Press, 1991, pp. 132–46.

15 For a stunning interrogation of this space see Michael Taussig's *Shamanism, Colonialism, and the Wild Man. A Study in Terror and Healing*, Chicago & London, University of Chicago Press, 1991.

16 Rosi Braidotti, *Patterns of Dissonance*, Cambridge, Polity Press, 1991, p. 146.

17 Isaac Julien in Isaac Julien and Colin MacCabe, *Diary of a Young Soul Rebel*, London, British Film Institute, 1991, p. 129.

18 Gayatri Chakravorty Spivak, 'Translator's Preface', in Jacques Derrida, *Of Grammatology*, Baltimore, Johns Hopkins University Press, 1977, p. lxix.

19 Heidegger used the phrase 'earth and blood' in his notorious 'The Self-Assertion of the German University, Address Delivered on the Solemn Assumption of the Rectorate of the University of Freiburg', delivered in 1933. In the post-war aftermath, however, he was increasingly forced to think in terms of 'homelessness'; see, in particular, Martin Heidegger, 'Letter on Humanism', in Martin Heidegger *Basic Writings*, New York, Harper & Row, 1977.

20 Wilson Harris, *The Womb of Space. The Cross-Cultural Imagination*, Westport, Greenwood Press, 1983, p. xviii.

21 Tejaswini Niranjana, *Siting Translation. History, Post-Structuralism and the Colonial Context*, Berkeley, Los Angeles & London, University of California Press, 1992, p. 170.

22 Remo Guidieri, *L'Abondance des pauvres. Six aperçus critiques sur l'anthropologie*, Paris, Editions du Seuil, 1984, p. 18.

23 'Anthropology is that interpretation of man that already knows fundamentally what man is and hence can never ask who he may be. For with this question it would have to confess itself shaken and overcome. But how can this be expected of anthropology when the latter has expressly to achieve nothing less than the securing consequent upon the self-secureness of the *subiectum*?': Martin Heidegger, 'The Age of the World Picture', in Martin Heidegger, *The Question Concerning Technology and Other Essays*, New York, Harper & Row, 1977, p. 153.

24 As Robert Young bluntly states the case referring to the nineteenth-
 century high point of this European design: 'To this extent, Marxism's
 universalising narrative of the unfolding of a rational system of world
 history is simply a negative form of the history of European imperialism:
 it was Hegel, after all, who declared that "Africa has no history", and it
 was Marx who, though critical of British imperialism, concluded that the
 British colonisation of India was ultimately for the best because it
 brought India into the evolutionary narrative of Western history':
 Robert Young, *White Mythologies. Writing, History and the West*,
 London & New York, Routledge, 1990, p. 2. To which can be added: 'In
 the Auschwitz apocalypse, it was nothing less than the West, in its
 essence, that revealed itself – and that continues, ever since to
 reveal itself. And it is thinking that event that Heidegger failed to do':
 Philippe Lacoue-Labarthe, *Heidegger, Art and Politics. The Fiction of
 the Political*, Oxford, Basil Blackwell, 1990, p. 35. All of this can be set
 alongside Horkheimer's and Adorno's critique of the Enlightenment
 overreaching itself and breaching its own limits in their *Dialectic of
 Enlightenment*. The quote on the 'spiritual strength of the West' comes
 from Heidegger's 1933 Rector's address, quoted in Arnold I. Davidson,
 'Symposium on Heidegger and Nazism', *Critical Inquiry* 15, Winter
 1989, p. 412.
25 Edward Said, 'Representing the Colonized, Anthropology's Inter-
 locutors', *Critical Inquiry* 15, Winter 1989, p. 217.
26 The idea of the milieu and its subsequent syntax comes from Bhiku
 Parekh's 'Britain and the Social Logic of Pluralism', quoted in Alan
 Durant, 'From the Rushdie Controversy to Social Pluralism', *New
 Formations* 12, Winter 1990, p. 149.
27 Edward Said, 'Representing the Colonized, Anthropology's Inter-
 locutors', *Critical Inquiry* 15, Winter 1989, p. 224.
28 Benedict Anderson, *Imagined Communities*, London, Verso, 1983.
29 See Andrew Benjamin's useful discussion on 'origins', 'tradition' and
 differential ontology in *Art, Mimesis and the Avant-Garde*, London &
 New York, Routledge, 1991, pp. 8–13.
30 Edward Said, 'Yeats and Decolonization', in D. Walden (ed.), *Literature
 in the Modern World*, Oxford, Oxford University Press, 1990, p. 38.
31 Johannes Fabian, *Time and the Other*, New York, Columbia University
 Press, 1983, p. 31.
32 See Remo Guidieri, *L'Abondance des pauvres. Six aperçus critiques sur
 l'anthropologie*, Paris, Editions du Seuil, 1984.
33 Hermano Viana, 'Les identités ne sont pas éternelles', *Le Monde*, 15
 August 1991.
34 Keya Ganguly, 'Migrant identities, personal memory and the con-
 struction of selfhood', *Cultural Studies* 6 (1), January 1992, p. 38.
35 Teshome H. Gabriel, 'Thoughts on nomadic aesthetics and the Black
 Independent Cinema: traces of a journey', in Mbye B. Cham and Claire
 Andrade-Watkins, *Blackframes. Critical Perspectives on Black Indepen-
 dent Cinema*, Cambridge, Mass., & London, MIT Press, 1988.
36 The quote is from V.S. Naipaul, *India. A Million Mutinies Now*, London,
 Minerva, 1990, p. 6.

37 Gayatri Chakravorty Spivak, 'Translator's Preface', in Jacques Derrida, *Of Grammatology*, Baltimore, Johns Hopkins University Press, 1977, p. lxxv. This is to propose a more localised and limited sense of 'authenticity' and 'tradition', one that is not metaphysically guaranteed by an ethnic or ontological essentialism, but is realised under the sign of performative exigencies. See Paul Gilroy, *Promised Lands*, London, Verso, 1993.

38 Sarat Maharaj, 'The Congo is Flooding the Acropolis', Art in Britain of the Immigration', *Third Text* 15, Summer 1991, p. 85.

39 Gloria Anzaldúa, 'How to Tame a Wild Tongue', in Russell Ferguson, Martha Gever, Trinh T. Minh-ha and Cornel West (eds), *Out There, Marginalization and Contemporary Cultures*, Cambridge, Mass., MIT Press, 1990, p. 207.

40 James Clifford, 'Notes on Travel and Theory', *Inscriptions* 5, 1989, p. 179.

41 Roland Robertson, 'Social Theory, Cultural Relativity and the Problem of Globality', in Anthony D. King (ed.), *Culture, Globalization and the World-System*, Binghamton, State University of New York, 1991, p. 74.

42 For example, in Italy, where certain identities are being re-affirmed by rapping in local dialects.

43 Geeta Kapur, 'The Centre–Periphery Model or How are we Placed? Contemporary Cultural Practice in India', *Third Text* 16/17, Autumn/Winter 1991, p. 10.

44 In jazz explicitly self-conscious experiments with the sonorities of other musical worlds, particularly of African inspiration, go back to the 1960s and to the catalytic moment of jazz in black nationalism in the United States in that decade. See Frank Kofsky, *Black Nationalism and the Revolution in Music*, New York, Pathfinder Press, 1970, and P. Carles and J.-L. Comolli, *Free Jazz/Black Power*, Paris, 1971.

45 Rabih Abou-Khalid, *Al-Jadida*, Enja Records, 1991.

46 Elizabeth Grosz, 'Judaism and Exile. The Ethics of Otherness', *New Formations* 12, Winter 1990, p. 78.

47 Peter Wollen, 'Tourism, Language and Art', *New Formations* 12, Winter 1990, p. 43.

48 Edward Said, 'Representing the Colonized, Anthropology's Inter-locutors', *Critical Inquiry* 15, Winter 1989, p. 225.

49 Kwame Anthony Appiah, 'Is the Post- in Postmodernism the Post in Post-colonial?', *Critical Inquiry* 17, Winter 1991, p. 353.

50 Ibid., p. 354.

51 Gayatri Chakravorty Spivak, *The Post-Colonial Critic*, London & New York, Routledge, 1990, p. 66.

52 The idea of tradition as 'an element of freedom' comes from Hans-Georg Gadamer, *Truth and Method*, New York, Crossroad, 1984, p. 250.

53 Dave Morley and Kevin Robins, 'No Place like Heimat, Images of Homeland in European Culture', *New Formations* 12, Winter 1990, p. 20.

54 Richard Kearney, quoted in Morley and Robins, ibid., p. 20.

55 Line Grenier, 'From "Diversity" to "Difference"', *New Formations* 9, Winter 1989.

56 On the 'politics of transfigurations', see Paul Gilroy, 'It Ain't Where You're From, It's Where You're At . . . The Dialectics of Diasporic Identification', *Third Text* 13, Winter 1990/1; for 'atonal ensembles', see Edward Said, 'Figures, Configurations, Transfigurations', *Race & Class* 32 (1), 1990.

57 Peter Wollen, 'Tourism, Language and Art', *New Formations* 12, Winter 1990, p. 57.

58 Simon Frith, *Music for Pleasure*, Cambridge, Polity Press, 1988.

59 Emmanuel Lévinas, *Totality and Infinity*, Pittsburgh, Duquesne University Press, 1969.

60 On the simultaneous recovery and oblivion of 'peripheral' histories, see Bill Schwarz's powerful account, 'Exorcizing the General', *New Formations* 14, Summer 1991.

61 Henry Louis Gates Jr, *Figures in Black*, New York & Oxford, Oxford University Press, 1989, p. 238.

62 Mary Louise Pratt, *Imperial Eyes. Travel Writing and Transculturation*, London & New York, Routledge, 1992, p. 2.

63 See David Dabydeen, 'Back to Black', in *New Statesman & Society*, 5 January 1990, pp. 31–3.

64 Peter Wollen, 'Tourism, Language and Art', *New Formations* 12, Winter 1990, p. 59.

65 Homi K. Bhabha, 'The Third Space. Interview with Homi Bhabha', in Jonathan Rutherford (ed.), *Identity. Community, Culture, Difference*, London, Lawrence & Wishart, 1990, p. 210.

66 Gregory Bateson, 'Pidgin English and Cross-cultural Communication', 1944, quoted in David Tomas, 'From Gesture to Activity, Dislocating the Anthropological Scriptorium', *Cultural Studies* 6 (1), January 1992, p. 19.

67 Keya Ganguly, 'Migrant Identities, Personal Memory and the Construction of Selfhood', *Cultural Studies* 6 (1), January 1992, p. 27.

68 Paul Gilroy, 'The End of Antiracism', in James Donald and Ali Rattansi (eds), *'Race', Culture and Difference*, London, Sage, 1992, p. 50. See also Paul Gilroy, *There Ain't No Black in the Union Jack*, London, Hutchinson, 1987.

69 Mona Seghal, 'Indian Video Films and Asian-British Identities', *Cultural Studies from Birmingham* 1, 1991, p. 84.

70 Gurinder Chadha, *I'm British But . . .*, London, British Film Institute, 1988.

6

CITIES WITHOUT MAPS

To arrive at the 'purity' of the gaze is not difficult, it is impossible.

Walter Benjamin[1]

The city, the contemporary metropolis, is for many the chosen metaphor for the experience of the modern world. In its everyday details, its mixed histories, languages and cultures, its elaborate evidence of global tendencies and local distinctions, the figure of the city, as both a real and an imaginary place, apparently provides a ready map for reading, interpretation and comprehension. Yet the very idea of a map, with its implicit dependence upon the survey of a stable terrain, fixed referents and measurement, seems to contradict the palpable flux and fluidity of metropolitan life and cosmopolitan movement. You often need a map to get around a city, its subway system, its streets. Maps are full of references and indications, but they are not peopled. They project the changing disposition of space through historical time in a mixed geometry of political, economic and cultural powers: centre, periphery, suburbia, industrial zone, residential area, public housing, commercial district, railway station, motorway exits, airport. With a map in our hands we can begin to grasp an outline, a shape, some sort of location. But that preliminary orientation hardly exhausts the reality in which we find ourselves. For the city's denuded streets, buildings, bridges, monuments, squares and roads are also the contested sites of historical memory and provide the contexts, cultures, stories, languages, experiences, desires and hopes that course through the urban body. The fluctuating contexts of languages and desires pierce the logic of cartography and spill over the borders of its tabular, taxonomic, space.

Beyond the edges of the map we enter the localities of the vibrant,

everyday world and the disturbance of complexity. Here we find ourselves in the gendered city, the city of ethnicities, the territories of different social groups, shifting centres and peripheries – the city that is a fixed object of design (architecture, commerce, urban planning, state administration) and yet simultaneously plastic and mutable: the site of transitory events, movements, memories. This is therefore also a significant space for analysis, critical thought and understanding. I want therefore to reflect for a moment on this space and the opportunity it provides us in reconsidering the scope and sense of cultural analysis today.

The idea of both lived and intellectual complexity, of Edgar Morin's 'la pensée complexe', finds us continually circulating around a changing social ecology of being and knowledge. Here both thought and everyday activities move in the realm of uncertainty. Linear argument and certainty break down as we find ourselves orbiting in a perpetual paradox around the wheel of being: we bestow sense, and yet we can never be certain in our proclamations.[2] The idea of cultural complexity, most sharply on display in the arabesque patterns of the modern metropolis – and that includes Lagos as well as London, Beijing and Buenos Aires – weakens earlier schemata and paradigms, destabilises and decentres previous theories and sociologies. Here the narrow arrow of progressive time is displaced by the open spiral of heterogeneous collaborations and contaminations, and what Edward Said has recently referred to as 'atonal ensembles'.[3] It is a reality that is multiform, heterotopic, diasporic. The city suggests an implosive disorder, sometimes liberating, often bewildering, that results in an interpolation in which the imagination carries you in every direction, even towards the previously unthought.[4] Here, in the dissonance and interrogation that lies between what Donna Haraway calls 'situated' and 'disembodied knowledges', the very location of theory is disturbed.[5]

'JE SUIS UN BEUR!'

If initially the world market sterilises local sources, in a second moment it revitalises them.

Edgar Morin[6]

Barbès is the traditional Arab immigrant quarter of Paris, the home of the sounds of Algerian raï, of Cheb Khaled. Here was born the statement 'Je suis un beur!', where *beur* is not the exact inversion,

but rather a deliberate mixing up, of the word *arabe*. The *beurs* are French born of Arab parents. *Beur* signifies a difference, a particular history and context, a sign of creolisation and cultural ambiguity.

There is also rap. BAB (*Bombe à Baiser*) is a member of the Zulu nation. He raps in French over an electronic instrumentation produced by his white, Italian collaborator. There is NTM from St Denis: 'We speak in our own name.' There is the ABC Nation. Their members, aged between 17 and 20, come from the French Antilles, Cameroon and Mali. They sport wide jeans, baseball caps, basketball pumps, rectangular hair cuts: the 'Zulu look'. On the northern periphery of Paris, in areas such as St Denis, Aubervilliers, La Courneuve, all last stops on the Métro, is 'Zululand'.[7] It is here, in the *banlieues populaires*, the 'popular suburbs', on the edges of the city, that sounds and stories from West Africa, from the Antilles, from the Maghreb, are mixed up and mixed down in reggae, raï and rap. The references are to Dr Martin Luther King, rebel chants against Babylon and the police, in praise of Malcolm X ('prophet of rage'). The raps are in French, with occasional phrases in English, and much in a subcultural slang. It is part of a *mélange* that stretches from the Bronx to Brixton, to Barbès, to Brazzaville. Composed of connective rhythms and local inflections, it proposes instances of mixing, remixing, translating and transforming a shared tonality into particular voices and situations. It helps to articulate the dissonance of the experiences of a particular time and place: to be Arab *and* French, to be black *and* Parisian.

Such examples, easily verified in parallel, but distinct, histories in London or Los Angeles, where Third Worlds rumble beneath the poverty lines in metropolitan ghettos, do not suggest any obvious integration with an existing cultural consensus or obliteration in the mainstream of modern life, but rather propose the shifting, mixing, contaminating, experimenting, revisiting and recomposing that the wider horizons and the inter- and trans-cultural networks of the city both permit and encourage. In rage, joy, pride and pain they offer continual evidence of that 'magic in which the connection of certain social facts with certain sounds creates irresistible symbols of the transformation of social reality'.[8]

TO JOURNEY WITHOUT MAPS

Ethics comes from *ethos* and Heidegger translates this Greek word not so much in the sense of 'the character that belongs to

man', but as 'lodging', 'the place where one lives', 'the open region in which man dwells'.

<div align="right">Pier Aldo Rovatti[9]</div>

To be simultaneously 'rooted and rootless'.

<div align="right">Trinh T. Minh-ha[10]</div>

The labyrinthine and contaminated quality of metropolitan life not only leads to new cultural connections, it also undermines the presumed purity of thought. If critical thought can entertain this encounter, and abandon a distanced monologue for dialogue, then it curves downwards into the more extensive regimes of the everyday world and a different register. To travel in this zone, without maps and charts, is to experience the dis-location of the intellectual subject and his – the gender is deliberate – mastery of the word/world. The illusions of identity organised around the privileged voice and stable subjectivity of the 'external' observer are swept up and broken down in a movement that no longer permits the obvious institution of self-identity between thought and reality. In this disjunctive moment, the object of the intellectual gaze – the cultures and habits of the 'natives' of local, national and global 'territories' – can no longer be confined to an obvious chart or map, and there freeze-dried as a fixed or essential component of 'knowledge'.[11]

To inhabit this world, both intellectually and ethically, individually and collectively, is, as Trinh T. Minh-ha puts it, to struggle to continue in its continuation.[12] Here we as individuals do not dominate the situation, but rather begin to lose our initial 'selves' in a passage destined to reveal further parts of the self. It opens up the possibility of 'dislodging the inertia of the "I"'.[13] It leads to the release of diverse voices, an encounter with an 'other' side, an unfolding of the self, that negates the possibility of reducing diversity to the identical, to the singular source and authority of the *cogito*. Knowledge takes a holiday from the traditional ideas of truth and knowledge as unitary and transcendental entities. It travels, takes a sabbatical. Against the virility of a self-assured, strong thought, we can propose a weaker, but more extensive, trans-valuation of thinking that is contaminated, heterotopic, contingent.[14]

While the intellectual condemnation of mass culture and the mass media is today more subdued, no longer as self-assured as 'the rhetorical violence that is unleashed in *Dialectic of Enlightenment*', it is nevertheless still quietly widespread.[15] The Italian critic Franco

Rella has recently pointed out that it is a line of argument based on principles that have yet to be demonstrated:

> the disappearance of the individual and the subject in the mass; the evil of technology. In the end the impression is not that of coming closer to the truth, but rather closer to a neurosis (or the diagnosis of a neurosis).[16]

Still, there remain many willing to berate the evils of mass culture, and to see in it merely an ideological façade masking the cynical logic of capital. Despite the often tortuous prose employed in unveiling the fetishist character of mass culture the conclusions are disarmingly simple. Their appeal is to a rigid obviousness in both moral and logical terms. It is this clarity that permitted the rapid slide of Adorno's judgement from the just dismissal of a particular mass politics (National Socialism) to the blind condemnation of a mass art (jazz). The verdict was as totalitarian as the totalitarianism it purported to denounce. Art, the mass media and the modern, urban culture of the day, so the argument runs, are all caught up in the infinity of commodity exchange. What other values they may have known are now completely overdetermined by this fact, reduced to the point of fetishist simulation in which 'false' values parade as 'real' ones. Rigorously argued, nothing, with the exception for Adorno of the dwindling possibilities of the art of the avant-garde, escapes this logic. At this point culture can no longer offer an alternative, only an idle diversion; it has been reduced to a techno logical display of human betrayal, an endless symbolisation of the extraction of surplus value. Believing itself to represent *something*, the sphere of culture actually represents nothing but the incessant variations of its own absorption in the nullifying circuits of capital.

To this we can oppose some countervailing observations. Technology is the web in which we are embedded, argues Heidegger. It is where we meet with all the ambiguities of being en-framed by its languages and techniques, and where the truth of our condition is revealed in the simultaneous presence of its danger and saving power.[17] The technical reproduction that is inherent in modern mass culture involves a shattering of tradition and the secularisation of the image. This, in turn, as Benjamin goes on to elaborate, leads to a distracted reception in which we all in different ways become 'experts'. We all learn to move around inside the languages of the mass media, whether sitting at our desks denouncing them on our word processors or, later in the evening, zapping through the TV

channels. This at least introduces us to the possibility of a 'metropolitan æsthetics', to a latent democratisation of the use of contemporary sounds, signs and images, and to the space for an unsuspected politics of everyday life.[18]

Opposed to the abstractions of an ideological critique of mass culture – invariably presented as a homogeneous totality, without contradictions or room for subtle, subaltern or alternative voices – are the details and differences that are historically revealed in how people go about using and inhabiting this culture, invariably domesticating and directing it in ways unforeseen by the producers of the 'culture industry'.

The critical monologue that drones on castigating contemporary culture as if it were a unique, ideological bloc subject to the rule of an unmediated, wholly rational, economic mechanism (Fredric Jameson's 'logic of late capitalism', David Harvey's 'condition of postmodernity'), is concerned with the philosophical fate of mankind (*sic*) and the alienation of MAN in the abstract.[19] It has little to say about how real women and men get by and make sense of the conditions in which they find themselves. It cannot speak to the lives, fears, hopes, passions and expressions revealed in the immediate culture of the everyday world. But what if contradictions lie not between capital and an imagined alternative or utopia, but in the very conditions of capitalist society? This is what Marx seems to be saying when he insists that the new society will emerge out of the old, as internal contradictions lead to new developments, new possibilities and a widened intercourse between those caught up in the social relations of modern capitalism.[20] To adopt this argument is to propose a stepping away from the historical sense of intellectual mission intent on maintaining a clear distinction between culture and industry, art and commerce. For it is a perspective that insists on the awareness that industry, commerce and urbanisation are not extraneous, but rather integral, to the production of contemporary cultures, identities, possibilities, lives.

This debate runs throughout the whole course of what we might call modernity. This is a central and often contradictory theme in Marshall Berman's influential book, *All That Is Solid Melts Into Air*. It was inaugurated by Romanticism around 1800, with its opposition to the mechanical body of industry (Dr Frankenstein's monster), but Romanticism itself also drew upon the separation, elaborated by Kant in the 1780s, between the rational and the æsthetic realms. This distinction rationally legitimated, and philosophically endorsed, the

treatment of the sphere of culture as an independent and autonomous reality: the source of eternal values, untouched by immediate history and the dirty hands of industry, commerce and the city.

From this influential history we inherit a fundamentally transcendental view of art and culture as an atemporal, metaphysical reality, set apart from the more pressing relations and concerns of the everyday world. Whereas the argument that spills out of this rationalist containment, and floods up from below as it were, suggests an opposed, secular, more open and complex outlook. It begins with the details and different histories of popular cultures, subaltern worlds, displaced realities, and the changes induced in culture as a whole by industrialisation, urbanisation, capitalism and globalisation. Here culture, its presumed values and æsthetics, cannot be conceived as a timeless entity. As sound, brush stroke, word, image, it is caught up in the times and the restless activities of the world. Here there are no eternal values, no pure states: everything is destined to emerge, develop and die within this movement.

What we are now called upon to confront is the emergence of differences under the sign of 'homelessness'; that is, of subjects, languages, histories, acts, texts, events . . . values that are forced to find their home in a world without guarantees. There emerges from here a radical shift in our understanding and interpretation of the languages of art, politics, culture and identity. These can no longer be associated with a stable epistemological point of view depending upon the presumptions of a transcendental, unique and homogeneous truth that ensures critical 'distance'. In its place there is the evocation of the idea of ontological truth that is inscribed in our being, in the continual becoming and mutation of our being in the languages in which we are formed. In this manner, for instance, the critique of consumerism comes necessarily to be based on consumerism itself, on the rules of the game and its languages of identity. In the same manner, the critique of technology is expressed through the deployment of technology: from writing with this computer to the hi-tech landscapes of Wim Wenders's film *Until the End of the World* (1990). Denied perennial positions or eternal truths, we find ourselves in shifting constellations of meaning that orbit around potential openings, interruptions, intervals – both break-downs and break-throughs – in the world, languages, histories and identities we have inherited, as we come to explore the tense truth of ambiguity.

Such an enframing of our lives suggests analyses attentive to the

nuanced differences of languages and narratives that combine in writing out, simultaneously explaining and excluding, our lives. Here the commonplace, and apparently homogeneous, material of popular tastes and cultures, for example, can reveal more complex stories and ways of making sense than often credited. As a minimum it involves, as Michel de Certeau insisted, listening to frequently overlooked activities that are hidden away in the label of the mundane, the banal, the quotidian: in other words, in the colloquial differentiation of the popular. For here we meet with activities that, while drawing upon the vocabularies of established lexicons and languages – cinema, television, music, the supermarket, the newspaper – and always remaining subject to those languages, nevertheless establish trajectories of interests and desires that are neither necessarily determined nor captured by the system in which they develop. It is this remaking, this transmutation, where translation always involves a travesty of any 'original' intent, that makes the experience of such languages and texts – the city, cinema, music: contemporary culture and the modern world – habitable; as though they offered a historical space borrowed by a transient, an immigrant, a nomad.

> The 'making' in question is a production, a *poiēsis* – but a hidden one, because it is scattered over areas defined and occupied by systems of 'production' (television, urban development, commerce, etc.), and because the steadily increasing expansion of these systems no longer leaves 'consumers' any *place* in which they can indicate what they *make* or *do* with the products of these systems. To a rationalized, expansionist and at the same time centralized, clamorous and spectacular production corresponds *another* production, called 'consumption'. The latter is devious, it is dispersed, but it insinuates itself everywhere, silently and almost invisibly, because it does not manifest itself through its own products, but rather through its *ways of using* the products imposed by a dominant economic order.[21]

> And since one does not 'leave' this language, since one cannot find another place from which to interpret it, since there are therefore no separate groups of false interpretations and true interpretations, but only illusory interpretations, since in short there is no *way out*, the fact remains that we are *foreigners* on the inside – *but there is no outside*.[22]

In such unobserved historical passages and details, and their transitive constructions of home, we can begin to glimpse how to cut the older ideological knot between capital and culture, and so critically get beyond both the condemnations of everyday culture as ideology and its apologetic and merely populist defence.

This is to suggest that there is no exterior 'truth' to be salvaged from the immediate world of commerce and everyday popular culture: as though somehow and somewhere beneath the surface, inside the sign, there lurks a deeper and more consistent message. The argument, central to both the Marxist and Baudrillardian critique of the sign (fetishism, simulacrum), is that surfaces and appearances are the deceptive, seductive and mystifying manifestations of an underlying reality: the alienation of the human condition. The reduction of the apparent to a concealed, hidden value – the value of 'authenticity' supposedly masked by false appearances – denies the ontological reality of signs, surfaces and everyday life. It denies that they, too, are sites of sense, of meaning. To appreciate this opening, this particular possibility, means again taking a holiday from the ideological critique that has traditionally disciplined our attention.

HOLIDAYS IN JAPAN

The idea of letting go, of taking a holiday from the languages that usually position us, of drifting free from domestic meanings, is how Roland Barthes prefaces his writings on Japan: *Empire of Signs*. He refers to that '*loss of meaning* that Zen calls a *satori*', and muses on the 'retreat of signs'. He uses his encounter with the 'Other' not to presume to explain that alterity, but rather to go beyond himself, his own language and sign culture, and thereby disturb and question the presumed stability of the symbolic order of which he is a part. Here differences remain as differences, irreducible to the same; they exist as an addition, an excess that causes 'knowledge, or the subject, to vacillate'.[23]

This idea of facing the other, of acknowledging differences, and with them the diverse inscriptions that inhabit and constitute our world, is not merely a geographical encounter typical of the metropolitan intellectual. It is also a rendezvous to be found within the internal territories of our own cultures – on the 'other' side of the city, culture and languages we inhabit.

'Japan' offers the possibility of undoing our own 'reality' and

displaces the usual position, or topology, of the subject, together with her or his voice and authority. What has been taken for granted, considered 'natural', hence universal, is revealed to be local and historical.[24] This Barthesian awareness, to return to the earlier point, does not emerge from excavating beneath the surfaces of appearances so much as from putting surface to surface, sign to sign, and there in the lateral or horizontal plane registering the difference. These are the differences that Barthes discovers in appearances – what he calls the 'shimmer of the signifier' – as found in the ornamental and fragmented arrangement of food, in the ceremonial bow, in the painted ideogram, in the Pachinko players, in the disregard for the Western illusion of totality in the *Bunraku* theatre, in the transitory instance of the haiku and its temporary suspension of finality (what we in the West call 'meaning'): signs, as Barthes puts it in describing Tokyo, that remind us 'that the rational is merely one system among others'.[25]

So, for Barthes, the plenitude of haiku, of these minimal expressions of the event, does not pertain to meaning but to language. These gestures of writing provide a space of pure fragments in which it is language itself that is celebrated in an 'exemption from meaning'. Or rather, its presence dissipates the Western desire for fullness and semantic arrest, for what is 'abolished is not meaning but any trace of finality'. There remains just a trace, a designation of words, where meaning is 'only a flash, a slash of light'. Without a centre or direction to grasp, there is just 'a repetition without origin, an event without cause, a memory without person, a language without moorings'.[26]

Signs and language can be set free from immediate referents. This is what Barthes's particular 'Japan' permitted him to contemplate. This does not mean that we are necessarily condemned to joining Baudrillard and the cultural pessimists in announcing the end of meaning. What Barthes's text opens up is the opposite of a resigned nihilism: it proposes an excess of sense.[27] We become aware that signs can be cast loose from their moorings in one system of thought, language, culture and history and acquire other, sometimes unrecognisable, perhaps incomprehensible, ones elsewhere. Such a semiotic movement, of setting sign to sign, and appearance to appearance, on the surfaces of language and culture, does not avoid the question of significance, but rather supplements, extends and complicates it.

THE RUIN

We could contrast this perspective with a project that is clearly intent on an opposed trajectory. Determined to break through contemporary appearances and the arc of modernity, it results in analyses, certain in their description, that are prematurely foreclosed in an insistence on seeking an ultimate finality, an anchorage and shelter, in the realm of 'authentic' being and its traditions.

To begin with some of the key words and concepts Marshall Berman employs in *All That Is Solid Melts Into Air*, we might run them against the grain of his own account and consider what further sense emerges.

> . . . the modern public expands, it shatters into a multitude of fragments, speaking incommensurable private languages: the idea of modernity, conceived in numerous fragmentary ways, loses much of its vividness, resonance and depth, and loses its capacity to organize and give meaning to people's lives. As a result of all this, we find ourselves today in the midst of a modern age that has lost touch with the roots of its own modernity.[28]

Berman's declared desire is to 'chart traditions to understand the ways in which they can nourish and enrich our own modernity'.[29] But what if modernity, as he himself elsewhere acknowledges, is not about continuity but discontinuity? What if there is no uninterrupted inheritance that reaches into the present from the past, but instead bits and pieces that exist in our present not as traces, as residues, of a unique tradition, but as elements of different histories that are continually being recomposed? What if history 'is present in reality in the form of the ruin', as 'irresistible decay'?[30] What, in other words, if there has occurred a cultural and semantic shift in the very understanding of 'tradition' with the result that any obvious identi-fication with a unitary sense of belonging has been dispersed and cast loose? To pass from faith in an imagined 'community' to the recognition of complex identities forged in discontinuous, hetero-geneous histories is to pass into a contingent world. Here traditions and roots become less important for themselves, as though stable tokens of a vanished 'authenticity', and acquire significance as part of a flexible and composite inheritance that is drawn upon, rewritten and modified in assembling an effective passage through the present. This is to propose a sense of 'authenticity' that emerges and becomes

in the contingent paths of memories and histories, in the re-member-ing in a language capable of providing a mobile home of identity able to dialogue with the constellations of contemporary life and there seek redemption.

Berman wants to put modernity back on the right tracks. But, if the Faustian double-bind, that is, the drive towards 'progress' and 'modernisation' at whatever price, is integral to modernity, why is he so reluctant to put those terms, and the very idea of 'modernity' itself, in question? He leaves us with the impression that modernity was once a noble project that has now degenerated, and that to salvage it we need to get back to its sources, to its wellsprings. My suggestion is that we cannot go back: that genesis exists today only as traces in memory, elements that we can choose to reconstruct through historical and textual analysis, stories and accounts that we encounter, interpret, hence position, inscribe and locate, in our present. We can never return to the primary scene of our beginnings and their pristine 'origins'.

The actors assembled by Berman in his epic account – the writer, the people, the crowd – are all abstract units, unified (pre-Freudian) subjects. It is as though they were merely the (by)products of modernity, modernisation and the capitalist mode of production, and not also its producers. The only producers that Berman's chronicle permits are those writers, thinkers, artists and architects capable of riding the storm of capitalist development. In a decidedly classical view of artistic expression and 'genius', attention is continually drawn to the voice, invariably male, that manages to rise above the maelstrom and cast it into the canon of significant expression.

Finally, there is the tragedy of modernity. For Berman this is played out on the world stage in the internal contradictions of progress, modernisation and capitalism. Agreed, it is indeed a global process. All I would suggest is that when we look further into the particular histories that constitute modernity we will discover that the raging sickness of the times sets problems and proposals that permit us to move beyond the nostalgic appeal for a lost unity, coherence and unified sense of tradition. We are confronted with a vista composed of heterogeneous subjectivity, occupied by histories and languages intent on transforming the fragmented inheritance of the past, together with other more immediate borrowings and suggestions, into a meaningful present. It is these particular histories that offer us the chance to further consider the contemporary sense of the city, its languages, cultures and possibilities. This means to put

aside the intellectual comfort afforded by the abstract clarity of 'logic' and 'dialectics', and to take a walk in the city. It is there, paying attention to its multiple voices, its ethnographic details, diverse stories and not always commensurable realities, that we are drawn beyond ourselves and the critical world we once inhabited.

The city I propose to walk in is Naples: arguably an atypical metropolis, but then what city is not specific, unique?

UNDER VESUVIUS

The city lived under Vesuvius, and its existence was therefore constantly threatened. As a consequence it participated in the diffusion of the technical and economic development of Europe in piecemeal fashion, because it was impossible to know whether the year would not be interrupted by a catastrophe.

Alfred Sohn-Rethel[31]

Now it occurred to me that perhaps this was what happened when cities died. They didn't die with a bang; they didn't die only when they were abandoned. Perhaps they died like this: when everybody was suffering, when transport was so hard that working people gave up jobs they needed because they feared the suffering of the travel; when no one had clean water or air; and no one could go walking. Perhaps cities died when they lost the amenities that cities provided, the visual excitement, the heightened sense of human possibility, and became simply places where there were too many people, and people suffered.

V.S. Naipaul[32]

Naples is a piecemeal city attached to the edge of southern Europe. It has often provided a favourite site for examining the loose ends of European society, where civil society and the state apparently wither away. For it is here that the urban web tends to come undone and expose a living museum of archaic fragments, customs and practices. Yesterday, its ruined landscapes were the source of the Romantic sublime (Goethe), or later of a disenchanted capitalism (Benjamin). Today, it attracts the gaze of anthropologists as they retreat from previous peripheries to considering Europe's own internal frontiers and the peculiar rituals of its own native populations. Yet Naples is not merely the laboratory of the archaic, or a zoo of arrested urban development. Its crumbling historical core toasting in

Plate 1 'The volcano is essential, the city an accessory.'
Pedro Antonio de Alarcón (1861)

Plate 2 'Naples is a city that has the structure of a novel. The streets are full of stories that call out to be transcribed. But Naples can only be a Baroque and Surrealist novel, always unfinished, unresolved, contradictory, in which the apotheosis of Catholicism and blasphemy coexist.'

Tahar Ben Jelloun, *Il Mattino* (1989)

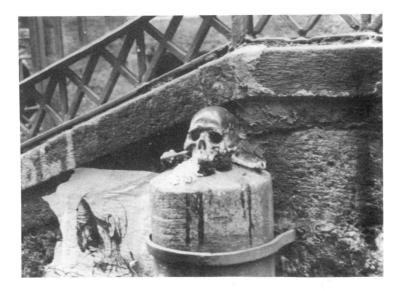

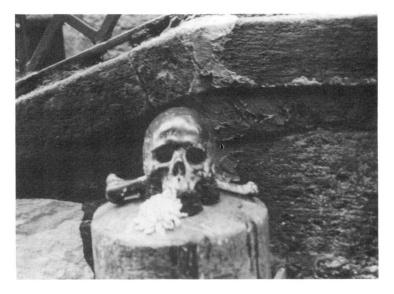

Plates 3 & 4 On a Neapolitan street fragments of Walter Benjamin's *Traerspiel*. The precarious Baroque allegory of mourning and melancholy resonates with the lament for the simultaneously contingent and incommensurable, the oxymoron of the mortal and the infinite, that puts 'progress' in question.

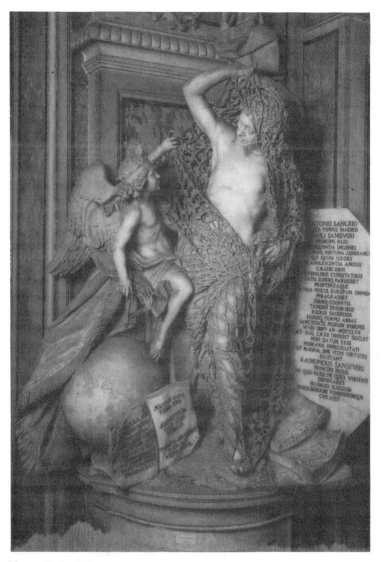

Plates 5 & 6 Cappella Sansevero, Naples: *Disenchantment* (Francesco Queirolo, 1752) and *Macchina Anatomica* (1765). In this apparently demonic display of the Baroque *episteme* there is an excess that returns to confirm the common measure of the world: 'No meaning exterior or anterior to the sign; no implicit presence of a previous discourse that must be reconstituted in order to reveal the autochthonous meaning of things.'
Michel Foucault, *The Order of Things*

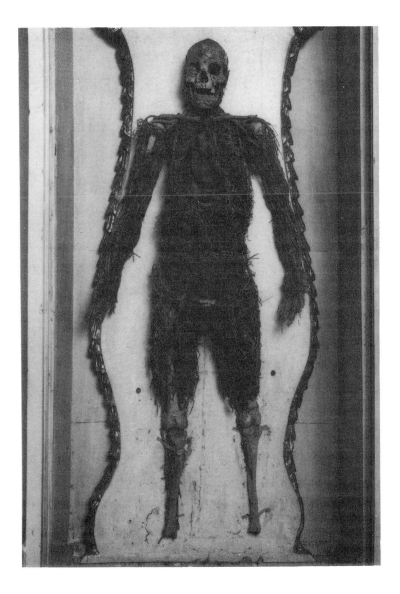

Plate 7 The corporeal city: survival in the visceral and permeable economy of effluence and excess.

Plate 8 The planned city, the rational city: the rigid logic of empty, homogeneous time.

Plate 9 The Islamic butcher: another city, a further transformation of urban space into a cultural place, history and identity.

the sun has also been abruptly interrupted by the modern skyline punctuation of a Japanese-conceived commercial and administrative centre. With its violent mixture of antiquated street rites and global design capital, Naples confronts us as an enigma. Its sphinx-like qualities, reflecting back to us what we hope, and fear, to see, reveal an unstable hubris dissected by different cultures and historical rhythms. A precarious water supply, an erratic public transport system, seventeenth-century streets and sewers blocked with the traffic of twentieth-century pollution are coupled with a fanatical private cleanliness oblivious to public filth. Although managed by capital the city seems frequently to be out of control. Only an exasperated individualism, everyone free to invent his or her own highway code, manages to leave its mark. The rational organisation of urban space, of production, labour and profit, is constantly interrupted, decomposed and deviated by innumerable pockets of mercantilism, barter, corruption and crime: the corner deal concluded on the cellular phone, black market couriers on their Vespas, the buying and selling of favours, the institutionalised bribe. This is the tangled undergrowth of another city and of a cultural formation that loses its strands in the labyrinth of kinship, street culture, local identities, popular memory and urban folklore.

To be open to this dimension, to the collective narration of identities and exchange of memories that pass under the name of 'Napoli', is clearly to abandon the possibility of conducting all these strands into a single conduit, a unique narrative able to explain such details. Of course, we can employ terms like 'uneven development' and refer to the local, national and international concatenations of mixed temporalities, of structural inequalities and the peculiarities of historical and political formations, but the particular syntax of these conditions, their 'Neapolitan' mix, can only find inconclusive explanations in these categories.

Like many Mediterranean cities, Naples refers to itself and its local hinterland long before the nation state appears in its sense of identity.[33] Even the Nativity scene becomes a Neapolitan scene: *il presepe*. The papier mâché models and ceramic figures of biblical Bethlehem are invariably populated with local markets, piazzas and pizzas. Two myths are fused into a miniaturised language of representation in which the religious and the secular, the past and the present, the distant and the immediate, the dead and the living, share the same world.[34] Once a capital city, Naples is now without a kingdom. Seemingly robbed of its destiny, its trajectory has stopped

short. As a defunct centre, as a corpse, it is perpetually ready to 'enter into the homeland of allegory'.[35] The visceral gestures of self-referentiality, and the *presepe* and its local literature are only the most documented exposure of this everyday practice, continue to propose all the pathos of that loss. This is to suggest that there is no overall project or unifying design able to encompass the Neapolitan experience. It is a story that can only be caught in fragments, in the economy of disorder, in the mythical half-light of an imagined decadence.

Seen under this aspect the city is not experienced merely as a physical reality, the sum of its collective histories, memories and monuments, but more in the instance of what the Situationists referred to as psychogeography: the practice of drifting that leads to rewriting the urban text in terms of a desire that snares the unexpected, the incalculable, the situation. The value of Naples, both socially and æsthetically (and are they really divisible?), may lie not in its pretended uniqueness but in its capacity for dispersal, for losing itself and thereby escaping the predictable. Here the city does not stand for a unique, rational, firm referent, but slips through predictable schemata to become a floating signifier, drifting through a hundred interpretations, a thousand stories. It exists beyond the rude physicality of its streets in the interior architecture that provides the scaffolding of the imaginary. Still, this imaginary place, like all dream material, has a language that calls for a mode of interpretation.

Alfred Sohn-Rethel's linking of the city of Naples to the idea of catastrophe, to imminent destruction and decay, draws us into the language of the ruin, the language of the baroque. This is how Walter Benjamin, who wrote much of his book on baroque theatre in 1925 while staying on Capri and frequently visiting Naples, comments on the centrality of the ruin in the figural economy of the baroque:

> In the ruin history has physically merged into the setting. And in this guise history does not assume the form of the process of an eternal life so much as that of irresistible decay. Allegory thereby declares itself to be beyond beauty. Allegories are, in the realm of thoughts, what ruins are in the realm of things. This explains the baroque cult of the ruin.[36]

It is in the allegorical style of the baroque, in its insistence on ruin and decay, in the shrivelling up of history and life, that the 'maximum energy emerges due to it being a corpse'.[37]

To live under the volcano, daily reminded of one's mortality: is

that the key to the city's schizophrenic energy, its languages of exultation and despair, its extremes of physical violence and mental resignation? In Naples you are constantly aware of not simply living an urban experience, but also of living urban life as a problem, as an interrogation, as a provocation. This strangely echoes the American architect Frank Lloyd Wright's description of the city as 'the form universal of anxiety'.[38] It is a fact that Naples continually talks to itself, offering us the scene of endless analysis. Constructing and reassuring itself in words, the city itself is continually displaced in laments for the past and fantasies for the future, while the present passes unattended, abandoned. Self-absorbed, as though blocked in what Lacan calls the mirror stage – the glance of Narcissus that avoids the void, the abyss (Vesuvius?), the other that might challenge and decentre its uniqueness, its identity – Naples, witnessed from elsewhere, also becomes the dream-site of an imaginary city.[39] For this city, despite all its specific details and insular claims on experience, cannot avoid acquiring a part in other stories, other idioms, other possibilities. It is ineluctably transformed from being a self-referring monument to becoming an intersection, a moment of rendezvous, a site of transit, in a wider network. Set loose from its moorings, the city begins to drift, to enter other accounts. The parochial hold on reality is compromised by economic and cultural forces that are being narrated elsewhere: in a global economy that is simultaneously signalled in the world stock exchanges and the world drug market. Inhabiting the baroque motif of the ruin, posed on the edge of Europe, on the threshold of disaster and decay, Naples perhaps becomes emblematic of the city in crisis, of the city as crisis. The self-conscious pathos of its language, its style, betrays the multiple histories and memories that swell up – 'as the rupture and revenge of signification' – into a profoundly metropolitan interrogation of the enigma of what Heidegger called the nebulous quality of life.[40]

FROM THE STREET TO THE GLOBE

The question is whether the real development of London or Manchester can be understood without reference to India, Africa, and Latin America any more than can the development of Kingston (Jamaica) or Bombay be understood without reference to the former.

Anthony D. King[41]

107

There is now a world culture, but we had better make sure that we understand what this means. It is marked by an organisation of diversity rather than by a replication of uniformity. No total homogenisation of systems of meaning and expression has occurred, nor does it appear likely that there will be one any time soon. But the world has become one network of social relationships, and between its different regions there is a flow of meanings as well as of people and goods.

Ulf Hannerz[42]

The details, these psychogeographic and allegorical particularities of Neapolitan life, also represent a local twist in a far vaster tale. The formation of a city like Naples is not inseparable from its historical place in a Mediterranean, a European and, ultimately, a global economy. The clearest symbol of such 'globalisation' today is the increasing immigrant labour force that lives in the city and hinterland. In Naples the vast majority of immigrant domestic female labour employed comes from Cabo Verde, Somalia and the Philippines, while immigrant male labour employed in agriculture and street vending largely comes from West Africa. To hear Arabic in the buses, observe the turbans, veils and the vivid patterns of the cotton dresses of the women from Somalia at the post office sending money home, is to recognise an urban future destined to transform local co-ordinates.

The earlier linkage of the emergence of the modern city to European expansionism and colonialism, both at the 'centre' and in the 'periphery', has today been redistributed along the spatio–temporal–information axes of a world economy.[43] A direct spatial exercise of powers – from the metropolitan centre towards the colonial periphery – is increasingly being realigned amongst a proliferation of centres, nodal points and communication networks that are co-ordinated by the inter-connected imperatives of finance, production, markets, property, leisure and life styles. The national, unilateral colonial model has been interrupted by the emergence of a transversal world that occupies a 'third space' (Bateson, Bhabha), a 'third culture' (Featherstone), beyond the confines of the nation state.[44]

There have always been inseparable connections between the world's cities. The political, cultural and economic development of an urban, economic and architectural reality such as London, New York, Madrid or Naples, on the one hand, and Singapore, New Delhi,

Lima or Adelaide, on the other, cannot be understood apart from each other, or in isolation from a tendentially global economy and its cultural networks and agendas. In the landscapes of contemporary urban geography it is increasingly difficult to ignore once hidden populations, often distanced by the international division of labour, whose forgotten labour sustains the wardrobes, diets and life styles of most modern metropolises.[45] Simultaneously, at the centre semi-clandestine labour markets, employing the hands, bodies and brains of the ex-colonised, provide services for baby-sitting, house-keeping, prostitution, street vending, sweat shops and seasonal rural labour.[46] Here, at least, the living evidence of repressed histories and dead empires is not so easily consigned to oblivion: the 'natives' have come home to haunt their 'origins'. Previously identified and subjected by metropolitan power they now bring elements of the 'Third World' – the absence of health care, welfare, housing, education and employment – back to the centre. Here they share the same time, increasingly the same streets, buses and shops, as those of other members of the metropolis. These are the 16 million 'non-European people' who currently live and work in Europe.[47]

Urban life is being transformed under the impact of a global formation. If we are to talk of globalism, it is a globalism which refers not only to the powers and movement of capital and the international division of labour, but also to social and cultural forces, institutions, relations and ideas. Individual cities and their inhabitants increasingly exist within an inter- and trans-national system of differentiated but global reference. Many may choose to mentally refuse the consequences of these processes, and racism, xenophobia and virulent nationalism are always ready to provide the languages of comprehension, but our destiny is now clearly elsewhere.

We are constantly reminded that 'social control, inequality and the constraints of social interaction in general are not simply a function of the expropriation of surplus value or economic exploitation but, perhaps more importantly, of symbolically rooted cultural practices and their reproduction'.[48] The cosmopolitan authority, language and logic of the West European and North American intellectual, techno-crat and administrator is increasingly interrogated by voices from India, Japan, Latin America, Africa. Histories, cultures, processes, texts are being read from the other side of the once presumed centre–periphery divide: from Tokyo, from Bombay, from Buenos Aires, from Lagos, from Cairo – in particular, from those cities that are setting the pattern for global urban development much more than

such older settlements as, say, Paris, London or New York.

Rethinking the economic, social and cultural production of space in a shared time – 'the world' – we are pushed into contemplating cultural, economic and political forms in new terms.[49] The co-presence of globalisation and differentiation both supplements and interrogates the limits of the nation state. We are drawn beyond ideas of nation, nationalism and national cultures, into a post-colonial set of realities, and a mode of critical thinking that is forced to rewrite the very grammar and language of modern thought in directing attention beyond the patriarchal boundaries of Eurocentric concerns and its presumptuous 'universalism'. However, this task, precisely because it does not represent the latest bulletin in the unfolding of 'progress', occurs in a paradoxical manner. For deterritorialisation produces both diasporic identities and a new fundamentalism, and here nothing is clear-cut or proceeds smoothly. Older formations stubbornly, often brutally, re-emerge and impose themselves on our differentiated but increasingly connected lives, forcing us to acknowledge murderous tendencies that insist on localised ethnicities, virulent nationalisms and religious fundamentalism, as they seek to establish rigid identities, parochial communities and traditional imperatives. It is a forcible reminder that the rational 'dialectic' has broken down. No one has a complete hold on the situation. The simple clarity of binary logic fractures into the complexities of unique intensities and blood-stained details. Returning to those deadly resolutions and crippling localisms, the questions of 'whose time?', 'whose history?' is managing, identifying and interpreting, both the local street and the global clock return to us with a dramatic urgency.

Here the dark spoils of a European, and Romantic, understanding of authenticity and national identity return in the nightmare continuities of phobia and fear to carry us spiralling down into a morass of vicious subjectivities and inhuman communities. This is the world represented by armed Serbian nationalists 'ethnically cleansing' Bosnia-Herzegovina and claiming a street in Mostar or Sarajevo as theirs, 'because it was so in 1388' (the year before Serbia was overthrown by the Turks). That such a form of belonging and home, violently brandishing its dead version of time, also expresses needs that cannot simply be expunged from current accounts is undeniable; but that they voice a particular cultural formation and mode of identity on which we feel called to express historical and ethical judgement is also equally irrefutable.

110

NO EQUATION

> ... modernity resides in its ambiguous status as a demand for external guarantees inside a culture that has erased the ontological preconditions for them.
>
> William E. Connolly[50]

> The discourse of radical democracy is no longer the discourse of the universal; the epistemological niche from which 'universal' classes and subjects spoke has been eradicated, and it has been replaced by a polyphony of voices, each of which constructs its own irreducible ... identity. This point is decisive: there is no radical and plural democracy without renouncing the discourse of the universal and its implicit assumption of a privileged point of access to 'the truth'.
>
> Ernesto Laclau and Chantal Mouffe[51]

Naturally, all this is a prelude, part of a reflection gathered from looking at the scene of contemporary cultural analyses, urban life, and the histories, prospects and lives that frame such work and experiences. I have tried to unpack some of the analytical baggage that is still being carried around in this landscape, and which frequently passes for critical 'common sense'. To query that language is hopefully already to reveal in the undoing other, more open, ways of engaging with our prospects. To move through such ruins, and to learn to live within them, is already to step through the gaps in the city into another place.

NOTES

1 Walter Benjamin, *Parigi. Capitale del XIX secolo*, Turin, Einaudi, 1986, p. 609.
2 Edgar Morin, *La Méthode. 1. La nature de la nature*, Paris, Editions du Seuil, 1977.
3 Edward Said, 'Figures, Configurations, Transfigurations', in *Race & Class* 32 (1), 1990, p. 16.
4 Giacomo Leopardi, 'Zibaldone', quoted in Franco Rella, *Asterischi*, Milan, Feltrinelli, 1989, p. 33.
5 Quoted in Lata Mani, 'Multiple Mediations. Feminist Scholarship in the Age of Multinational Reception', *Inscriptions* 5, 1989. This latter essay contains an important discussion on the shifting location and subsequent disturbance of theory.
6 Edgar Morin, '1965, We Don't Know the Song', in Edgar Morin, *Sociologie*, Paris, Fayard 1984; Italian edition, Rome, Edizioni Lavoro, 1987, p. 92.

7 For a descriptive journey into these territories, see François Maspero, *Beyond the Gates of Paris*, London, Verso, 1992.

8 Greil Marcus, *Lipstick Traces. A Secret History of the Twentieth Century*, London, Secker & Warburg, 1989, p. 2.

9 Pier Aldo Rovatti, in Alessandro Dal Lago and Pier Aldo Rovatti, *Elogio del pudore*, Milan, Feltrinelli, 1990, p. 39.

10 Trinh T. Minh-ha, 'Cotton and Iron', in Russell Ferguson, Martha Gever, Trinh T. Minh-ha and Cornel West (eds), *Out There, Marginalization and Contemporary Cultures*, Cambridge, Mass., MIT Press, 1990, p. 335.

11 James Clifford, 'Travelling Cultures', in Lawrence Grossberg, Cary Nelson and Paula Treichler (eds), *Cultural Studies*, London & New York, Routledge, 1992.

12 Trinh T. Minh-ha, *Woman, Native, Other*, Bloomington & Indianapolis, Indiana University Press, 1989, p. 49.

13 Pier Aldo Rovatti, in Alessandro Dal Lago and Pier Aldo Rovatti, *Elogio del pudore*, Milan, Feltrinelli, 1990, p. 30.

14 This is to introduce the post-Nietzschean theme of 'weak thought', most widely associated with the work of the Italian philosopher Gianni Vattimo. See Gianni Vattimo, *The End of Modernity*, Oxford, Polity Press, 1988. For a further exploration of this trope in the context of cultural analyses, see Iain Chambers, *Border Dialogues. Journeys in Postmodernity*, London & New York, Routledge, 1990.

15 The quote is from Jamie Owen Daniel's 'Temporary Shelter. Adorno's Exile and the Language of Home', *New Formations* 17, Summer 1992, p. 33.

16 Franco Rella, *Asterischi*, Milan, Feltrinelli, 1989, p. 25.

17 Martin Heidegger, 'The Question Concerning Technology', in Martin Heidegger, *The Question Concerning Technology and Other Essays*, New York, Harper & Row, 1977.

18 Walter Benjamin, 'The Work of Art in the Age of Mechanical Reproduction', in Walter Benjamin, *Illuminations*, London, Collins/Fontana, 1973.

19 The 'logic of late capitalism' is, of course, a reference to Fredric Jameson's attempts to synthesise the world in a cartography of powers susceptible to political 'mapping' from a peerless point of view; see Fredric Jameson, *Postmodernism, or the Cultural Logic of Late Capitalism*, London, Verso, 1992. Also see Meaghan Morris's brilliant and incisive review of David Harvey's *The Condition of Postmodernity* (Oxford, Basil Blackwell, 1989) in Meaghan Morris, 'The Man in the Mirror: David Harvey's "Condition" of Postmodernity', *Theory, Culture & Society* 9 (1), 1992.

20 Karl Marx, *Grundrisse*, Harmondsworth, Penguin, 1973, pp. 541–2.

21 Michel de Certeau, *The Practice of Everyday Life*, Berkeley, Los Angeles & London, University of California Press, 1988, pp. xii–xiii.

22 Ibid., pp. 13–14.

23 Roland Barthes, *Empire of Signs*, New York, Hill & Wang, 1982, p. 4.

24 Ibid., p. 6.

25 Ibid., p. 33.

26 Ibid., pp. 79–83.

27 For a more extensive account of Barthes's encounter with the Orient and the aperture it opens up, see Trinh T. Minh-ha's 'The Plural Void: Barthes and Asia', in Trinh T. Minh-ha, *When the Moon Waxes Red*, London & New York, Routledge, 1991.

28 Marshal Berman, *All That Is Solid Melts Into Air*, New York, Penguin, 1988, p. 17.

29 Ibid., p. 16.

30 Walter Benjamin, *The Origin of German Tragic Drama* , London, Verso, 1990, p. 117–18.

31 Alfred Sohn-Rethel, *Napoli, la filosofia del rotto*, Naples, Alessandra Caròla Editrice, 1991, p. 21.

32 V.S. Naipaul, *India. A Million Mutinies Now*, London, Minerva, 1990, p. 347. The author is speaking of Calcutta.

33 Predrag Matvejević, *Mediteranski Brevijar*, Zagreb, 1987; I have used the Italian edition, *Mediterraneo*, Milan, Garzanti, 1991.

34 Vincenzo Esposito, 'Il mondo in una piazza: note sul presepe', at the conference 'La Piazza nella Storia', Salerno, 10 December 1992.

35 Walter Benjamin, *The Origin of German Tragic Drama*, London, Verso, 1990, p. 217.

36 Ibid., pp. 177–8.

37 Christine Buci-Glucksmann, *La Raison baroque*, Paris, Galilée, 1983, p. 71.

38 The expression comes from his pastoral-inspired diatribe against 'rented aggregations of hard cells on upended pavements overlooking hard pavements', in *The Living City*, first published in 1945 as *When Democracy Builds*: Frank Lloyd Wright, *The Living City*, New York, New American Library, 1956, pp. 20–1.

39 There exists a whole book of quotations published in both German and Italian that testifies to how Naples has been a city for others: Fabrizia Ramondino and Andreas Friedrich Müller, *Neapel «. . . Da fiel kein Traum herab . . . Da fiel mir Leben zu . . .»*, Zurich, Arche, 1988; *Dadapolis*, Turin, Einaudi, 1992.

40 The quote is from Michael Taussig, *Shamanism, Colonialism and the Wild Man. A Study in Terror and Healing*, Chicago & London, University of Chicago Press, 1991, p. 5.

41 Anthony D. King, *Urbanism, Colonialism, and the World-Economy*, London & New York, Routledge, 1991, p. 78.

42 Ulf Hannerz, 'Cosmopolitans and Locals in World Culture', in Mike Featherstone (ed.), *Global Culture. Nationalism, Globalization and Modernity*, London, Newbury Park & New Delhi, Sage, 1990, p. 237.

43 Anthony D. King, *Global Cities. Post-Imperialism and the Internationalization of London*, London & New York, Routledge, 1991.

44 See Gregory Bateson, 'Pidgin English and Cross-Cultural Communication', *Transactions of the New York Academy of Sciences* 6, 1944, Homi K. Bhabha, 'The Third Space. Interview with Homi Bhabha', in Jonathan Rutherford (ed.), *Identity. Community, Culture, Difference*, London, Lawrence & Wishart, 1990, and Mike Featherstone, 'Global Culture. An Introduction', in Mike Featherstone (ed.), *Global Culture.*

Nationalism, Globalization and Modernity, London, Newbury Park & New Delhi, Sage, 1990.

45 Eric R. Wolf, *Europe and the People without History*, Berkeley, Los Angeles & London, University of California Press, 1982.

46 'In the early 1980s, half of all the immigrants lived in the 10 largest American cities compared to only 11 per cent of the US population as a whole. In the last twenty years, 2 million Third-World migrants from South-East Asia, the Middle East, and Latin America have moved into the Los Angeles region resulting in a major change in the ethnic, economic, and social composition of the city (in 1953, Los Angeles County was 85 per cent Anglo-Saxon; in 1983, Hispanics, Blacks and Asians comprised 50 per cent of the population)': Anthony D. King, *Global Cities. Post-Imperialism and the Internationalization of London*, London & New York, Routledge, 1991, p. 28.

47 'Editorial', *Third Text* 18, Spring 1992, p. 3.

48 Robert C. Ulin, 'Critical Anthropology Twenty Years Later', *Critique of Anthropology* 11 (1), 1991, p. 80.

49 Anthony King, in Anthony D. King (ed.), *Culture, Globalization and the World-System*, Binghamton, State University of New York, 1991, p. x.

50 William E. Connolly, *Political Theory and Modernity*, Oxford, Basil Blackwell, 1989, p. 11.

51 Ernesto Laclau and Chantal Mouffe, *Hegemony and Socialist Strategy*, London, Verso 1985, pp. 191–2.

7

THE WOUND AND THE SHADOW

The point is not to stay marginal, but to participate in whatever network of marginal zones is spawned from other disciplinary centers and which, together, constitute a multiple displacement of those authorities.

Judith Butler[1]

What is tradition? A higher authority which one obeys, not because it commands what is *useful* to us, but because it *commands*.

Friedrich Nietzsche[2]

. . . it's always too late for truth, I thought.

Jean Rhys[3]

Travel, migration and movement invariably bring us up against the limits of our inheritance. We may choose to withdraw from this impact and only select a confirmation of our initial views. In this case whatever lies on the other side remains in the shadows, in obscurity. We could, however, opt to slacken control, to let ourselves go, and respond to the challenge of a world that is more extensive than the one we have been accustomed to inhabiting.

To choose the second path involves undoing the ties and directions that once held us to a particular centre. It is to disturb and interrupt our sense of place with a set of questions. A previous sense is revealed to be not necessarily common, its reason not always universal. So critical intentions against the limits of our inherited rationalism, its frequently unproblematic understanding of reality and truth, invoke a language that 'bears within itself the necessity of its own critique'.[4]

For, although historically of the West, the logic that has hegemon-

ised, disciplined and directed reason is invariably represented in the powerful myth of universal law, as though it were an integral part of a 'natural' order. It is not by chance that the challenge to the ubiquitous claims of Western thought to represent reason and 'reality' is most precisely focused on the presumed natural ground and authorial body of the subject. The world begins, and concludes, with this presumed source of individual unity and integrity: the 'I' who thinks, observes, speaks, sets down the conclusion. Such a foundation for thought *and* action, such a *ratio*, where subject and consciousness are understood to be transparent to each other, identical, is clearly pre-Freudian.

> If the unconscious means anything, in fact, it is precisely the guarantee against a return to the traditional idea that the subject is one, full, self-transparent entity, governed by the laws of rational discourse.[5]

In the certitude of the omnipotent subject, language contains no slips or elisions, no threatening slide into the intimations and mysteries of the libidinal economy of the unconscious that 'abolishes the postulate of the subject presumed to know'.[6] Here, on the contrary, all is light. Yet even the Cartesian *cogito* demands its shadow, that it be split. It calls for a binary opposite, an other that reflects its passage and confirms the path of *logos* through the world: a *logos* that returns, full of meaning, to legitimate the sovereignty of the subject. However, although it is essential to the realisation of its path and sense of being, the rational mind has ultimately to deny the alternative claims on knowledge that such alterity represents. The subject of reason is ultimately articulated through resisting the temptation to its unity represented by the eventual complication of this excess.[7] Such logocentric premises constitute what Nietzsche once scathingly referred to as the grammatical fallacy of thought: posing itself as the independent source–subject of language rather than being caught up in it, subjected to its precarious practices.[8]

When critics and commentators distinguish between postmodernism and modernism, or postmodernism and feminism, on the repeatedly cited grounds that postmodernism lacks a theory of agency, they are invariably and anxiously returning us to this prehistory of the modern *episteme*, to the 'grammatical' and conceptual stability embodied in 'the notion of unified subjects, of meaning as portable property'.[9] Such a sense of centre, and its assured distribution of meaning (and power), confidently spawns

those abstract binaries – subject/object, rational/irrational, absolute/relative, true/false, reality/appearance – that constitute the cultural bedrock of Western knowledge. If we choose to refuse this beguiling clarity, and desire to decentre that inheritance for the complex benefits of acquiring a wider frame, then we must also begin to suspend the agenda of 'agency' that previously guided and explained the *ratio* between our thought and actions.[10] We might begin to suspect that such an agenda is prisoner of an abstract logic, a metaphysical grammar, a causal narrative, that is incapable of replying to our demands.

> It is no more than a moral prejudice that truth is worth more than appearance; it is even the worst-proved assumption that exists. Let us concede at least this much: there would be no life at all if not on the basis of perspective evaluations and appearances; and if, with the virtuous enthusiasm and awkwardness exhibited by some philosophers, one wanted to abolish the 'apparent world' altogether, well, assuming you could do that – at any rate nothing would remain of your 'truth' either! Indeed what compels us to assume that there exists any essential antithesis between 'true' and 'false'? Is it not enough to suppose grades of apparentness and as it were lighter and darker shades and tones of appearances – different *valeurs*, to speak in the language of painters? Why could the world *which is of any concern to us* – not be a fiction? And he who then objects: 'but to the fiction there belongs an author?' – could he not be met with the round retort: *why*? Does this 'belongs' perhaps not also belong to the fiction? Are we not permitted to be a little ironical now about the subject as we are about the predicate and object? Ought the philosopher not to rise above the belief in grammar?[11]

Opposed to the presumed autonomy of the rational subject who exists before the event as a fundamentally abstract and ahistorical figure, there is the 'subject' that emerges in worldly processes, that is perpetually constituted in the turbulent interweaving of memory, language and history. A subject that is never transparent to itself. The subject who is cast – simultaneously thrown and formed – into this opening can no longer be considered a complete and fully realised historical agent. Without a fixed origin or destination this subject lacks even the relative stability afforded by the cumulative intersection of multiple localities (gender, ethnicity, class, sexuality . . .).

For even such composite identities, often presumed to express more local or mini-essentialisms, also experience the permanent betrayal of mutability and metamorphoses. The subject that emerges is a provisional, contingent, historical figure composed in the speech of becoming, where the performative event takes precedence over any structural grammar. It is to insist on that event, on the radical historicity of that moment of cultural speech, for it is there that we encounter not only the grammar of being but the fact that it speaks. It is in the circumstances of cultural speech that our particular formation, inheritance, memory and language are re-membered, temporarily rendered whole and authorised. It is in that time that our identities are performed, and that the only authenticity available to us is realised. Take, for example, my gender identity:

> gender is always a doing, though not a doing by a subject who might be said to pre-exist the deed. The challenge for rethinking gender categories outside of a metaphysics of substance will have to consider the relevance of Nietzsche's claim in *On the Genealogy of Morals* that 'there is no "being" behind doing, effecting, becoming, "the doer" is merely a fiction added to the deed – the deed is everything'. In an application that Nietzsche himself would not have anticipated or condoned, we might state as a corollary: There is no gender identity behind the expressions of gender; that identity is performatively constituted by the very 'expressions' that are said to be its results.[12]

Here we glimpse what Lévinas calls 'the violence of transitivity', or the surplus of being, that exceeds the formal moment of thinking the subject.[13] It allows us to insist on the precariousness of the 'subject' who always comes after the event to rationalise and enframe it.

The 'truth' of the subject emerges only in a fragmentary manner, in an interweaving of appearances, perspectives, practices and narratives. The identity of the subject – this is Paul Ricœur amplifying an argument of Hannah Arendt's – does not involve a logical identity, but is rather the 'same' that varies, modifies itself, has various faces and phases: a subject, Ricœur continues, that loses its Cartesian certainty and is only able to recognise itself when it is 'in play', in movement, in other words, when exposed to alterity. This subject does not have its foundations within itself, it can only 'believe in itself' through the testimony of its body, memory, language, other subjects and the opacity of its own consciousness.[14]

To proceed from a metaphysical sense of centre and stability is already fully to know the 'subject'. As Susan Hekman points out, it is to betray a neurotic unwillingness to rethink knowledge, truth, power and politics in a radical manner.[15] It is to insist on the power and truth of mental abstractions over lived, historical contingencies, of metaphysics over life, of thought over being. To which we can begin to reply by borrowing Michel Foucault's striking objection: is a 'progressive' politics necessarily linked to totalising themes, 'themes that guarantee to history the inexhaustible presence of the Logos, the sovereignty of a pure subject, and the profound teleology of an original destination'?[16] For the taking of refuge in the absolute of the abstract, in the 'logic of late capitalism', in the 'global history of totalities', in the agency of the *cogito*, or, to employ a further Foucauldean expression, in the 'syncopated transcendental', is to ignore the imperfect figures, untimely pressures and radical presence of the traces of alterity thrown up in specific histories, localities and subsequent identities.[17] It is to be oblivious to the insistent inter-rogation of knowledge and power that derives from such syncretic provocations, from the asymmetrical modes in which they, we, you, I, occupy and inhabit 'history'.

In the shadows along the desired path of transparent agency and rational calculus the omnivorous eye/I discerns in the decentred and deconstructed subject the further negative sub-text of 'relativism'. Like the subject it espouses, this critical identification is equally dependent on assumptions of epistemological absolutism. At this point the Nietzschean query comes to our lips: why do you desire to find an irrefutable, grounded, fixed truth; why do you want certainty rather than uncertainty; what is the value of the value of truth? Is all this to protect yourself and confirm your power?[18] Surely we have a right to question that history: a critical tradition that has commanded us for so long? Is the subject, the steadfast 'core' of thought, experience and action, capable of producing a knowledge without shadows, gaps, elisions or an unconscious, or does the subject represent a mobile en-framing constituted through mutable experi-ences and the associated transformations of languages, memories, identities and histories? The very desire for firm ground, for stability and certainty, for the essential, for the centre, is surely a phallocratic question – 'that is, it is a question that can only be posed in the metalanguage of a philosophy the aim of which is to discern the one, true answer'.[19] If there is no absolute reason, unequivocal map or exhaustive epistemology, able to explain all, then surely it is

legitimate to ask, 'Relative to what?' And as we step away and down from the homogeneity of absolute knowledge into a less bounded space, we might choose to relax and reply, 'Relative to life' – that is, related, connected and implicated in contingent complexities, relative to the economies of a particular cultural and historical formation, to a particular place.[20] There we find ourselves responsible for the safekeeping of a knowledge that in being limited, but not immobile, is always destined to be incomplete, exposed, open.

Today in the West, out of the nebulous vectors and histories of 'New Age', there emerges a legitimation of syncretism that challenges and scrambles the binary certainties that pass for knowledge and 'truth'. From fractals, ecology and chaos theory to world (and whale) music and alternative medicine (homeopathy, acupuncture, yoga and shamanism), there lies a hybrid constellation balanced between official knowledge and occult folklore, vacillating between scientific innovation and the perennial philosophy of the esoteric.[21] No doubt many details of this precarious archipelago can be confined to the brief space of an allegory, a symptom of unease with the jagged achievements of 'progress'. Yet, in its implicit critique of the representative claims of scientific and technological rationalism, such a constellation and set of practices are elements of an altogether more extensive disturbance. They represent part of a widening interrogation that also reappears in the crisis of Western anthropology, in the querying of accepted literary canons and historical protocols, and in the critical dispersal of much radical, but undeniably Eurocentric, thought. Coming out of regional chronologies and seemingly discrete crises, they all contribute to the general undoing of the privileged 'reason' of the self-centred subject.

The contemporary absorption of epistemology – the abstract protocols and paradigms of knowledge – by ontology, or better still, by onto-chrono-logy, as Heidegger would have it, involves a fundamental rewriting of knowledge within the interrogative space of being-in-time. Here we *inhabit* a *particular* space, body, language, and the strands of histories that weave them together into *this* place, as opposed to another. What passes for 'knowledge' is challenged not by the generalised category of 'being', or by simply opposing the physical insistence of the body to the ethereal abstractness of the mind, but rather by tracking the question of knowledge inside movements and moments fuelled by complexity and difference: scattered among practices and resurrected in our sense of being

caught up in time, language, history and contingency. To live in this space is to experience the waning and eventual repudiation of the traditional academic ideal of critical distance. In the ruins of neutral scientificity, timeless æsthetic judgement and metaphysical truth, we can invoke a critical involvement in which the very idea of critical distance – 'It was out of this *pathos of distance* that they assumed the right to create values, to coin the names of values' – is interrogated and analysed.[22] The question of knowledge now spills out of these spaces into areas that are not restricted to the academy, learned journal or accredited 'intellectual'.[23]

We move beyond the patriarchal ordering of the 'master narratives', as well as their inverted counter-images of subaltern resistance. Seeking to avoid the premature haven of a correct 'position', we try, instead, to establish the axis of a questioning movement. This inevitably leads to our meeting with the academic abhorrence of 'crossing borderlines', and the institutional fear disseminated by the confusion between analytical and poetic languages – as though the truth can reside only in the restricted protocols of the former rather than also in the risks and revealing gestures of the latter.[24] As a minimum this calls upon us to embark on an enquiry into the disciplinary distinctions of academic life, and much energy is invariably expended in discussing, defending and modifying protocols, paradigms and practices in the name of 'history', 'literature', 'anthropology', 'sociology', 'philosophy', and so on. The more suggestive status of this questioning, however, lies in the actual crisis of these disciplines as they struggle to preserve their identities. In the doubts, hesitancies and resistances that shadow the ambiguous edges of these fields of knowledge, we can trace a wider, interdisciplinary disturbance and momentum.

For some, this has recently become the space of 'cultural studies', an overarching term that is able to address both local disciplinary crises and their wider repercussions within a self-conscious critical language. However, even this apparent salvation – the academically dignified exit from yesterday into tomorrow – can still involve a treacherous double-bind that resurrects an unstable supplement to critical language, an extension that offers no obvious or easy consolation. For critical thought is ultimately condemned to instability and movement, to be always on the margins of ironically subverting itself. It cannot rest content within an inherited discipline, invariable paradigm or fixed set of protocols. It exists as an act of interrogation: a moment of doubt, dispersal and dissemination. It

reveals an opening, not a conclusion; it always marks the moment of departure, never a homecoming.

Criticism practised in this manner, in this style, cannot pretend disciplinary recognition. It is a voice that is destined to resonate in the spaces between received knowledge and institutional disciplines, to exist and persist as a question mark hanging in the margins of discourse: an interrogative trace in a journey which, like that of our lives, is without obvious finality. It has to establish its own mode of signification on the edges of more public and predictable languages, and there attempt to propose a sense that reaches beyond established interpretations – thereby intellectually and politically widening the sense of the possible. This is to insist on the displacing and deferring movement of critical thought. Such a critical practice, which we who move in the Anglo-American world may, for the moment, feel bound to call 'cultural studies', is simultaneously present and absent as the sceptical echo that doubles and displaces the established, authorising voice. In relation to official knowledge and its disciplinary hierarchies of access and closure, it exists in parenthesis, or, as Heidegger and Derrida propose, as a presence that exists in abeyance, under erasure: ~~cultural studies~~.[25] Perhaps 'abeyance' is ultimately the more fitting term. For it draws our attention to a sense of critical interruption that suggests an addition, an excess, rather than a subtraction.[26]

This cross also underlines the point of meeting, the crossing of different paths where lines of thought and the roads of history intersect and open up the space of an encounter, a dialogue, in which neither trajectory is reduced to the direction of the other. In his account of the ethical importance of the meeting with the other for Lévinas, Simon Critchley writes:

> The figure that Lévinas employs to explain this meeting, or dialogue, is that of the chiasmus, itself of course derived from the Greek letter χ, which denotes a crossing or interlacing. Indeed Derrida has employed the same trope to describe the double gesture of deconstructive reading. If, in any chiasmic dialogue, the two lines of thought are bound to cross in what Lévinas calls 'the heart of a chiasmus', then this should not blind one to the multiplicity of points where those lines of thought diverge. Ethical dialogue should not result in the annulment of alterity, but in respect for it.[27]

122

So cultural studies, as a conjunctural metaphor for critical encounters, can only imply a travelling voice, a disseminating criticism. As a migrant intellectual disposition, it acquires shape and pertinence in the crossings, intersections and interlacing of the lives, situations, histories, in which it dwells and becomes. Such thought and practice are neither free-floating nor timeless, but come together in that Benjaminian instance in which past and present are fused in the constellation of the now (*Jetzt*). Its language does not emerge from a single site or perspective.[28] Its voice is therefore not merely critical; it is ultimately ethical. Comprehended in this mode, 'cultural studies' is not simply a radical additive to be stirred into the different mixes of historiography, sociology, film studies or literary criticism. It is suspended between these realms. It shadows them, questioning the nature and pertinence of their languages – existing, if you like, as a wound in the body of knowledge, exposed to the infections of the world.

What does such exposure entail? We might open up this question by taking the important proposal put forward by the American feminist historian Joan Scott to pursue the question of history and gender as 'an attempt to articulate the nature of the connection between these two terms'.[29] Yet I hesitate here. For to insist on an eventual *connection,* and therefore on an initial division, is surely to privilege the binary logic that initially permitted the separating (and then the subsequent bringing together) of 'gender' and 'history' as *individual* fields of knowledge subject to study as 'epistemological phenomena'.[30] Epistemology requires that knowledge has fixed foundations. But what medium exists beyond the mediation of knowledge to guarantee this stability? The answer is none.[31] So, if Joan Scott's terminology undoubtedly draws attention to questions that are central to our historical sense of being, it is perhaps still to be doubted whether a critical opening lies necessarily at this point, entangled in such conceptual consolidations. For to question the status of epistemology, and the disciplinary spatialisation of knowledge between supposedly distinct entities such as 'gender' and 'history', is to doubt, double and displace the critical space.

Women, men, events, institutions, documents, chronologies . . . power: these are the tropes of historical writing. If the question of gender 'rewrites' history, the question of 'history' – as language, representation, discourse, knowledge, power – simultaneously rewrites the conditions for understanding gender. Neither is stable, and

neither is exempt from investment by wider interrogations. This, as Joan Scott recognises, is where the contingent dependencies and differences sustained by 'textuality' become central.[32] It recalls both Friedrich Nietzsche's and Jacques Lacan's insistence on *style*. This is the gesture that visualises and constitutes the pathos of a practice through the play of language, writing and signs that continually put in question the very foundations of the discipline it apparently practices.

To render the gesture visible is to privilege the fragment, the event, the body, the voice. It results in an inevitable dispersal of the co-ordinates of transparent identity and universal subjectivity. It proposes an altogether richer provocation and realignment than that implied in the statement that 'deconstruction' adds 'an important new dimension to the exegetical project'.[33] There lies, quite literally, a world of difference between the addition of a 'new dimension' and the radical proposal to rewrite the grammar of historical exegesis. For, as Gayatri Spivak has emphasised: '. . . textuality is not only true of the "object" of study but also true of the "subject" that studies. It effaces the neat distinction between subject and object'.[34] Such an extension to historical codification opens up a gap or interruption that promises to become vertiginous as it folds back over, threatening to dissipate, the preceding discursive space. Perhaps the cautious hesitancy of the historian betrays an intellectual reluctance to take this wider leap and consider things from the other side of the Western *ratio*, from the site of its shadow, from the place where we can begin to discern the 'other'. In the Appendixes to 'The Age of the World Picture', Martin Heidegger wrote:

> Everyday opinion sees in the shadow only the lack of light, if not light's complete denial. In truth, however, the shadow is a manifest, though impenetrable, testimony to the concealed emitting of light. In keeping with this concept of shadow, we experience the incalculable as that which, withdrawn from representation, is nevertheless manifest in whatever is, pointing to Being, which remains concealed.[35]

The historian, despite the recognition that 'consciousness is never fixed, never attained once and for all', still seeks the light, the illuminated path, evidently believing that truth lies there in a stable intellectual referent rather than in the intellectual (and worldly) turbulence that has been unleashed.[36] This leaves historiography subject to internal critique and adjustment, but safe from the wider,

more uncomfortable, questioning that might refuse or simply ignore its epistemological pretensions and their institutional authority.[37]

So, if a redressing of the figure of history leads to a less universalistic, less positivist, more modest sense of practice and knowledge, it can still refuse to raise the question, 'Why history?' Put another way, what does the historian want? Historians can refer to textuality and deconstruction but still shy away from the heart of the matter: history as an allegorical construction, as the constant return to the sense of our lives, of being. We are left, however sensitive to change and limits, working with the map of a lost world, where the discipline and directions of erudite knowledge take precedence over the complexities, confusion and contingencies of our being. This means to opt for the stability and self-assurance of the hermetic mode – subject of the institutional panopticon and the academic discourse – rather than the excesses of heteronomy and the de-situating responsibility for other places: the sites of the ambiguous, the unsaid, the silent, the repressed.[38]

For the ethics of writing history surely emerges from our perpetual dialogue with the dead. To inter-pret the past is also, as Michel de Certeau points out, to inter it: to honour and exorcise it by inscribing it in the possibilities of language and discourse.[39] To name and mark past time and recover it for the present is to produce a *tombeau*, a funeral commemoration that simultaneously celebrates life.[40] For it 'is to make a place for the dead, but also to redistribute the space of possibility, to determine negatively what must be done, and consequently to use the narrativity that buries the dead as a way of establishing a place for the living'.[41]

Historiography, Michel de Certeau suggests, emerges from the European encounter with the unknown other.[42] As a product of the Renaissance it marks the emergence, the so-called 'discovery', of non-European worlds – 'whose only history was the one about to begin' – and their re-location within the physical, psychic and imaginary landscapes of the 'West'.[43] The West, as the apparent maker and custodian of history in both geopolitical and scriptural terms, was the site of 'truth'. Under its institutional and technological aegis – universities, printing, museums, syllabuses, photography, sound recording, film – history transcribed all human practice; it recorded, reordered and rewrote the world.

Historiography did not merely study the past: it registered, transmitted and translated it. Its truth was the faith and mission of the West. So, the recent irruption of others into the heartland of

European *savoir* poses disturbing questions about the status of *our* knowledge and the particular protocols of historiography. For this intrusion rewrites the conditions of the West: its sense of truth, its sense of time, its sense of being.

Much of what passes for history is trapped in a continual exchange between realism and representation that relies on a naïve metaphysics of truth (absolute, total, complete) as though it were the property of the West. Yet representation is not a natural or obvious thing. It is, in both its political and æsthetic dimensions, a process of continual construction, enunciation and interpretation. The multiple representations and voices of the once excluded, of women, of black peoples, of discriminated sexualities, in contemporary culture, history and society, for example, do not simply exist in creating a space for them, of widening academic disciplines, political institutions, and adopting a pluralist gaze. It lies, rather, in reworking the very sense of history, culture, society and language that had previously excluded or silenced such voices, such a presence.

This is not to propose a history that, now able to recognise what was previously hidden and ignored, is therefore more 'complete', more convincing, more whole. It is rather to seek to propose a version that is more 'authentic' to our conditions by discussing what the very desire for history might involve. This entails a recognition of responsibility for the 'hunger of shadows', for the oblivion of being.[44] Here in the West, 'history', with its desire for mastery and its drive to fully explain, has provided the perennial testimony to the rewriting of the world as a European text. This observation carries us far beyond the obvious narratives of colony and Empire. For, concomitant with exploring, mapping and claiming the world, European identities were fashioning and defining themselves as the subjects of the modern *episteme*. While laying claim to the ownership of 'universal' knowledge Europeans were simultaneously involved in the paradoxical exercise of inventing the myths and traditions of the emerging modern (European) state and the national identities that sustained such a claim. Knowledge and power were mirrored and sustained in an assumed global destiny. The European became the universal 'we' – able to grant and withdraw history from others: the pervasive 'I' that speaks in knowledge and science, never the object, the 'they', of these discourses. Today, in a world in which the unity of knowledge and power meets with resistance and is being interrupted, challenged and decentred, such aspirations turn out to involve a limited account, and one, even in its critical and self-

reflective moments, that remains deeply imbricated in the history of Eurocentrism. To recognise this aperture, and with it the falling away of a unique centre, is also to recognise the 'pertinence of the critique of historicism to a world undergoing decolonization'.[45]

This particular sense of history – one that confidently appropriates the rest of the world to its point of view – depends upon the invariable and unquestioned sense of identity of the knowing subject. What cannot be reduced to his law and logic, and the gender is deliberate, is declared to be irrational. This universal 'he' of mankind cannot accept or tolerate otherness: the idea that something or somebody might exist beyond its domain and empire. It proposes a sense of history from a unique perspective: the eye of God now secularised, brought down to earth to inhabit the measured voice of the expert, the scientist, the intellectual, and the infra-red surveillance eye of a Los Angeles Police Department helicopter.[46] This appeal to the universal claims of modern rationalism, to the Cartesian certainties established in the singular abstraction of thought that avoids the differences of our historical bodies and their in-corporation in diverse languages, encompasses everything within its possessive gaze and power. The observed is reduced to 'a speechless, denuded, biological body'.[47] Alterity is swallowed up: the observed is removed from a precise historical and cultural economy and subsequently relocated in the scientific, literary and philosophical typologies employed to describe, fix and explain the 'other'.[48] It is a mode of enquiry that refuses to let others be. Differences are reduced to a common measure, the complexity of life to the narrow path of Eurocentric knowledge, to its particular myths of reason, progress, authenticity, closure and truth. In this fashion, disinterested and 'scientific' knowledge underwrites 'colonial appropriation, even as it rejects the rhetoric, and probably the practice, of conquest and subjugation'.[49]

This is why the narrative of 'history', which in some accounts stands for liberation – the rise of the nation state, of modern democracy and citizenship, of science and 'progress', of the victories of the locally oppressed – can for others simply indicate the label of terror and repression. As other histories emerge from the archaeology of modernity to disturb the monologue of History, we are reminded of the multiple rhythms of life that have been written out and forgotten, as the ambiguous, the disruptive and the excessive were reduced to the European accounting of past, present and future.

If modern slavery, racism, imperialism, total warfare, the Holo-

caust, Hiroshima and ecological break-down represent the limits of Europe's attempt to devour the world, how can we learn to allow the other to remain as other? How can we live in difference, respecting alterity? Hence the very title of Emmanuel Lévinas's most famous work, *Totality and Infinity* (1969), in which he indicates the choice between reducing everything to the selfsame totality or letting beings be. Lévinas argues that instead of attempting to fully 'explain' and assimilate the other, thereby reducing her or him to *our* world, we need to open ourselves up to a relationship that goes beyond ourselves, that exists beyond and apart from us. To acknowledge others, and in that recognition the impossibility of speaking for them, is to inscribe that impossibility, that limit, into my discourse and to recognise my being not for itself but for being with and for the other. Instead of reducing the encounter with the other to the rational transparency and finite closure of self-centred Cartesian subjectivity, Lévinas proposes the open web of language. In particular, it is the ethical event of dialogue that maintains a recognition of difference and distance: the surplus of the encounter that cannot be reduced to one or other of the speakers, that is irreducible to a common measure or totality, that remains vulnerable to the radical alterity of infinity.[50]

Writing is re-presentation, a simulation of what has been lost to it. History comes to us not as raw, bleeding facts but in textual production, in narratives woven by desire (for truth) and a will (for power). Such knowledge amounts to the violence, the force, that activates thought. For it deals with a memory that knows the impossibility of ever fully knowing either itself or the past. What are transcribed and translated are traces, residues, shadows and echoes. Here there is no obvious clarity to be narrated but rather a continual sorting through the debris of time. And as the accounting of the past constantly prefigures new questions, or else the most ancient of demands in new constellations, the chronicle is continually being re-written, re-viewed, re-presented. The resulting narrative can only be historical *and* fragmentary, structured *and* open, continuous *and* interrupted. For historiography involves both the re-membering and the re-covering of the past: its temporary coherence simultaneously invokes disclosure and disguise.

This terminates a discourse based on the assumption of an unequivocal distinction between truth and falsehood – as though the former were guaranteed by reason and the latter merely an appearance, a mask, to be stripped away. When every discourse is put together, articulated, fabulated, in the ambiguous territory between

128

(or beyond) such poles, then the very idea of the 'authentic' subject and its grammar of truth is displaced. We are left discussing the event of the gesture, the sign, the signature, simulation, language. This suggests an ethics whose only recourse lies in the recognition and acknowledgement of the transient mechanisms that sustain such a presence and representation: the contingency of the *mise en scène*. Here, in acknowledging the mechanisms of language, the instance of the genre (realist, surrealist . . .), and the mode of the narrative (historiographic, sociological, literary . . .), we also perceive that what is being represented is already in quotation marks, already a re-presentation. It is not for that reason any less valid or true, given that language, representation and discourse are the unique modes that permit speech, a voice, and access to the truth.

It is also in these contingencies that the apparently seamless textures of the everyday and the routine rituals of thought reveal folds, openings and a hesitant semantics that release further questions. In the interruption, in this temporary abeyance – for example, caused by the uproar following the 1991 and 1992 Benetton advertising campaigns: newly born child, war cemetery, AIDS deathbed, Mafia victim, Albanian refugees, the bird caught in the Gulf War oil spillage that two years later becomes the Shetland oil spillage – the predictable opportunity for moral policing acquires an unexpected aperture as these adverts deliberately overstep the mark and punctuate the assumed by confusing the generic distinctions between advertising and ethics, commerce and culture, public and private, stereotypical and atypical: hence shock, scandal, sermons and censure. The eternal phantoms that continue to haunt the details and specificity of these Benetton manifestos – life, death, suffering – rotate around the wheel of being, engendering discussion, debate and dialogue that exceed the limits of commercial or moral arrest. They circulate, openly and ambiguously, as a provocation in the world. We may demand a meaning, but we – for this 'we' is limited, circumscribed – are no longer so naïve as to expect it to be unchanging and unequivocal, as though it rests with us as a universal and 'portable property'.

What is the name of the wider movement that seeks to reach beyond inherited epistemological confines? We could call it political, although that, too, is now a discourse whose earlier epistemological pretensions have fallen apart. It is, to return to an already announced theme, certainly ethical. For we might say that 'ethics occurs as the

putting into question of the ego, the knowing subject, self-consciousness, of what Lévinas, following Plato, calls the Same (*le même; to auton*)'.[51] To live on the threshold of this possibility, in the interstices of heterogeneous practices, means to live in their shadows, always at the crossroads under the gaze of past and present myths that we can neither abandon nor simply adopt. We adapt them, and live within them not as isolated, self-sufficient, subjects clinging to the old subjectivity of truth but rather subject to them.

This means, ultimately, to inhabit the pathos of being subject to the knowledge of the earth, exposed to the risks of being-in-the-world (Heidegger's *Dasein*), where being occurs and takes place 'without appeal and without certainty'.[52] It calls for a radical transformation of interests (Husserl) in all our practices. Interests have to be directed towards the *opening* of sense: this is ethics. Interests are not directed towards themselves, but towards an opening. This means to be subject to the question of the question that 'disqualifies all claims to the self-foundation of an unconditioned *I*': for the definitive reply never arrives.[53] It also means to distinguish between the name of the law (morality), in which we are positioned and apparently held in custody, and the language of becoming, in which we become responsible for what sustains our being (ethics). This proposes a shift from the prescribed formation of the already formed and completed subject to the perpetual in-formation and performance of the subject who is constituted in a critical space: a critical space that is no longer assumed to exemplify the truth, but exists rather as an opening, a critical protocol.[54]

Let me now move towards a conclusion by borrowing Edgar Allan Poe's voice from 'Murders in the Rue Morgue':

> Thus there is such a thing as being too profound. Truth is not always in a well. In fact, as regards the more important knowledge, I do believe that she is invariably superficial.[55]

While Dupin's–Poe's gendered attribution of knowledge returns us to the traditional perception of truth as a woman – as something that is ultimately veiled, inscrutable, unknowable, essentially an 'other' – this observation simultaneously opens up the question of how we are all exposed, and expose ourselves, on the surfaces of language. Here, bending our ear to Shoshana Felman's elucidating commentary on Jacques Lacan, who begins his own *Ecrits* through nominating Poe's 'The Purloined Letter', we encounter a mutual resonance

between the Lacanian observation that 'man is inhabited by the signifier' and Heidegger's insistence that we dwell in language.[56] This sharp cancellation of the signified also cancels the possibility of an exterior critical space, outside or anterior to language, in which the truth is presumed to reside. 'There is no metalanguage,' writes Lacan.[57] We are all – interpreters and interpreted, producers and consumers – on the inside.

So language is split, divided, and what is obscured, hidden, does not lie elsewhere, but on the surfaces, in the folds, fissures and flaws of language itself. This means to return to language with a heightened sense of listening in order to hear what speaks from within the speech of consciousness, what resists, negates transparency, remains foreign, defies translation, and thereby displaces the privileged speaking position of the conscious.[58]

Many talk of the 'linguistic turn' in contemporary critical thought. But that phrase suggests a narrow and formalist evaluation, when it is rather the 'turn of', or 'turn into', language, into the discursive dissemination of the metaphor, the reality of language itself, that most sharply distinguishes the critical climate of the late twentieth century in the West. The turning into language of the speech of being is what after Nietzsche – from Freud to Kristeva, from Heidegger to Cixous, to name some of the promontories of this continent – provides the shared landscape for the contemporary passages of thinking. It is a telling move for it proposes an irreparable breach in rationalist thought. What it emphasises is that agency does not lie so much with the subject, or the individual, but with the individuation (I, you, we, they) established by language. Language, once presumed to provide the transparent means of rational design, is not our personal property. The harmonious bringing together of knowledge and being flees our private volition. Language is neither installed nor controlled by the subject. We inherit it, dwell in it, and seek to deposit a trace, a signature, as it speaks through us and to us. It is, to couple Marx and Heidegger, among the conditions we inherit, into which we are thrown, and which we struggle to make our own. But, where the former saw in this process an ultimate resolution and rational redemption, the latter saw only an opening, albeit the unique one we have. For to 'find a voice' is to take up dwelling in language that exists before – both expectant of, and anterior to – the subject. This is not to say that language is immutable or oblivious to individuation. It is rather to insist on its radical historicity, and thereby to underline its existence beyond and prior to our selves.

Language is what permits our being to be, to occur, to be explored, carried out and carried on. For in the radical historicity of language we meet not simply the grammar of being but the fact that it speaks: the speech of a particular cultural web, inheritance and network, in which the inscribed and pre-scribed is re-written.[59] It is where what we refer to as our historical, cultural and personal identities are not simply formed, but, more significantly, performed. Language calls out for a voice, a body. Such a summons propels us beyond the limited refrain of instrumental speech and writing into song, dance and dream. In any scansion of time and being that exceeds and befuddles the limited logic of authority we slip our rationalist leashes and expose ourselves to the movement of metaphor, to the performative consequences of speech and the ultimate consequences of language: the poetics of a place. Bob Marley takes a small axe to cut down the big tree. Almost two decades on, the act of black redemption is reiterated in a collage mix that slips through the musical score to settle the score, and thereby underscore a re-membering and a re-collecting that provides the sparse, but essential, baggage to keep on moving.[60] Rastafarian vibrations in Kingston's Trench Town and digital soundtracks assembled at the hands of Camden Town's Funki Dreds involve musical encounters and cultural exchanges that lie beside, or beyond, the point of 'the distant, retrospective rationalisations of the historian'.[61] For such sounds do not merely echo in historical space. In reverberating and recalling each other through the openings of musical and cultural memories they contribute to its making. Their time is both here and there. Their trajectories cut both ways to compound our time with other times. Song, the voice, the body, interrupt and divert the mastery of explanation and meaning with a poetics that always overflows and exceeds the description. These sounds, these bodies, these encounters in language scan and choreograph historical space. They speak, and in speaking become part of the language that we dwell in and (re)collect in constituting our identities, our selves, our place.

The question of language, this infinite complication that subverts the rationalist geometry of the observer and the observed, this shattering of the academic spy-glass and interruption of the 'neutral' scientific gaze, stands for a theoretical insurrection not merely in terms of criticism (literary, historical, anthropological), but for the whole of the Western *episteme* that we have inherited. This is to undermine, weaken and dissipate all metaphysical understandings of knowledge and truth. The moment of language announces a turning

away from knowledge considered as a stable entity, waiting to be unearthed, discovered and eventually accumulated by a subject who dreads and denies 'the stimulus of the enigmatic'.[62] Knowledge, on the contrary, involves an ambiguous freedom: its dangerous illusions of omnipotence can paradoxically save us from ourselves.[63] Thinking our limits we can perhaps glimpse the possibility of our redemption. For knowledge, like our selves, is essentially equivocal, composed of shadows and light, of imposed clarity and recalcitrant resistances. It does not lie on the other side of language, waiting to be announced; it can only exist in language. Knowledge is not a store house to be discovered and then broken into, but is rather a performative event – it speaks; and in speaking to us and through us it bears our histories, traces, signatures and responsibilities, always in transit.

Events, languages and knowledge are handed down to us, according to certain protocols, scripts, schemata, narratives. For although broadcast as a gesture of acquisition, the institutions and techniques of knowledge operate through exclusion rather than inclusion, by repressing, rather than exposing or rendering visible, their genesis. In every history there is always something left out, something that outstrips the limits of the transcription and the possibilities of a 'chain of words' (Jacques Lacan). According to Lacan it is the *réel* that constitutes that space left unmarked by language or signs. Although everything is coded, not everything is simultaneously reducible to the same code. To write, to speak, to be, always invokes the act of repudiation: in opting for this inscription, direction, movement, we simultaneously forgo another. The world is marked by language, not engulfed by it. While continually translated into the texts we read, watch, listen to, write, interpret and live by, the world stubbornly resists closure. The alchemy of language is not so powerful.[64] It is through this rift, this opening, that our bodies, our gestures and our language are constantly renewed: drawn on by the desire for the promise of the impossible.

To reproduce and codify the world in an exhaustive encyclopaedia, the dream of the compilers trapped in the logic of a tale by Borges, remains a futile illusion. In language we inhabit, construct and extend realities. Yet the *réel* remains beyond the frame, apparently dumb; for it is the *réel* that exists on the other side of language, reason and thought.[65] It is the indecipherable and unfathomable, an excess, a silent surplus, a necessary but impossible condition, that constantly interrogates reality: the white whale that swims in the

ocean of every epoch, the dancer on the borders of reason, the joker in the analytical pack. Every account is susceptible to its interruption, to its challenge.

Here, acknowledging our limits, our mortality, our place, we are forced to abandon all pretence to a conclusion in which everything seemingly comes to a halt and falls into place. Such a culmination, in which everything is explained and conclusively fitted together (the male death wish), need not correspond with our own particular limits. We continue to breach and dislocate our inheritance, and so continue to struggle, continue to imagine, continue to dream: the eternal return of being and becoming.[66] This might be considered utopic, but 'utopia' here does not represent a mental closure, a finished project, a back to the future that resolves and shapes our actions and thoughts. It is rather the ache that accompanies what we yearn after: the endless dream, the dreaming, of an ethical freedom to be inscribed in the heterotopias of our lives, histories and being. *'Here, in the field of the dream, you are at home.'*[67] At this point I, apparently a 'man of knowledge', stop to listen to the words of the dreamer:

> Appearance is for me the active and living itself, which goes so far in its self-mockery as to allow me to feel that there is nothing here but appearance and will-o'-the-wisp and a flickering dance of spirits – that among all these dreamers I, too, the 'man of knowledge', dance my dance, that the man of knowledge is a means of spinning out the earthly dance and to that extent one of the masters-of-ceremonies of existence, and that the sublime consistency and unity of all knowledge is and will be perhaps the supreme means of *preserving* the universality of dreaming and the mutual intelligibility of all these dreamers, and thereby *the continuance of the dream.* [68]

In this dance, in this dream of life, lives the angel of history. This is the allegorical angel whose wings brushed Walter Benjamin's writings: the famous figure contemplating the growing debris of the past as it is blown backwards into the future. These are the black and white angels that inhabit the fragmentary, dream-like cinema of Isaac Julien's extraordinary *Looking for Langston* (1989). This is also the angel that sings through the trees in the final sequence of Sally Potter's film *Orlando* (1992).[69] These angels condense past, present and future. Under their gaze we find ourselves caught between the apparent ineluctability of time and its continual crisis.[70]

They remind us of the spark of eternity that is revealed as we unravel the uniqueness of the present to take responsibility for the oblivion of the past and the multiplicity of possible futures. For the angels announce history as a perpetual becoming, an inexhaustible emerging, an eternal provocation, a desire that defies and transgresses the linear flow of historicist reason with the insistent now, the *Jetz*, of the permanent time of the possible.

NOTES

1 Judith Butler, *Gender Trouble. Feminism and the Subversion of Identity*, London & New York, Routledge, 1990, p. xiii.

2 Friedrich Nietzsche, *Daybreak*, quoted in R.J. Hollingdale (ed.), *A Nietzsche Reader*, Harmondsworth, Penguin, 1977, p. 87.

3 Jean Rhys, *The Wide Sargasso Sea*, Harmondsworth, Penguin, 1988, p. 96.

4 Jacques Derrida, quoted in Gayatri Chakravorty Spivak, 'Translator's Preface', in Jacques Derrida, *Of Grammatology*, Baltimore, Johns Hopkins University Press, 1977, p. xviii.

5 Rosi Braidotti, *Patterns of Dissonance*, Cambridge, Polity Press, 1991, pp. 35–6.

6 Jacques Lacan, quoted in Shoshana Felman, *Jacques Lacan and the Adventure of Insight. Psychoanalysis in Contemporary Culture*, Cambridge, Mass., & London, Harvard University Press, 1987, p. 84.

7 See Geoffrey Galt Harpham, 'Derrida and the Ethics of Criticism', *Textual Practices* 5 (3), Winter 1991.

8 An argument later repeated by Heidegger, for example in 'Letter on Humanism', published in 1947: 'In this regard "subject" and "object" are inappropriate terms of metaphysics, which very early on in the form of Occidental "logic" and "grammar" seized control of the interpretation of language. We today can only begin to descry what is concealed in that occurrence': Martin Heidegger, 'Letter on Humanism', in Martin Heidegger, *Basic Writings*, New York, Harper & Row, 1977, p. 194. The Heideggerian critique of grammatical logic, in particular the use of the third person that invariably slides into becoming a global enunciation, has more recently been extended by Jean-François Lyotard; see Jean-François Lyotard, 'Missive sur l'Histoire', in Jean-François Lyotard, *Le Postmoderne expliqué aux enfants*, Paris, Galilée, 1986; now available in English as *The Postmodern Explained to Children*, London, Turnaround, 1992.

9 See Linda Hutcheon, *The Politics of Postmodernism*, London & New York, Routledge, 1989, ch. 6. The quote is from Gayatri Chakravorty Spivak, 'Translator's Preface', in Jacques Derrida, *Of Grammatology*, Baltimore, Johns Hopkins University Press, 1977, p. lvii.

10 Susan J. Hekman, *Gender and Knowledge. Elements of a Postmodern Feminism*, Cambridge, Polity Press, 1990, p. 134.

11 Friedrich Nietzsche, *Beyond Good and Evil*, Harmondsworth, Penguin,

1973, pp. 47–8. Or: 'he really thought that in language he possessed knowledge of the world. The sculptor of language was not so modest as to believe he was only giving things designations, he conceived rather that with words he was expressing supreme knowledge of things . . . it is the *belief that the truth has been found* out of which the mightiest sources of energy flowed': Friedrich Nietzsche, *Human, All Too Human*, quoted in R.J. Hollingdale (ed.), *A Nietzsche Reader,* Harmondsworth, Penguin, 1977, pp. 55–6.

12 Judith Butler, *Gender Trouble. Feminism and the Subversion of Identity,* London & New York, Routledge, 1990, p. 25.

13 Emmanuel Lévinas, *Totality and Infinity*, Pittsburgh, Duquesne University Press, 1969.

14 Paul Ricœur, *Soi-même comme un autre*, Paris, Editions du Seuil, 1991.

15 Susan J. Hekman, *Gender and Knowledge. Elements of a Postmodern Feminism*, Cambridge, Polity Press, 1990, pp. 183–6.

16 Michel Foucault, 'Politics and the Study of Discourse', *Ideology and Consciousness* 3, 1978, p. 19.

17 Ibid., p. 10.

18 Sarah Kofman, 'Descartes Entrapped', in E. Cadava, P. Connor and J.-L. Nancy (eds), *Who Comes After the Subject?*, London & New York, Routledge, 1991, p. 180.

19 Jean-François Lyotard, 'Some of the Things at Stake in Women's Struggles', *SubStance* 20, 1978, quoted in Susan J. Hekman, *Gender and Knowledge. Elements of a Postmodern Feminism*, Cambridge, Polity Press, 1990, p. 108.

20 '. . . all the sciences concerned with life, must necessarily be inexact just in order to remain rigorous': Martin Heidegger, 'The Age of the World Picture', in Martin Heidegger, *The Question Concerning Technology and Other Essays*, New York, Harper & Row, 1977, p. 120.

21 Many of these histories betray a long lineage, one of which certainly stretches back to religious cults, pseudo-scientific theories, occult sects and exiled European utopias that mingled in the haze of southern Californian sunshine back in the 1930s. See Mike Davis, *City of Quartz. Excavating the Future in Los Angeles,* London, Vintage, 1992, pp. 46–54.

22 The quote is again from Friedrich Nietzsche, *On the Genealogy of Morals*, quoted in R.J. Hollingdale (ed.), *A Nietzsche Reader,* Harmondsworth, Penguin, 1977, p. 109.

23 One of the symptoms of this over-spill is the self-conscious migration of theoretical discourses into the heart of literary culture. In Britain the novels of David Lodge, Malcolm Bradbury and Christine Brooke-Rose, not to speak of its spread, via Biff cartoons, to lifestyle magazines and newspapers, has virtually given rise to a local genre. But the amusement invoked here is often disquieting, our enjoyment seeded with discomfort. While Dick Hebdige, for example, hears in his own 'bitter-sweet' laughter at Biff the recognition of masculine postmodernist disenchantment, I personally think that the exploration of that particular state is only a temporary detour before the return home to a much older formation and its cynical denial of anything but the really 'real'. See

Dick Hebdige, 'Making Do with the "Nonetheless", In the Whacky World of Biff', in Dick Hebdige, *Hiding in the Light,* London & New York, Routledge, 1988. By ironically representing contemporary intellectual concerns in the form of satire, these texts recover the space of 'critical distance' as though from the 'inside', and thereby avoid taking too seriously any thought of excess, fantasy, imagination or . . . change. Reduced to laughter, whatever lies on the 'other' side of this reading matter is contained and regulated, disturbance is domesticated. The fear implied here of the threat of excess bursting the generic, and institutional, boundaries of criticism has an appointment, no doubt unconscious, with the extensive formation of British pragmatism and its persistent anti-intellectualism. That many of these writers are also often critics, writing text books of literary theory and criticism, only further underlines the reproduction of a narrow, pragmatic distinction between the critical and the poetic modes of enquiry that elsewhere – post-Nietzschean criticism, to simplify its identification – is inhabited and explored as a ruin.

24 Trinh T. Minh-ha speaking with Pratibha Parmar, 'Woman, Native, Other. Pratibha Parmar Interviews Trinh T. Minh-ha', *Feminist Review* 36, Autumn 1990, p. 68.

25 I am grateful to Lidia Curti for initially drawing my attention to the question of erasure.

26 The cross that is laid over the concept establishes the four cardinal points, what Heidegger refers to as the 'fourfold', of the sky, earth, mortals and divinities, that poetically establish the place of our dwelling. Although Heidegger is undoubtedly still haunted by the metaphysics of authenticity, he nevertheless reaches out to establish the terrestrial and mortal limits of thought. This is how the French philosopher Jean-François Courtine glosses it: 'It is in the 1955 text *The Question of Being* that Heidegger dares to strike out – with a mark like the cross of Saint Andrew – the name of being; this scratching out (b̶e̶i̶n̶g̶) . . . does not erase anything, but rather adds the sign of the fourfold (*Geviert*) to the most ancient "word" of philosophy': Jean François Courtine, 'Voice of Conscience and Call of Being', in E. Cadava, P. Connor and J.-L. Nancy (eds), *Who Comes After the Subject?,* London & New York, Routledge, 1991, p. 90. See also Martin Heidegger, 'Building, Dwelling, Thinking', in Martin Heidegger, *Basic Writings,* New York, Harper & Row, 1977.

27 Simon Critchley, *The Ethics of Deconstruction, Derrida and Lévinas,* Oxford, Basil Blackwell, 1992, p. 13. The asymmetrical nature of such encounters are clearly distinct from the communicative consensus proposed with Gadamer's hermeneutic dialogue.

28 This, of course, is to open up a further critical itinerary, in which the journey of cultural studies now fluctuates between re-location in local translations and transformations and becoming transfixed in a sort of global academic apothecary. See the contents of *Cultural Studies* 6 (3), October 1992, culled from a conference on this theme held in Western Australia the previous year entitled 'Dismantle Fremantle'.

29 Joan Wallach Scott, *Gender and the Politics of History,* New York, Columbia University Press, 1988, p. 1.

30 Ibid., p. 5.

31 The centrality of this question to the making and subsequent unmaking of the project of modernity is well expressed by William Connolly in his superb book on modern political theory:
'To establish a medium or instrument by which to attain knowledge and then to use it to know is to guarantee that the initial optimism in which modern epistemology begins will issue in a dismal skepticism. The Enlightenment slides from Descartes to Hume. For each attempt to test the instrument or the medium for accuracy ends up either by introducing another one itself in need of redemption or reiterating the one which needed to be checked. It thus falls either into an infinite regress or a vicious circle. Theorists who invoke different criteria of knowledge have no final court of appeal in common. Even if they do concur upon a final court of appeal *for us* as humans they can never know whether the knowledge concurred upon reaches beyond the world as it appears to us into the world as it is in itself.'
William E. Connolly, *Political Theory and Modernity*, Oxford & New York, Basil Blackwell, 1989, p. 91.

32 Joan Wallach Scott, *Gender and the Politics of History*, New York, Columbia University Press, 1988, p. 7.

33 Ibid., p. 7.

34 Gayatri Chakravorty Spivak, 'Translator's Preface', in Jacques Derrida, *Of Grammatology*, Baltimore, Johns Hopkins University Press, 1977, p. lvii.

35 Martin Heidegger, 'The Age of the World Picture', in Martin Heidegger, *The Question Concerning Technology and Other Essays*, New York, Harper & Row, 1977, p. 154.

36 Teresa de Lauretis, quoted in Joan Wallach Scott, *Gender and the Politics of History*, New York, Columbia University Press, 1988, p. 6.

37 But see Jane Gallop, 'Afterword', in Jane Gallop, *Around 1981. Academic Feminist Literary Theory*, London & New York, Routledge, 1992, for a more direct questioning of disciplinary status in the case of literature.

38 John Llewelyn, 'Lévinas, Derrida and Others *Vis-à-vis*', in Robert Bernasconi and David Wood (eds), *The Provocation of Lévinas. Rethinking the Other*, London & New York, Routledge, 1988.

39 Michel de Certeau, *The Writing of History*, New York, Columbia University Press, 1988, p. 101.

40 Amongst the most eloquent of these baroque compositions are those composed by the lute masters of the seventeenth and eighteenth centuries: Denis Gaultier's *Tombeau de Monsieur de Lenclos* and Silvius Weiss's *Tombeau sur la mort de Mr. Cajetan, Baron d'Hartig*.

41 Michel de Certeau, *The Writing of History*, New York, Columbia University Press, 1988, p. 100.

42 Ibid.

43 The quote is from Mary Louise Pratt, *Imperial Eyes. Travel Writing and Transculturation,* London & New York, Routledge, 1992, p. 126.

44 The quote comes from Isaac Julien's film *Looking for Langston* (1989).

45 Tejaswini Niranjana, *Siting Translation. History, Post-Structuralism*

and the Colonial Context, Berkeley, Los Angeles & London, University of California Press, 1992, p. 4.

46 See Dennis Hopper's film *Colors* (1988), and the chapter on 'Fortress L.A.', in Mike Davis, *City of Quartz. Excavating the Future in Los Angeles,* London, Vintage, 1992. With Heidegger, for example, the logic of modern science and technology, although oblivious to its metaphysical formation, represents the continuation and extension of Western metaphysics on a global scale; see Martin Heidegger, 'The End of Philosophy and the Task of Thinking', in Martin Heidegger, *Basic Writings,* New York, Harper & Row, 1977, p. 377.

47 Mary Louise Pratt, *Imperial Eyes. Travel Writing and Transculturation,* London & New York, Routledge, 1992, p. 53.

48 Ibid., p. 53.

49 Ibid., p. 53.

50 Emmanuel Lévinas, *Totality and Infinity,* Pittsburgh, Duquesne University Press, 1969; but see also Emmanuel Lévinas, *Ethics and Infinity,* Pittsburgh, Duquesne University Press, 1985.

51 Simon Critchley, *The Ethics of Deconstruction, Derrida and Lévinas,* Oxford, Basil Blackwell, 1992, p. 4.

52 Jean-Luc Marion, 'L'Interloqué', in E. Cadava, P. Connor and J.-L. Nancy (eds), *Who Comes After the Subject?,* London & New York, Routledge, 1991, p. 237.

53 Ibid., p. 238.

54 Carlo Sini, 'L'etica della scrittura e la pratica del foglio-mondo', Istituto Italiano per gli Studi Filosofici, 7 February 1992.

55 Edgar Allan Poe, 'Murders in the Rue Morgue', in E.A. Poe, *Some Tales of Mystery and Imagination*, Harmondsworth, Penguin, 1938, p. 213.

56 Shoshana Felman, *Jacques Lacan and the Adventure of Insight. Psychoanalysis in Contemporary Culture,* Cambridge, Mass., & London, Harvard University Press, 1987, p. 45. Also see Martin Heidegger, 'Letter on Humanism', in Martin Heidegger, *Basic Writings,* New York, Harper & Row, 1977. This is also anticipated by Benjamin when in 1924 in a letter to Hofmannsthal he writes, 'each truth has its home, its ancestral palace, in language'; see Hannah Arendt 'Introduction', in Walter Benjamin, *Illuminations,* London, Collins/Fontana, 1973, pp. 46–7.

57 Shoshana Felman, *Jacques Lacan and the Adventure of Insight. Psychoanalysis in Contemporary Culture,* Cambridge, Mass., & London, Harvard University Press, 1987, p. 48.

58 '. . . this thing speaks and functions in a way quite as elaborate as at the level of the conscious, which thus loses what seemed to be its privilege': Jacques Lacan, *The Four Fundamental Concepts of Psycho-Analysis,* Harmondsworth, Penguin, 1991, p. 24. Also see Shoshana Felman, *Jacques Lacan and the Adventure of Insight. Psychoanalysis in Contemporary Culture,* Cambridge, Mass., & London, Harvard University Press, 1987, pp. 53–8.

59 As C.L.R. James puts it in commenting on the Guyanese writer Wilson Harris: 'Mountains are, horses are, books are but only man *exists* and the source of man's existence is not only the *dasein*. The means he uses to

find what he is finding out, to live an authentic existence, is language, and I have seen that nowhere stated as sharply as Harris states it.' The quote comes from C.L.R. James's essay, 'Wilson Harris and the Existentialist Doctrine', quoted in the Series Foreword to Wilson Harris, *The Womb of Space. The Cross-Cultural Imagination*, Westport, Greenwood Press, 1983, p. xi.

60 'Small Axe' is on the classic Wailers' album *Burnin'*, Island Records, 1973; while 'Keep On Movin'', featuring Caron Wheeler is on Soul II Soul's *club classics vol. one*, 10 Records, 1989.

61 Paul Carter, *Living in a New Country. History, Travelling and Language,* London, Faber & Faber, 1992, p. 175.

62 Friedrich Nietzsche, *The Will to Power*, New York, Vintage, 1968, p. 262.

63 This is to paraphrase Hölderlin, Nietzsche and Heidegger.

64 It is within this limit that we might return to Derrida's famous provocation, 'there is nothing outside the text'. Pushed in one direction this seems to reduce the world to textual confines. Pushed in another, it suggests, modestly and realistically, that what does not appear in language lies in that moment beyond us. This is not to say that what lies beyond us does not exist, only to insist that until it is invested by language and appears to us, is re-presented, it remains elsewhere. It is to introduce contingency into the event of language. For it is one thing to say we live in language. It is another to suggest that our being is wholly reduced to an abstract linguistic matter. In the former practice we recognise context and contingency inscribed in our tongue while simultaneously acknowledging that language always speaks with a supplement, that it also addresses an elsewhere, an other besides ourselves. I speak, but language neither commences nor concludes with that event. The second perspective appears to deny the ambiguous cleft in this simultaneous contextualisation and circulation of the tongue, and assumes a strangely dematerialised tone: a linguistic universalism that invariably denies the body, the theatre of identities, the syntax of sexualities, the lexicons of flesh and blood. It is this second, 'measured', version that Tzvetan Todorov, for example, appears to prefer; see Tzvetan Todorov, 'Bilingualism, Dialogism and Schizophrenia', *New Formations* 17, Summer 1992.

65 Tom Conley, 'Translator's Introduction, For a Literary Historiography', in Michel de Certeau, *The Writing of History*, New York, Columbia University Press, 1988, p. xvii.

66 Gilles Deleuze, *Nietzsche and Philosophy*, London, Athlone Press, 1983, p. 24.

67 Jacques Lacan, *The Four Fundamental Concepts of Psycho-Analysis*, Harmondsworth, Penguin, 1991, p. 44.

68 Friedrich Nietzsche, *The Gay Science*, quoted in R.J. Hollingdale (ed.), *A Nietzsche Reader,* Harmondsworth, Penguin, 1977, p. 206.

69 The androgynous figure of Virginia Woolf's Orlando recalls and doubles the androgynous sexuality of Klee-Benjamin's angel. Androgyny is central to the figure of the angel Christine Buci-Glucksmann elucidates in exploring Benjamin's fascination with the transgressive and ambiguous passages of modernity. See Christine Buci-Glucksmann, *La Raison baroque*, Paris, Galilée, 1984.

70 This conception of history, which owes so much to radical Jewish thought, and in particular to the writings of Benjamin, Scholem and Rosenzweig, is suggestively explored in Stéphane Mosès, *L'Ange de l'histoire. Rosenzweig, Benjamin, Scholem*, Paris, Editions du Seuil, 1992.

BIBLIOGRAPHY

Anderson, B., *Imagined Communities*, London, Verso, 1983.

Anzaldúa, G., 'How to Tame a Wild Tongue', in R. Ferguson, M. Gever, Trinh T. Minh-ha & C. West (eds), *Out There, Marginalization and Contemporary Cultures*, Cambridge, Mass., MIT Press, 1990.

Appiah, K.A., 'Is the Post- in Postmodernism the Post in Postcolonial?', *Critical Inquiry* 17, Winter 1991.

Arendt, H., *The Human Condition*, Chicago, University of Chicago Press, 1958.

Arendt, H., 'Introduction', in W. Benjamin, *Illuminations*, London, Collins/ Fontana, 1973.

Ashcroft, B., Griffiths, G. & Tiffin, H., *The Empire Writes Back*, London & New York, Routledge, 1990.

Bailey, D.A. & Hall, S.,'Critical Decade. Black British Photography in the 80s', *Ten.8* 2 (3), 1992.

Barthes, R., 'The Brain of Einstein', in R. Barthes, *Mythologies*, London, Paladin, 1973.

Barthes, R., *Image–Music–Text*, London, Collins/Fontana, 1977.

Barthes, R., *Empire of Signs*, New York, Hill & Wang, 1982.

Bateson, G., 'Pidgin English and Cross-Cultural Communication', *Transactions of the New York Academy of Sciences* 6, 1944.

Baudrillard, J., 'Le Xérox et l'infini', *Traverses* 44/45, 1987.

Baudrillard, J., *Cool Memories II*, Paris, Galilée, 1990.

Bauman, Z., *Modernity and the Holocaust*, Cambridge, Polity Press, 1989.

Bauman, Z., 'Modernity and Ambivalence', in M. Featherstone (ed.), *Global Culture. Nationalism, Globalization and Modernity*, London, Newbury Park & New Delhi, Sage, 1990.

Benjamin, A., *Art, Mimesis and the Avant-Garde*, London & New York, Routledge, 1991.

Benjamin, W., 'The Task of the Translator', in W. Benjamin, *Illuminations*, London, Collins/Fontana, 1973.

Benjamin, W., 'The Work of Art in the Age of Mechanical Reproduction', in W. Benjamin, *Illuminations*, London, Collins/Fontana, 1973.

Benjamin, W., 'Theses on the Philosophy of History', in W. Benjamin, *Illuminations*, London, Collins/Fontana, 1973.

Benjamin, W., *Das Passagen-Werk*, Frankfurt, Suhrkamp Verlag, 1982; *Parigi. Capitale del XIX secolo*, Turin, Einaudi, 1986.

Benjamin, W., *The Origin of German Tragic Drama*, London, Verso, 1990.

Ben Jelloun, T., *The Sand Child*, New York, Ballantine Books, 1989.

Berman, M., *All That Is Solid Melts Into Air*, New York, Penguin, 1988.

Bhabha, H.K., 'DissemiNation', in H.K. Bhabha (ed.), *Nation and Narration*, London & New York, Routledge, 1990.

Bhabha, H.K. 'The Third Space. Interview with Homi Bhabha', in J. Rutherford (ed.), *Identity. Community, Culture, Difference*, London, Lawrence & Wishart, 1990.

Bowles, P., *The Sheltering Sky*, New York, Vintage, 1990.

Braidotti, R., *Patterns of Dissonance*, Cambridge, Polity Press, 1991.

Brand, S., *The Media Lab*, Harmondsworth, Penguin, 1988.

Brathwaite, E.K., *History of the Voice*, London & Port of Spain, New Beacon Books, 1984.

Brathwaite, E.K., *X/Self*, London & New York, Oxford University Press, 1987.

Breton, P., *La Tribu informatique*, Paris, Métailié, 1990.

Buci-Glucksmann, C., *La Raison baroque*, Paris, Galilée, 1983.

Butler, J., *Gender Trouble. Feminism and the Subversion of Identity*, London & New York, Routledge, 1990.

Byatt, A.S., 'Identity and the Writer', in L. Appignanesi (ed.), *The Real Me. Post-Modernism and the Question of Identity*, ICA Documents 6, London, ICA, 1987.

Carles, P. & Comolli, J.-L., *Free Jazz/Black Power*, Paris, Editions Champ Libre, 1971.

Carter, P., *Living in a New Country. History, Travelling and Language*, London, Faber & Faber, 1992.

Chabram, A.C. & Fregoso, R.L., 'Chicana/o cultural representations, reframing alternative critical discourses', *Cultural Studies* 4 (3), October 1990.

Chambers, I., *Border Dialogues. Journeys in Postmodernity*, London & New York, Routledge, 1990.

Chatwin, B., *The Songlines*, London, Picador, 1988.

Cixous, H. & Clément, C., *The Newly Born Woman*, Manchester, Manchester University Press, 1987.

Cliff, M., *No Telephone to Heaven*, New York, Vintage, 1989.

Clifford, J., 'Notes on Travel and Theory', *Inscriptions* 5, 1989.

Clifford, J., 'Travelling Cultures', in L. Grossberg, C. Nelson & P. Treichler (eds), *Cultural Studies*, London & New York, Routledge, 1992.

Cockburn, C., *Brothers. Male Dominance and Technological Change*, London, Pluto, 1983.

Collins, M., *Rotten Pomerack*, London, Virago, 1992.

Conley, T., 'Translator's Introduction, For a Literary Historiography', in de Certeau, M., *The Writing of History*, New York, Columbia University Press, 1988.

Connolly, W.E., *Political Theory and Modernity*, Oxford & New York, Basil Blackwell, 1989.

Courtine, J.-F., 'Voice of Conscience and Call of Being', in E. Cadava, P.

Connor & J.-L. Nancy (eds), *Who Comes After the Subject?*, London & New York, Routledge, 1991.

Critchley, S., *The Ethics of Deconstruction. Derrida and Lévinas*, Oxford, Basil Blackwell, 1992.

Curti, L., 'What is Real and What is Not: Female Fabulations in Cultural Analysis', in L. Grossberg, C. Nelson & P. Treichler (eds), *Cultural Studies*, London & New York, Routledge, 1992.

Dabydeen, D., 'Back to Black', *New Statesman & Society*, 5 January 1990.

Dal Lago, A. & Rovatti, P.A., *Elogio del pudore*, Milan, Feltrinelli, 1990.

Damon, M., 'Talking Yiddish at the Boundaries', *Cultural Studies* 5 (1), January 1991.

Daniel, J.O., 'Temporary Shelter. Adorno's Exile and the Language of Home', *New Formations* 17, Summer 1992.

Davidson, A.I., 'Symposium on Heidegger and Nazism', *Critical Inquiry* 15, Winter 1989.

Davis, M., *City of Quartz. Excavating the Future in Los Angeles*, London, Vintage, 1992.

de Certeau, M., *The Practice of Everyday Life*, Berkeley, Los Angeles & London, University of California Press, 1988.

de Certeau, M., *The Writing of History*, New York, Columbia University Press, 1988.

Deleuze, G., *Nietzsche and Philosophy*, London, Athlone Press, 1983.

Derrida, J., 'Living On, Border Lines', in H. Bloom *et al.* (eds), *Deconstruction and Criticism*, London, Routledge & Kegan Paul, 1979.

Doane, M.A., *The Desire to Desire,* Bloomington & Indianapolis, Indiana University Press, 1987.

Durant, A., 'From the Rushdie Controversy to Social Pluralism', *New Formations* 12, Winter 1990.

Edwards, P., 'The Army and the Microworld. Computers and the Politics of Gender Identity', *Signs* 16 (1), Autumn 1990.

Fabian, J., *Time and the Other*, New York, Columbia University Press, 1983.

Fanon, F., *Black Skins, White Masks*, London, Pluto, 1991.

Featherstone, M., 'Global Culture. An Introduction', in M. Featherstone (ed.), *Global Culture. Nationalism, Globalization and Modernity*, London, Newbury Park & New Delhi, Sage, 1990.

Felman, S., *Jacques Lacan and the Adventure of Insight. Psychoanalysis in Contemporary Culture*, Cambridge, Mass., & London, Harvard University Press, 1987.

Felman, S., 'Paul de Man's Silence', *Critical Inquiry* 15 (4), Summer 1989.

Flax, J., *Thinking Fragments*, Berkeley, Los Angeles & London, University of California Press, 1990.

Foucault, M., 'Politics and the Study of Discourse', *Ideology and Consciousness* 3, 1978.

Foucault, M., *The Order of Things*, London & New York, Routledge, 1991.

Frith, S., *Music for Pleasure*, Cambridge, Polity Press, 1988.

Gabriel, T.H., 'Thoughts on Nomadic Aesthetics and the Black Independent Cinema: Traces of a Journey', in M.B. Cham & C. Andrade-Watkins (eds), *Blackframes. Critical Perspectives on Black Independent Cinema*, Cambridge, Mass., & London, MIT Press, 1988.

Gadamer, H.-G., *Truth and Method*, New York, Crossroad, 1984.

Gallop, J., *Around 1981. Academic Feminist Literary Theory,* London & New York, Routledge, 1992.

Ganguly, K., 'Migrant Identities, Personal Memory and the Construction of Selfhood', *Cultural Studies* 6 (1), January 1992.

Garber, M., *Shakespeare's Ghost Writers. Literature as Uncanny Causality*, London & New York, Methuen, 1987.

Gates Jr, H.L., *Figures in Black*, New York & Oxford, Oxford University Press, 1989.

Geraghty, C., *Women and Soap Opera*, Cambridge, Polity Press, 1991.

Gibson, W., *Neuromancer*, London, Grafton Books, 1986.

Gilroy, P., *There Ain't No Black in the Union Jack*, London, Hutchinson, 1987.

Gilroy, P., 'It Ain't Where You're From, It's Where You're At . . . The Dialectics of Diasporic Identification', *Third Text* 13, Winter 1990/1.

Gilroy, P., 'The End of Antiracism', in J. Donald & A. Rattansi (eds), *'Race', Culture and Difference*, London, Sage, 1992.

Gilroy, P., *Promised Lands*, London, Verso, 1993.

Goodwin, A., 'Pushing the Feel Button', *New Statesman & Society*, 5 January 1990.

Grenier, L., 'From "Diversity" to "Difference"', *New Formations* 9, Winter 1989.

Grewal, S., Kay, J., Landor, L., Lewis, G. & Parmar, P. (eds), *Charting the Journey. Writings by Black and Third World Women*, London, Sheba Feminist Publishers, 1988.

Grosz, E., 'Judaism and Exile. The Ethics of Otherness', *New Formations* 12, Winter 1990.

Guattari, F., 'The Three Ecologies', *New Formations* 8, Summer 1989.

Guidieri, R., *L'Abondance des pauvres. Six aperçus critiques sur l'anthropologie*, Paris, Editions du Seuil, 1984.

Hall, S., 'Minimal Selves', in L. Appignanesi (ed.), *The Real Me. Post-Modernism and the Question of Identity*, ICA Documents 6, London, ICA, 1987.

Hannerz, U., 'Cosmopolitans and Locals in World Culture', in M. Featherstone (ed.), *Global Culture. Nationalism, Globalization and Modernity*, London, Newbury Park & New Delhi, Sage, 1990.

Haraway, D., 'A Manifesto for Cyborgs. Science, Technology and Socialist Feminism in the 1980s', *Socialist Review* 80, 1985.

Harpham, G.G., 'Derrida and the Ethics of Criticism', *Textual Practices* 5 (3), Winter 1991.

Harris, W., *The Womb of Space. The Cross-Cultural Imagination*, Westport, Greenwood Press, 1983.

Harris, W., 'In the Name of Liberty', *Third Text* 11, Summer 1990.

Harvey, D., *The Condition of Postmodernity*, Oxford, Basil Blackwell, 1989.

Hatton, B., 'From Neurosis to Narrative', in *Metropolis. New British Architecture and the City*, London, ICA, 1988.

Hebdige, D., *Hiding in the Light*, London & New York, Routledge, 1988.

Heidegger, M., 'Building, Dwelling, Thinking', in M. Heidegger, *Basic Writings*, New York, Harper & Row, 1977.

Heidegger, M., 'Letter on Humanism', in M. Heidegger, *Basic Writings*, New York, Harper & Row, 1977.

Heidegger, M., 'The Age of the World Picture', in M. Heidegger, *The Question Concerning Technology and Other Essays*, New York, Harper & Row, 1977.

Heidegger, M., 'The End of Philosophy and the Task of Thinking', in M. Heidegger, *Basic Writings*, New York, Harper & Row, 1977.

Heidegger, M., 'The Question Concerning Technology', in M. Heidegger, *The Question Concerning Technology and Other Essays*, New York, Harper & Row, 1977.

Heidegger, M., 'The Turning', in M. Heidegger, *The Question Concerning Technology and Other Essays*, New York, Harper & Row, 1977.

Hekman, S.J., *Gender and Knowledge. Elements of a Postmodern Feminism*, Cambridge, Polity Press, 1990.

Hollingdale, R.J. (ed.), *A Nietzsche Reader*, Harmondsworth, Penguin, 1977.

Hong Kingston, M., *China Men*, New York, Vintage, 1990.

Horkheimer, M. and Adorno, T.W., *Dialectic of Enlightenment*, New York, Continuum, 1982.

Hosokawa, S., *Walkman no Shûjigaku*, Tokyo, Asahi Shuppan, 1981.

Hosokawa, S., 'The Walkman Effect', *Popular Music* 4, 1984.

Hutcheon, L., *The Politics of Postmodernism*, London & New York, Routledge, 1989.

Jabès, E., *The Book of Questions*, vol. 1, Middletown, Wesleyan University Press, 1976.

Jabès, E., *Un étranger avec, sous le bras, un livre de petit format*, Paris, Gallimard, 1989.

Jabès, E., *Le Livre de l'hospitalité*, Paris, Gallimard, 1991.

Jameson, F., *Postmodernism, or the Cultural Logic of Late Capitalism*, London, Verso, 1992.

Julien, I. & MacCabe, C., *Diary of a Young Soul Rebel*, London, British Film Institute, 1991.

Kadohata, C., *The Floating World*, London, Minerva, 1989.

Kapur, G., 'The Centre–Periphery Model or How are we Placed? Contemporary Cultural Practice in India', *Third Text* 16/17, Autumn/Winter 1991.

King, A.D., *Culture, Globalization and the World System*, Binghamton, State University of New York, 1991.

King, A.D., *Global Cities. Post-Imperialism and the Internationalization of London*, London & New York, Routledge, 1991.

King, A.D., *Urbanism, Colonialism, and the World-Economy*, London & New York, Routledge, 1991.

Kirby, V., 'Corporeographies', *Inscriptions* 5, 1989.

Kofman, S., 'Descartes Entrapped', in E. Cadava, P. Connor & J.-L. Nancy (eds), *Who Comes After the Subject?*, London & New York, Routledge, 1991.

Kofsky, F., *Black Nationalism and the Revolution in Music*, New York, Pathfinder Press, 1970.

Kracauer, S., *History: The Last Things Before the Last*, New York, Oxford University Press, 1969.

Kristeva, J., *Étrangers à nous-mêmes*, Paris, Fayard, 1988; Kristeva, J., *Strangers to Ourselves*, Hemel Hempstead, Harvester Wheatsheaf, 1991; Kristeva, J., *Stranieri a se stessi*, Milan, Feltrinelli, 1990.

Kureishi, H., *The Buddha of Surburbia*, London, Faber & Faber, 1990.

Lacan, J., *The Four Fundamental Concepts of Psycho-Analysis*, Harmondsworth, Penguin, 1991.

Laclau, E. & Mouffe, C., *Hegemony and Socialist Strategy*, London, Verso, 1985.

Lacoue-Labarthe, P., *Heidegger, Art and Politics. The Fiction of the Political*, Oxford, Basil Blackwell, 1990.

Lévinas, E., *Totality and Infinity*, Pittsburgh, Duquesne University Press, 1969.

Lévinas, E., *Ethics and Infinity*, Pittsburgh, Duquesne University Press, 1985.

Lévinas, E., 'The Paradox of Morality: an Interview with Emmanuel Lévinas', in R. Bernasconi & D. Wood (eds), *The Provocation of Lévinas. Rethinking the Other*, London and New York, Routledge, 1988.

Llewelyn, J., 'Lévinas, Derrida and Others *Vis-à-vis*', in R. Bernasconi & D. Wood (eds), *The Provocation of Lévinas. Rethinking the Other*, London & New York, Routledge, 1988.

Lucas Bridges, E., *Uttermost Part of the Earth*, London, Hodder & Stoughton, 1951.

Lyotard, J.-F., *The postmoderne expliqué aux enfants*, Paris, Galilée, 1986.

Lyotard, J.-F., *The Postmodern Explained to Children*, London, Turnaround, 1992.

Maharaj, S., '"The Congo is Flooding the Acropolis". Art in Britain of the Immigration', *Third Text* 15, Summer 1991.

Mani, L., 'Multiple Mediations. Feminist Scholarship in the Age of Multinational Reception', *Inscriptions* 5, 1989.

Marcus, G., *Lipstick Traces. A Secret History of the Twentieth Century*, London, Secker & Warburg, 1989.

Mariani, P. (ed.), *Critical Fictions. The Politics of Imaginative Writing*, Seattle, Bay Press, 1991.

Marion, J.-L., 'L'Interloqué', in E. Cadava, P. Connor & J.-L. Nancy (eds), *Who Comes After the Subject?*, London & New York, Routledge, 1991.

Marx, K., *Grundrisse*, Harmondsworth, Penguin, 1973.

Mason, P., *Deconstructing America. Representations of the Other*, London and New York, Routledge, 1990.

Maspero, F., *Beyond the Gates of Paris*, London, Verso, 1992.

Matvejević, P., *Mediterraneo*, Milan, Garzanti, 1991.

Mercer, K., 'Black hair/style politics', *New Formations* 3, Winter 1987.

Mercer, K., (ed.), *Black Film/British Cinema*, ICA Documents 7, London, ICA 1988.

Mercer, K., 'Black Art and the Burden of Representation', *Third Text* 10, Spring 1990.

Morin, E., *La Méthode. 1. La nature de la nature*, Paris, Editions du Seuil, 1977.

Morin, E., *Sociologie*, Paris, Fayard, 1984.

Morin, E., *Vidal et les siens*, Paris, Editions du Seuil, 1989.

Morley, D. & Robins, K., 'No Place like Heimat, Images of Homeland in European Culture', *New Formations* 12, Winter 1990.

Morris, M., 'The Man in the Mirror: David Harvey's "Condition" of Postmodernity', *Theory, Culture & Society* 9 (1), 1992.

Mosès, S., *L'Ange de l'histoire. Rosenzweig, Benjamin, Scholem*, Paris, Editions du Seuil, 1992.

Naipaul, V.S., *The Enigma of Arrival*, New York, Vintage, 1988.

Naipaul, V.S., *India. A Million Mutinies Now*, London, Minerva, 1990.

Nandy, A., 'Dialogue and the Diaspora', *Third Text* 11, Summer 1990.

Nietzsche, F., *The Will to Power*, New York, Vintage, 1968.

Nietzsche, F., *Beyond Good and Evil*, Harmondsworth, Penguin, 1973.

Niranjana, T., *Siting Translation. History, Post-Structuralism and the Colonial Context*, Berkeley, Los Angeles & London, University of California Press, 1992.

Perry, R. & Greber, L., 'Woman and Computers', *Signs* 16 (1), Autumn 1990.

Poe, E.A., *Some Tales of Mystery and Imagination*, Harmondsworth, Penguin, 1938.

Pratt, M. L., *Imperial Eyes. Travel Writing and Transculturation*, London & New York, Routledge, 1992.

Pynchon, T., *Vineland*, London, Minerva, 1990.

Radway, J., *Reading the Romance*, Chapel Hill & London, University of North Carolina Press, 1984.

Ramondino, F. & Müller, A.F., *Dadapolis*, Turin, Einaudi, 1992.

Rella, F., *Asterischi*, Milan, Feltrinelli, 1989.

Rhys, J., *The Wide Sargasso Sea*, Harmondsworth, Penguin, 1988.

Ricœur, P., *Soi-même comme un autre*, Paris, Editions du Seuil, 1991.

Robertson, R., 'Social Theory, Cultural Relativity and the Problems of Globality', in A.D. King (ed.), *Culture, Globalization and the World-System*, Binghamton, State University of New York, 1991.

Roché, H.-P., *Jules et Jim*, London, Marion Boyars, 1993.

Romanyshyn, R.D., *Technology as Symptom and Dream*, London & New York, Routledge, 1989.

Rose, J., *Sexuality in the Field of Vision*, London, Verso, 1986.

Rosenzweig, F.L., *Der Stern der Erlösung*, The Hague, Martinus Nijhoff, 1981.

Rosenzweig, F., *L'Etoile de la rédemption*, Paris, Editions du Seuil, 1982.

Rotman, B., *Signifying Nothing. The Semiotics of Zero*, London, Macmillan, 1987.

Rushdie, S., *Midnight's Children*, London, Picador, 1981.

Rutherford, J., *Identity. Community, Culture, Difference*, London, Lawrence & Wishart, 1990.

Said, E., 'Representing the Colonized, Anthropology's Interlocutors', *Critical Inquiry* 15, Winter 1989.

Said, E., 'Figures, Configurations, Transfigurations', *Race & Class*, vol. 32, no. 1, 1990.

Said, E., 'Reflections on Exile', in R. Ferguson, M. Gever, Trinh T. Minh-ha & C. West (eds), *Out There, Marginalization and Contemporary Cultures*, Cambridge, Mass., MIT Press, 1990.

Said, E., 'Yeats and Decolonization', in D. Walden (ed.), *Literature in the*

Modern World, Oxford, Oxford University Press, 1990.

Schafer, M., *The Tuning of the World*, New York, Alfred Knopf, 1977.

Schwarz, B., 'Exorcizing the General', *New Formations* 14, Summer 1991.

Scott, J.W., *Gender and the Politics of History*, New York, Columbia University Press, 1988.

Seghal, M., 'Indian Video Films and Asian-British Identities', *Cultural Studies from Birmingham* 1, 1991.

Silko, L.M., *Storyteller*, New York, Little Brown & Company, 1981.

Sohn-Rethel, A., *Napoli, la filosofia del rotto*, Naples, Alessandra Caròla Editrice, 1991.

Spivak, G.C., 'Translator's Preface', in J. Derrida, *Of Grammatology*, Baltimore, Johns Hopkins University Press, 1977.

Spivak, G.C., 'Can the Subaltern Speak?', in C. Nelson & L. Grossberg (eds), *Marxism and the Interpretation of Culture*, Urbana, University of Illinois Press, 1988.

Spivak, G.C., 'Reading *The Satanic Verses*', *Third Text* 11, Summer 1990.

Spivak, G.C., *The Post-Colonial Critic*, London & New York, Routledge, 1990.

Taussig, M., *Shamanism, Colonialism and the Wild Man. A Study in Terror and Healing*, Chicago & London, University of Chicago Press, 1991.

Todorov, T., 'Bilingualism, Dialogism and Schizophrenia', *New Formations* 17, Summer 1992.

Tomas, D., 'From Gesture to Activity, Dislocating the Anthropological Scriptorium', *Cultural Studies* 6 (1), January 1992.

Trinh T. Minh-ha, *Woman, Native, Other*, Bloomington & Indianapolis, Indiana University Press, 1989.

Trinh T. Minh-ha, 'Woman, Native, Other. Pratibha Parmar interviews Trinh T. Minh-ha', *Feminist Review* 36, Autumn 1990.

Trinh T. Minh-ha, 'Cotton and Iron', in R. Ferguson, M. Gever, Trinh T. Minh-ha & C. West (eds), *Out There, Marginalization and Contemporary Cultures*, Cambridge, Mass., MIT Press, 1990.

Trinh T. Minh-ha, *When the Moon Waxes Red*, London & New York, Routledge, 1991.

Turkle, S. & Papert, S.,'Epistemological Pluralism. Styles and Voices within the Computer Culture', *Signs* 16 (1), Autumn 1990.

Ulin, R.C., 'Critical Anthropology Twenty Years Later', *Critique of Anthropology* 11 (1), 1991.

Vattimo, G., *The End of Modernity*, Oxford, Polity Press, 1988.

Vilder, A., 'Homes for Cyborgs', *Ottagno*, 96, September 1990.

Virilio, P., *L'Espace critique*, Paris, Christian Bourgois, 1984.

Virilio, P., *Lo spazio critico*, Bari, Dedalo, 1988.

Walcott, D., *Selected Poetry*, London, Heinemann, 1981.

Walcott, D., *Omeros*, London, Faber & Faber, 1990.

White, A., *The Uses of Obscurity. The Fiction of Early Modernism*, London, Routledge & Kegan Paul, 1981.

Wiener, N., *The Human Use of Human Beings*, London, Sphere Books, 1968.

Williams, R., *The Country and the City*, London, Chatto & Windus, 1973.

Williams, R., 'Metropolitan Perceptions and the Emergence of Modernism', in R. Williams, *The Politics of Modernism*, London, Verso, 1989.

Winterson, J., *Sexing the Cherry*, London, Vintage, 1990.
Wolf, E.R., *Europe and the People without History*, Berkeley, Los Angeles & London, University of California Press, 1982.
Wollen, P., 'Tourism, Language and Art', *New Formations* 12, Winter 1990.
Wright, F.L., *The Living City*, New York, New American Library, 1956.
Young, R., *White Mythologies. Writing, History and the West*, London & New York, Routledge, 1990.

INDEX

151